Food Photography.
From
Snapshots to
Great Shots

Nicole S. Young

Peachpit
Press

Food Photography: From Snapshots to Great Shots
Nicole S. Young

Peachpit Press
1249 Eighth Street
Berkeley, CA 94710
510/524-2178
510/524-2221 (fax)

Find us on the Web at www.peachpit.com
To report errors, please send a note to errata@peachpit.com
Peachpit Press is a division of Pearson Education

Copyright © 2012 by Peachpit Press

Associate Editor: Valerie Witte
Production Editor: Becky Winter
Copyeditor: Scout Festa
Technical Editor: Rich Legg
Proofreader: Patricia Pane
Composition: Danielle Foster
Indexer: Valerie Haynes Perry
Cover Image: Nicole S. Young
Cover Design: Aren Straiger
Back Cover Author Photo: dav.d daniels

The illustration elements featured in this book are ©iStockphoto.com/Patrick Wong.

ISBN-13: 978-0-321-78411-7
ISBN–10: 0-321-78411-1

9 8 7 6 5 4 3 2

Printed and bound in the United States of America

DEDICATION

To foodies, food bloggers, home cooks, and chefs...and to anyone who craves a delicious meal, chases beauty, and wants to make people hungry with their photographs.

ACKNOWLEDGMENTS

The process of writing, editing, and publishing a book is, at times, overwhelming. It's a creative challenge to make the content work within the pages, teach the reader (as clearly as possible) about technique, skill, vision, and creativity, and also stay true to the layout, flow, and structure of the book itself. My name may be on the cover of the book, but I'm really only a part of the process, and there's no way that this book would be what it is without the guidance, hard work, dedication, inspiration, and motivation of so many other people.

I wouldn't be where I am today without the support and love from my family. They have always believed in me and never doubted my ability to succeed at whatever I set my mind and heart to do, and because of that I will be forever grateful. I love you guys!

I am blessed with an amazing group of friends, mentors, and colleagues. You all have opened my eyes to things I couldn't see without your guidance, and you have also been the voice of reason when I stumbled. Thank you for your never-ending dedication, loyalty, and patience. Thank you also for your wisdom, advice, and knowledge, and, even more importantly, thank you for giving me hope and inspiring confidence.

I truly want to thank the Peachpit crew and the team involved in producing this book, and especially my editor, Valerie. This road was a little bumpier than with previous projects, but we all seemed to make it through unscathed. Thank you for your patience, flexibility, and teamwork while working on this book.

I am extremely thankful to my readers. It means so much to me when I get a note from someone thanking me for a book, a blog post, or a bit of knowledge that helped him or her become a better photographer. You, my readers, are the reason I wrote this book, and I, in turn, have learned so much from being a part of an amazing, worldwide, kind, and generous community of creative and talented people.

And lastly, my faith has always been a very big part of my life. My passion for art and my talent for teaching and sharing my knowledge with others are gifts that I have been extremely blessed with, and I am so grateful for having God in my life, which keeps my heart alive and refreshed each day.

Contents

Introduction

I had this book in my brain long before I started writing it. I love food and I love photography, and it was just natural to blend the two together and evolve into becoming a food photographer. I also know there are a lot of other photographers and foodies who want to make their food look gorgeous, too. Because of this, I felt a strong desire to write a book that would help food lovers create images that truly expressed the beauty of the food they wanted to photograph.

We all develop our own style of photography, but one thing rings true when photographing food: It needs to look delicious. The purpose of this book is to guide photographers at all levels to make their food look as good as it tastes, and to do so as naturally, organically, and simply as possible.

Here is a quick Q&A about the book to help you understand what you'll see in the following pages:

Q: WHAT CAN I EXPECT TO LEARN FROM THIS BOOK?

A: This book starts with the basics of photography (photographic fundamentals and equipment) and works through the steps of lighting, styling, composing, and editing the photographs. It shows how to present the food that you've cooked and prepared and turn it into a mouthwatering photograph.

Q: WHO IS THIS BOOK WRITTEN FOR?

A: Ultimately, this book is for anyone who wants to create beautiful food photographs. I wrote it with food bloggers and home cooks in mind, but all of the techniques can be used by photographers, cooks, or chefs of any type or skill level in any situation or environment.

Q: DO I NEED A FANCY CAMERA AND LIGHTING EQUIPMENT TO GET GOOD FOOD PHOTOGRAPHS?

A: No! You can get great photographs by using a minimal amount of gear, and the last thing you should do before learning any type of photography is to overspend and buy gear that you *think* you will need. You will, of course, need a camera to work with, but use what you have for now before running out and buying new equipment. As you develop your photographic style and your skills evolve, it will be easy to narrow down the gear that will help share your vision. This book does teach how to light food with strobe (artificial) light, and I do think that it's a very important skill to learn, since you may not always be able to find the right light to use for a photograph. But if you have God-given, beautiful, diffused window light nearby, there's no need to spend money on strobe lights or flashes immediately. You'll end up saving money, and you can buy the proper gear later.

Q: WHAT ARE THE CHALLENGES ALL ABOUT?

A: At the end of most chapters, I list a few exercises that will help you practice and solidify some of the techniques and settings you learned about. Feel free to try them out if you like, and if you do, be sure to check out the Flickr group and share your photographs!

A: There's really no set way to read the book. If you're new to photography, however, I recommend that you read the first two chapters to get an understanding of the basics and build a solid foundation of photography before diving in to the lighting and food-specific information. If you're a fairly seasoned photographer who understands your camera and most of the basic techniques, then you can go ahead and jump straight to the more food-specific chapters.

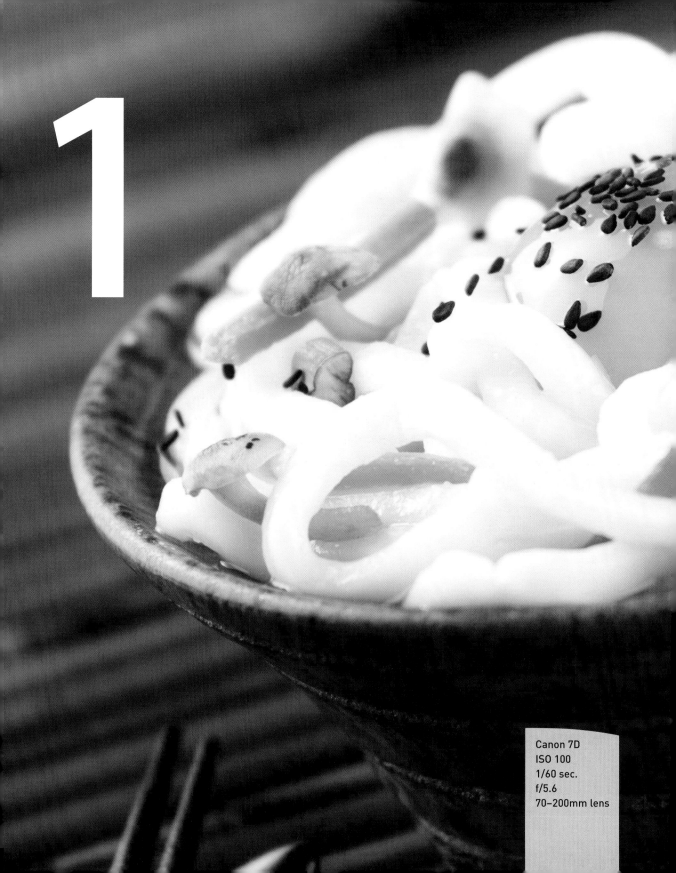

1

Canon 7D
ISO 100
1/60 sec.
f/5.6
70–200mm lens

Photography Fundamentals

UNDERSTANDING THE BASICS OF DIGITAL PHOTOGRAPHY

When it comes to photographing food, the basics of digital photography are really no different than those of other photographic genres. If you're new to photography in general or could use a refresher, then this chapter is for you! It's important to have a solid understanding of basics like file formats, aperture, shutter speed, and white balance before venturing into food photography—if you want your images to make mouths water, that is.

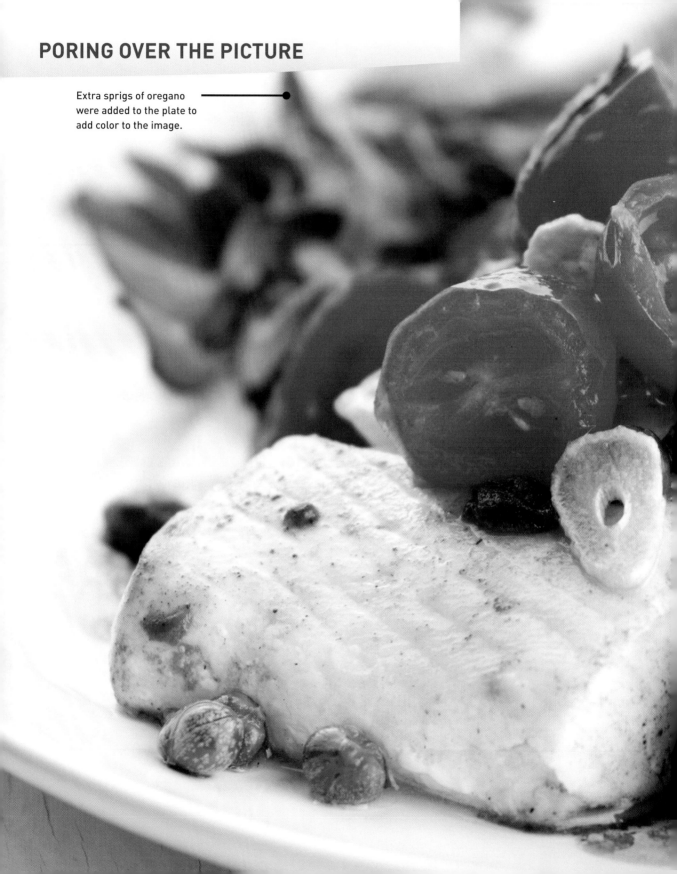

PORING OVER THE PICTURE

Extra sprigs of oregano
were added to the plate to
add color to the image.

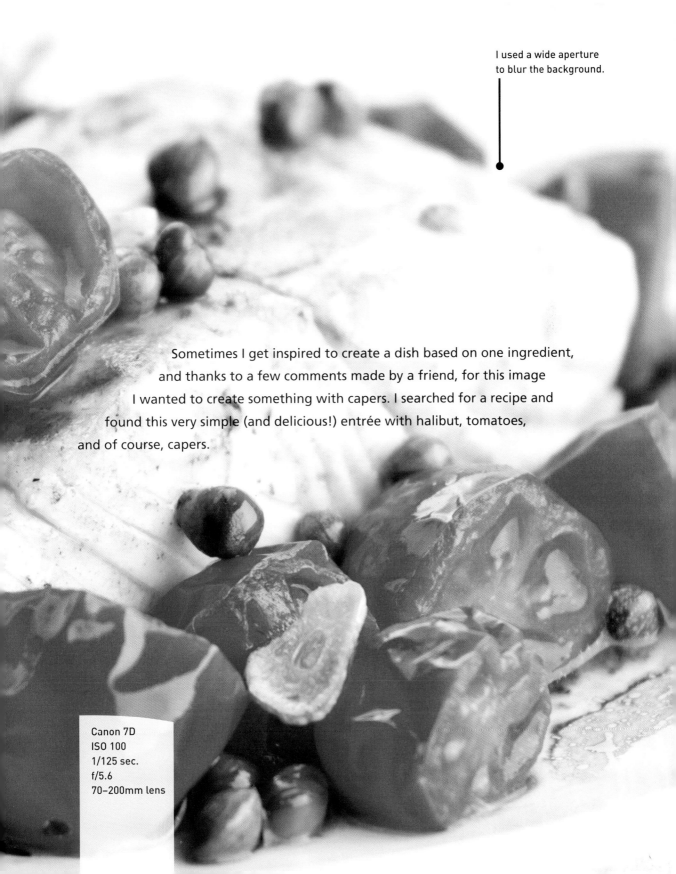

I used a wide aperture
to blur the background.

Sometimes I get inspired to create a dish based on one ingredient,
and thanks to a few comments made by a friend, for this image
I wanted to create something with capers. I searched for a recipe and
found this very simple (and delicious!) entrée with halibut, tomatoes,
and of course, capers.

Canon 7D
ISO 100
1/125 sec.
f/5.6
70–200mm lens

PORING OVER THE PICTURE

I wanted a very "clean" look to this image, so I chose a white plate and table covering.

I saw this dish prepared on a TV show and thought it not only looked delicious but would also make a great photograph! So I found the recipe, cooked it up, and styled it. To light the image, I used diffused window light coming from behind. The image needed some additional fill light, so I used a silver reflector on one side and a large piece of white foam board on the other to bounce some light to the front and sides of the dish.

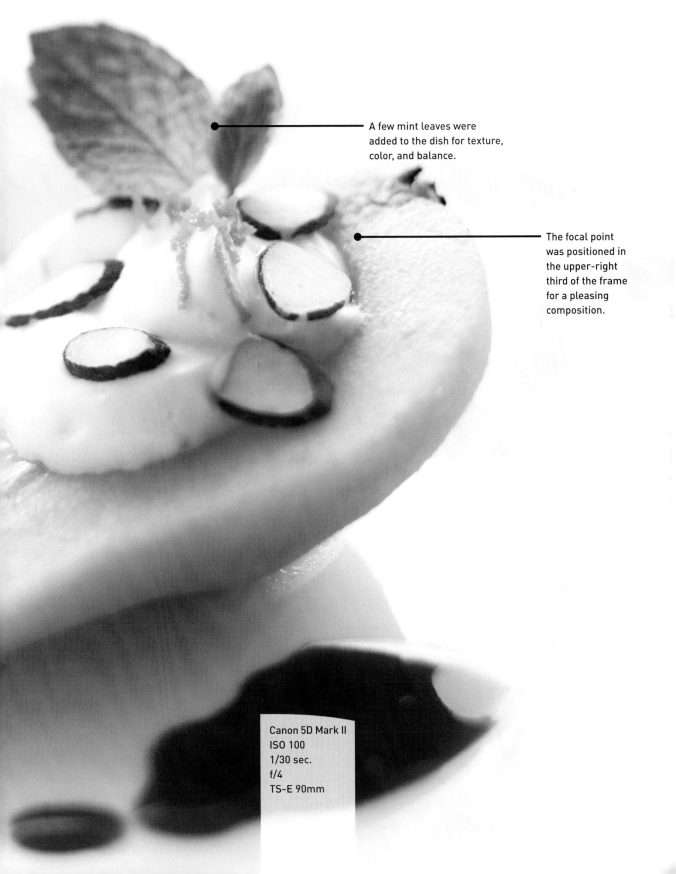

A few mint leaves were added to the dish for texture, color, and balance.

The focal point was positioned in the upper-right third of the frame for a pleasing composition.

Canon 5D Mark II
ISO 100
1/30 sec.
f/4
TS-E 90mm

FILE TYPES: RAW AND JPEG

When photographing with a digital camera, you will usually have the option of using one of two different file formats: RAW and JPEG. Some cameras will only create JPEG images, but the majority of Digital Single Lens Reflex (DSLR) cameras—in other words, cameras that use interchangeable lenses and allow you to see exactly what you are photographing—will allow you to photograph in the RAW format. So, to start, let's get into the specifics of what each of these file types do, and also review the advantages and disadvantages of each.

RAW

The RAW file format is the preferred file type for most professional photographers. With digital photography, when we create an image we are actually recording data to our memory cards, and the RAW file format will save as much data as possible each time you press the shutter button. This is extremely beneficial when it comes to processing the images on your computer in programs like Adobe® Photoshop® Lightroom® or Adobe® Photoshop®, since you can make essential nondestructive changes and edits to the image.

Now, RAW files do have their limits. You still need to do your best to get the image as close to perfect in-camera as possible (always a good idea in general), but if your exposure is off a little bit (the image is over- or underexposed) and you need to fix the white balance or fill in the shadows, then you can make those changes easily and without significant loss of quality to the photograph.

The RAW file type is often referred to as a digital negative. If you're familiar with film photography, you know that the negative is not a finished product but that it contains as much visual information possible to *create* the finished product. In a film negative, the dynamic range (the amount of detail contained in the shadows and bright portions of the image) is significantly greater than with a finished photo-graph, and this is also true with a digital RAW file.

When you create an image using a RAW file, each camera brand will have its own unique file extension. For example, a Canon RAW file is ".CR2" and a Nikon RAW file is ".NEF"—but, deep in their core, they are all pretty much the same thing. You will also need special software in order to make changes and edit RAW files, since your final output will be a TIFF, a JPEG, or whatever file format is needed for your project (remember: a RAW file is just a "negative"). Most cameras ship with brand-specific software that you can use, but I prefer to use Lightroom or Adobe Camera RAW (available with Photoshop) for editing my RAW files. (Please turn to Chapter 6 for more information on processing and editing images.)

When I photograph food, I use RAW one hundred percent of the time. I prefer this file format for virtually all of my photography and really love the control it allows when editing my photos. My goal with my food images is to make them as clean-looking as possible, and RAW enables me to get the most out of my photographs while editing.

DNG

Another common type of RAW file is Adobe DNG, or Digital Negative. This nonproprietary format is typically not created in-camera but can be converted during postprocessing using Adobe software. It is thought to potentially outlast some of the camera-specific/proprietary file types. I prefer this file type, and converting RAW files to DNG upon import to my computer is part of my regular workflow.

ADVANTAGES OF RAW:

- Wide dynamic range
- Ability to change white balance in editing
- Ease in making nondestructive edits

DISADVANTAGES OF RAW:

- Large file size
- Additional software and editing experience required

WHO BENEFITS FROM USING RAW?

- Photographers who have large enough memory cards, want the best-quality image they can create, and can take the time to edit each of their images on their computer.

JPEG

If your camera doesn't write RAW files or you're not quite comfortable with editing RAW, then you'll still be just fine working with JPEG. A JPEG (Joint Photographic Experts Group) is essentially a compressed version of a RAW file. Instead of holding on to all of the extra data that a RAW file saves (what I like to call "editing wiggle room"), a JPEG compresses all that data down to a very small file and discards the extra information that isn't actually visible in the image. Because of this, you lose the ability to do any substantial edits without damaging the image's pixels.

Earlier I compared RAW files to film negatives. By contrast, think of a JPEG as a finished print. Most of the dynamic range in the image is lost, so you basically get what you see. You can, of course, make changes to the image in postprocessing, but you run the risk of overprocessing the image and losing detail in the shadows or bright areas.

Another issue with photographing in JPEG is that you don't have a lot of leeway when it comes to white balance. The white balance (which is discussed in detail in the next section) determines the majority of the color balance in your image. With a RAW file you have complete control of the white balance while editing, so it really doesn't matter what it's set to when you create the photograph. With a JPEG, however, whatever the white balance is set to while you're making the image is what is embedded into the final photograph. If it's significantly off you may have no chance of recovering the colors while editing, and you may run the risk of a huge loss in image quality due to destructive editing.

The only reason I would suggest using JPEG is if you don't want to edit RAW files or have absolutely no desire to learn how. Now, I'm sure there are many photographers who prefer to use JPEG all the time and are extremely successful with their images. My personal opinion is that if your camera can be set to RAW, you have no problem spending 30 seconds editing the RAW file, and you want to protect the quality of the image as much as possible, don't use JPEG.

ADVANTAGES OF JPEG:

- Small file size
- Little editing required

DISADVANTAGES OF JPEG:

- Editing may cause loss in details and image quality
- Exposure and white balance must be extremely accurate in-camera

WHO BENEFITS FROM USING JPEG?

- Photographers who need smaller files, can get their exposure and white balance close to perfect in-camera, and want to do very little (if any) editing on their computer

"LOSSLESS" AND "LOSSY"

One of the main differences between RAW and JPEG is that RAW is considered *lossless*, whereas JPEG is *lossy*. With a RAW file, you lose no data (lossless) when creating the image and writing the data to your memory card. Also, once the image is on your computer you are able to edit the file, save it, re-edit it, save it, and so on, with no loss of data. A JPEG, on the other hand, is considered lossy because it throws out a lot of information when you create the image and write it to the card, and editing and saving over and over causes even more compression and loss of quality to the file.

WHITE BALANCE

In the previous section I mentioned the term *white balance* a few times. This is a very, very important fundamental to understand, especially with food photography, since it deals with color balance in the image, and a food's colors can greatly affect its visual appeal. It's called white balance because the overall intent is to make sure that the whites are actually white and that the balance of color in the photograph is true to its original color, depending on the type of light it was photographed in.

To get a bit deeper into understanding this (without going too geeky), I'll start by defining white balance and why we have it. Basically, different light sources give off different temperatures of light, measured in Kelvin, and your camera has settings that sync the two so that the color of your image is as true to its natural state as possible. The settings on digital cameras usually will say things like Cloudy, Daylight, or Fluorescent (among a few other settings). Most of the time these are just averages of what the color balances typically look like in each of these situations. There's also a setting on most cameras that lets you dial in the specific Kelvin temperature of the light, if you know it. In **Figure 1.1,** I show the same scene photographed at different white balance settings—it's not too difficult to see which ones look best.

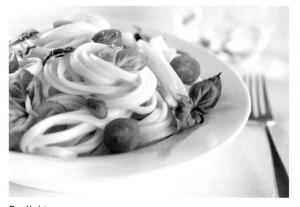

Daylight

Shade

Canon 7D
ISO 100
1/20 sec.
f/4
24–105mm lens

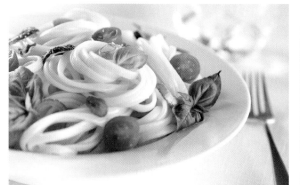

Cloudy

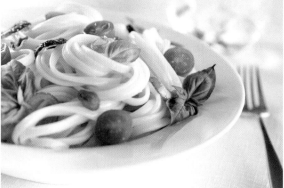

Flash

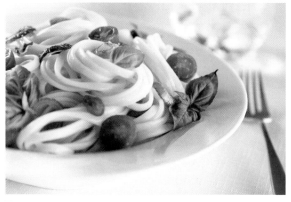

Tungsten

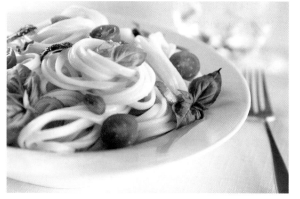

Fluorescent

FIGURE 1.1

These images are of the same subject photographed at different white balance settings, using a mixture of natural light and flash to light the scene. You can see that the Daylight, Shade, Cloudy, and Flash settings all produce decent results, mostly because they are based on daylight-balanced light, and only slight adjustments would be needed when editing. The Tungsten and Fluorescent results, however, are less than desirable.

Here are the basic descriptions of standard white balance settings:

- **Auto:** The default setting for your camera—the camera determines the color temperature of each photo based on the available light coming through the lens.

- **Daylight:** Most often used for general daylight/sunlit photography.

- **Shade:** Used when working in shaded areas that are still using sunlight as the dominant light source.

- **Cloudy:** The choice for overcast or very cloudy days. This and the Shade setting will eliminate the blue colorcast from your images.

- **Flash:** Used whenever you're using a flash with your photographs.

- **Tungsten:** Used for any occasion when you are using regular incandescent household-type bulbs as your light source. Tungsten is a very warm light source and will result in a yellow/orange cast if you don't correct for it.

- **Fluorescent:** Used to get rid of the green-blue cast that can result from using regular fluorescent lights as your dominant light source. Some fluorescent lights are actually balanced for daylight, which would allow you to use the Daylight white balance setting.

When photographing food, the majority of the time you will probably be working in daylight, whether it's shaded sunlight or off-camera flash/strobe; if so, you could pick from the Daylight, Shade, or Cloudy white balance settings and probably get pretty close to a desirable color balance. If you were to ask me what I do, I'd tell you that I usually just keep my white balance setting on Auto (shh, don't tell anyone!). The newer SLR cameras tend to do a very good job getting an accurate white balance, often requiring only minor adjustments in the editing process.

Now if your camera is set to RAW, this is not going to be a big deal for you to worry about while creating the image. As much as I loathe saying "you can fix it in Photoshop," this is one of those settings that I really don't sweat about until I'm sitting in front of my computer, mostly because Auto white balance usually does a pretty good job to begin with. It's also something that I almost *always* adjust while editing, even if the white balance was customized as I created the image in my camera. If you are using JPEG, however, you'll really want to make sure that this setting is as accurate as possible, since you don't have as much wiggle room to work with in postprocessing.

If you do want to achieve an accurate (or close to accurate) custom white balance setting, there are tools you can buy or create to get you pretty close. A simple gray card, white piece of paper, disposable white plastic coffee lid, or a perfectly color-balanced white balancing device can usually get your images close to where you want it. Consult your camera's user manual for more information on setting up a custom white balance.

WHITE BALANCE AND COLOR TEMPERATURE

When you select different white balances in your camera, you will notice that underneath several of the choices are numbers, for example, 5200K, 7000K, or 3200K. These numbers refer to the Kelvin temperature of the colors in the visible spectrum. The visible spectrum is the range of light that the human eye can see (think of a rainbow or the color bands that come out of a prism). The visible spectrum of light has been placed into a scale called the Kelvin temperature scale, which identifies the thermodynamic temperature of a given color of light. Put simply, reds and yellows are "warm," and greens and blues are "cool." Even more confusing can be the actual temperature ratings. Warm temperatures are lower on the Kelvin scale, ranging from 3000 degrees to 5000 degrees, while cool temperatures run from 5500 degrees to around 10,000 degrees. Take a look at this list for examples of Kelvin temperature properties.

KELVIN TEMPERATURE PROPERTIES

FLAMES	1700K–1900K	DAYLIGHT	5000K
Incandescent bulb	2800K–3300K	Camera flash	5500K
White fluorescent	4000K	Overcast sky	6000K
Moonlight	4000K	Open shade	7000K

The most important thing to remember here is how the color temperature of light will affect the look of your images. If something is "warm," it will look reddish-yellow, and if something is "cool," it will have a bluish cast.

THE EXPOSURE TRIANGLE: APERTURE, SHUTTER SPEED, AND ISO

To create a photograph you need light, and there are three camera settings that need to balance in order to get a proper exposure: aperture, shutter speed, and ISO. Your goal in using these elements is to find a good balance of light, depth of field, and focus, and while there are some principles to understand and follow, there's no set of rules or presets that you can use to always get the correct exposure. The key is to know how they work together so you can make your own creative decisions.

APERTURE

The aperture is the element in a lens that allows the light to pass through it and into the camera, ultimately reaching the sensor. Aperture controls two things: the amount of light coming into the lens and depth of field. To control the light you change the physical size of the aperture. It looks like a circle, but is actually made up of blades that fan in and out to decrease and increase the aperture's size. When opened wide the aperture lets a lot of light in, and when tightened to be very small it lets very little light in. The actual size limits of the aperture will depend on each particular lens's capabilities.

When setting the aperture, you will be selecting an f-stop number—a smaller number equals a wide opening, which means more light coming through the lens; a larger number equals a smaller opening and less light coming through the lens (**Figure 1.2**).

The easiest way to remember this is to think of the numbers as fractions, where $f/2$ is going to be bigger than $f/16$, for example. A lens with an extremely wide opening is considered a very "fast" lens and is typically more expensive, too. The benefits of using fast lenses are that you not only have more light to work with, but you also have enormous control over depth of field. A fast lens photographed at its widest aperture will create a shallow depth of field, but will also allow you to tighten the aperture if a wide aperture isn't required (for example, to move from $f/2.8$ to $f/8$ or smaller). Another great thing about fast lenses is that they give you flexibility in low-light situations, especially when handholding your camera. You do need to be careful when focusing a lens that is set to a wide aperture, however, since it's likely that much of the image will be out of focus.

DEPTH OF FIELD

Depth of field describes how much of your image is actually in focus. If an image has great depth of field, the majority of the photograph is in focus. In an image with little (or shallow) depth of field, there is usually a selective point of focus with the foreground and/or background out of focus (or blurry); this is usually achieved with a combination of focal length and a wide aperture. Controlling the depth of field in an image is a useful creative tool and one that I consider extremely important in my own photography.

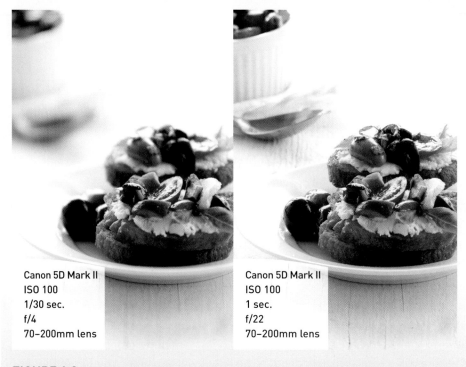

Canon 5D Mark II
ISO 100
1/30 sec.
f/4
70–200mm lens

Canon 5D Mark II
ISO 100
1 sec.
f/22
70–200mm lens

FIGURE 1.2
These two images show the difference in depth of field when using a wide aperture (f/4) and a very small aperture (f/22). Both images were photographed on a tripod at ISO 100 at 200mm.

The camera sensor is the light-sensitive area within the camera that converts the optical signal of your image and turns it into digital data. If you're familiar with film photography, think of it as the piece of film that is exposed to create the negative.

SHUTTER SPEED

Before I get into defining shutter speed, first let's discuss what the shutter does and how it works inside the camera. In the previous section we discussed aperture, the opening inside the lens that controls the amount of light entering the camera. Think of the shutter as a door or curtain inside the camera, directly in front of a sensor, that opens and closes to allow the light from the aperture to actually expose the sensor and create the photograph.

When we set the shutter speed, we are literally determining how long the shutter stays open. With a fast shutter speed, the shutter will be open for only a brief period of time, thereby allowing very little light to hit the sensor. When opened for a longer period of time, it allows more light to reach the sensor. A fast shutter speed will "freeze" action and allow you to handhold the camera, whereas a long shutter speed will capture movement in the frame (if there is any) and will almost always require the camera to be on a tripod.

Shutter speed is measured in seconds and fractions of seconds. A fraction of a second might seem pretty fast, and it is, but you'd be surprised at how much movement you can introduce into images with settings like 1/15 and 1/30 of a second. With a non-moving object, the shutter speed is really irrelevant as far as the final product is concerned, especially if you are using a tripod. But there may be times when you want to add movement to your image (or prevent movement), so it's important to understand how shutter speed works.

When photographing food, it's likely that you'll be more concerned, creatively speaking, with the aperture setting to control depth of field, and that you'll determine the shutter speed by how much light is still required to properly expose the image. With a typical SLR and a 50mm lens, you can safely handhold your camera at a shutter speed of 1/60 of a second, and maybe even 1/30 of a second, depending on how steady your hands are. Anything longer than that will require a tripod, since handholding a long exposure can introduce camera shake and blurred movement that you might not want to see in your image. Also, if you are using a lens with a longer

focal length, you'll have to increase this "base level" of handheld shutter speed, since the longer the lens the more movement you can introduce in your image. A good rule of thumb is to use the same shutter speed as your focal length—if you are using a 100mm lens, then you should try to keep your shutter speed at or above 1/125 of a second (1/100 of a second isn't an actual shutter speed). This, of course, will depend on you and the type of light you are using. If you are using studio lights or off-camera strobes, for example, then the shutter speed is dependent on the shutter sync speed of your camera (see Chapter 3 for more information on using lights in food photography).

ISO

The final element of exposure is ISO. ISO is an acronym for the International Organization for Standardization, and is used as a term to describe the sensitivity of the camera's sensor to light. ISO numbers usually start at 100 and can go up to 12,800 (or even higher, depending on your camera). The lower the number is, the less sensitive to light; the higher the number, the more sensitive to light. So, if you have your ISO set to 100, you would need more light to create a proper exposure than you would with a setting of ISO 800, for example.

Now, if you're creating an image and have set your aperture and shutter speed, but then realize you need more light, you may be tempted to just crank the ISO way up so that the sensor is more sensitive, allowing you to create your photograph with no other changes. Unfortunately, it's not that simple. You see, there's a disadvantage to using an extremely high ISO—noise. With a low number, you'll see very little noise; however, the higher that number gets, the more noise you will see in your images (**Figure 1.3**).

The amount of noise you actually see in your images will also be determined by the final output of your photograph. If you plan to use your photos only as low-resolution digital images on a Web site, then you can probably get away with increasing the ISO number, since the larger you view the image, the more clearly you will see its noise, and Web images are typically small. Ultimately, the acceptable amount of noise in your images is up to you. If you have the resources, light, and ability to create your images at a low ISO, that's usually a good choice. But if you're in an environment where you have no option but to increase the ISO, and the content of the photograph is more important than the quality, then by all means, do what you have to do to make the photograph. For my images, especially food photographs, I do my best to photograph everything at ISO 100, the lowest native ISO level my camera allows, to ensure a crisp, clean, noise-free image.

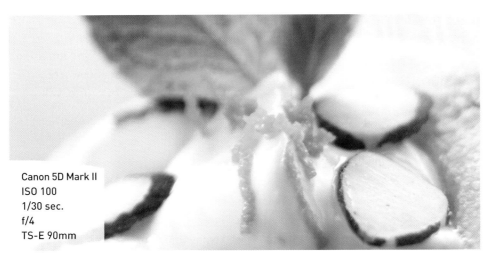

Canon 5D Mark II
ISO 100
1/30 sec.
f/4
TS-E 90mm

FIGURE 1.3
These three images
show the same
subject photo-
graphed at different
ISO settings—100,
800, and 6400.

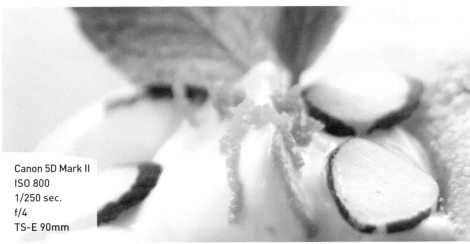

Canon 5D Mark II
ISO 800
1/250 sec.
f/4
TS-E 90mm

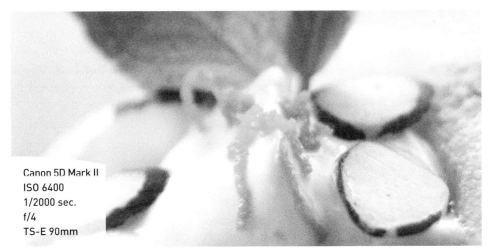

Canon 5D Mark II
ISO 6400
1/2000 sec.
f/4
TS-E 90mm

CALCULATING OVERALL EXPOSURE

As I mentioned at the beginning of this section, each of the components of the exposure triangle—aperture, shutter speed, and ISO—need to be balanced to create a proper exposure. Now that you know what they are and how they determine exposure, you might still be wondering where to start. How are you supposed to know where to set each of the settings to create a properly exposed photograph? The thing is, there's no single way to create a photograph, and there's definitely not a right way. Creating a proper exposure is about balancing each of the elements to get the look and feel *you* want out of your photographs.

To start, you'll very likely be using the meter inside your camera. The overall goal of this meter is to balance all of these elements so that what it sees, tonally speaking, is gray. Here's an easy way to test this out. Take your camera (make sure the flash is turned off) and point it at a white wall. Don't worry about the settings for now; just set it to auto and take a photo. Now, look at the photo. Assuming there is nothing off with your settings, the image of your once-white wall that you are previewing on your camera is now very likely a muddy gray. That's the camera's meter at work. It saw that white wall and tried to bring it back to a neutral gray. If you were to repeat the same experiment with a black surface, you would get the same results.

As I mentioned earlier, there are many ways to create a proper exposure. Any single setting is interchangeable with different settings to create the exact same exposure, with what is called reciprocal exposures—that is, the images will look different in regard to depth of field, motion, and noise levels, but the amount of light reaching the sensor is the same. This means that if your camera is set one way, and you change one of the settings but want to maintain the same amount of light reaching the sensor, you would simply adjust the other two settings—whether aperture, shutter speed, or ISO—to balance it out. It's your job to adjust the settings to get the final creative look you want to achieve.

RECIPROCAL EXPOSURES: ISO 100

F-STOP (APERTURE)	2.0	2.8	4.0	5.6	8	11	16	22
SHUTTER SPEED	1/8000	1/4000	1/2000	1/1000	1/500	1/250	1/125	1/60

Now that you know what your camera is trying to do, it's your job as a photographer to take back that control and choose your own settings. There are different ways to do this, and the most obvious is to use the Manual setting on your camera. Photographing in Manual mode allows you full control of your settings without letting the camera choose anything for you. You can still see the meter at work on your camera but maintain control over aperture, shutter speed, and ISO (**Figure 1.4**). Two other camera modes, Aperture Priority and Shutter Priority, allow you to select the ISO and one of the settings (let's use aperture for this example), and the camera determines the other setting for you (in this case, the shutter speed). You can still maintain control over the exposure

FIGURE 1.4

The circled area represents what a meter looks like in the viewfinder. In this example, the photograph is balanced perfectly, indicated by the meter mark/arrow centered on the metering scale in the viewfinder. When using a camera mode other than Manual, you can adjust where the camera balances exposure by moving the mark to the left (to underexpose) or right (to overexpose).

by adjusting the exposure compensation (by moving the center "dot" in the meter to give it a new place to balance the light), which allows you to trick the meter into over- or underexposing the image. Whichever method you use is up to you and completely depends on the method that best fits your style of photography. My advice? Steer clear of any of the full-Auto modes. Please.

Many of us have our preferences and "looks" we are trying to achieve, and some elements may be more important or more relevant than others. For example, if it's important to you to have a small amount of noise in your images, you might want to set your ISO to 100 or 200. This means that the sensor is less sensitive to light and will probably need a wider aperture and/or a longer shutter speed...or more light.

Mastering the relationship of these elements of exposure in your photographs is the first step to understanding photography. If you can grasp the basics, the rest is easy—it's all just a matter of experimenting, playing around with your camera, and discovering your style and preferences.

CAMERA MODES

All cameras come with at least five basic modes: Program, Manual, Aperture Priority, Shutter Priority, and some form of Auto mode. Along with other possible modes (such as specific scene selections), you may have the Bulb mode on your camera as well. Here's a breakdown of what most of these camera modes do:

- **Program (P)**: When your camera is set to Program mode, the camera determines both aperture and shutter speed, and you select the ISO. You can often override these settings and adjust the camera to a specific aperture while maintaining a reciprocal shutter speed, and vice versa.

- **Manual (M)**: Manual mode offers you complete control over the camera's settings. This is a good choice when you don't want the camera making any decisions for you, and it is used often with studio lights or strobes. I use this mode regularly, especially when photographing food.

- **Aperture Priority (A or Av)**: Aperture Priority lets you set the aperture and ISO, and the camera sets the shutter speed based on the available light. This is another setting I use frequently, since I prefer to have full creative control of depth of field. You can still completely control the exposure by adjusting the exposure compensation, allowing you to trick the camera into over- or underexposing the photograph.

- **Shutter Priority (S or Tv)**: With Shutter Priority, you select the shutter speed and ISO, and the camera determines aperture. This is a good setting if you want to control the amount of movement in your photograph and are not concerned with depth of field.

- **Auto**: Most of the Auto modes will take complete control over the camera and leave you no choice over any of your settings.

- **Bulb (B)**: The Bulb mode controls the shutter speed, and you set the aperture and ISO. With this mode, the camera's shutter stays open as long as your finger stays on the shutter button. It is often used in conjunction with a tripod and cable release, allowing you to eliminate camera shake by remotely pressing the shutter. This is mostly used for extremely long exposures, such as when creating star trails or photographing subjects like lightning or fireworks.

Chapter 1 Challenges

Understanding how to balance each of the basic elements—aperture, shutter speed, ISO, and white balance—to create a beautiful photograph can take a bit of time and patience, but it's an extremely important step in learning photography. In fact, it's probably one of the most important steps.

White Balance

Find something to photograph, and try out each of the white balance settings on your camera. Start with the obvious (for example, if you're photographing in sunlight then pick the Daylight setting), take a photo, and then pick a few random ones, too, like Fluorescent or Tungsten, and take a photo with each setting. Scroll through the preview images on your camera and compare the color differences. Lastly, set it to Auto, take a photo, and see how it compares with the other settings.

Camera Modes

Play around with the different camera modes on your camera. Start with Aperture Priority, set the aperture as wide as it will go (smallest number), find a subject, get as close as possible, and take a photo. Next, decrease the size of the aperture (a larger number), take the same photograph, and compare the two images. Do the same with Shutter Priority—starting with a fast shutter speed, like 1/500 of a second, and moving to a slower shutter speed, like 1/15 of a second, watch how the different settings affect the movement in the images. Finally, set the camera to Manual mode and use the camera's meter to balance the exposure. You'll notice that each time you change one setting, you'll need to balance it with another setting.

ISO

To get a feel for how ISO works, start with your camera mode of choice, set the ISO to 100, and take a photo. Next, increase the ISO to 1600 and watch the settings on the camera and how they changed, or, if in manual mode, how the settings should be changed when looking at the meter. Take another photo. Then zoom in to the preview images on your camera and take a look at the noise level in each image. You'll notice that there is very little noise in the ISO 100 image when compared to the (noisy) ISO 1600 image.

Share your results with the book's Flickr group!

Join the group here: flickr.com/groups/foodphotographyfromsnapshotstogreatshots/

2

Canon 7D
ISO 100
1/125 sec.
f/4
70–200mm lens

Photography Equipment

TOOLS OF THE TRADE

For photographers, gear is important. To create photographs, we will use at the very least a camera, lenses, and light, and we will never get around the fact that we need these essentials to do our work. There are a lot of different tools available for creating food photographs, and in this chapter I will discuss some of the basic types of photography equipment you should know how to use in order to create delicious-looking food photographs.

PORING OVER THE PICTURE

I found this recipe in an old cooking magazine and really wanted to try it out. Scallops are one of those food items that, in my opinion, always photograph beautifully, and this dish was no exception.

The green color in the peas and the red tones in the pancetta contrast nicely with the lighter colors of the scallops.

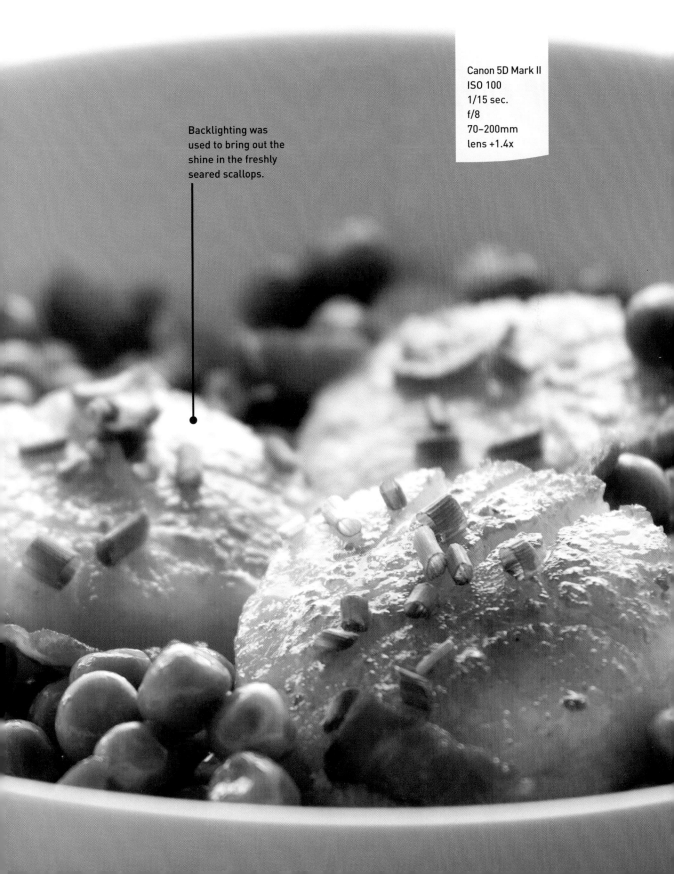

Backlighting was
used to bring out the
shine in the freshly
seared scallops.

Canon 5D Mark II
ISO 100
1/15 sec.
f/8
70–200mm
lens +1.4x

PORING OVER THE PICTURE

I tend to pick my food subjects because of their colors, textures, and overall beauty, and salmon roe is one of those ingredients that looks absolutely gorgeous in a photograph. I topped buckwheat blinis with smoked salmon, crème fraiche, salmon roe, and chives to create a delicious-looking hors d'oeuvre.

Small pieces of chive were added to the plate to add balance and continuity to the photograph.

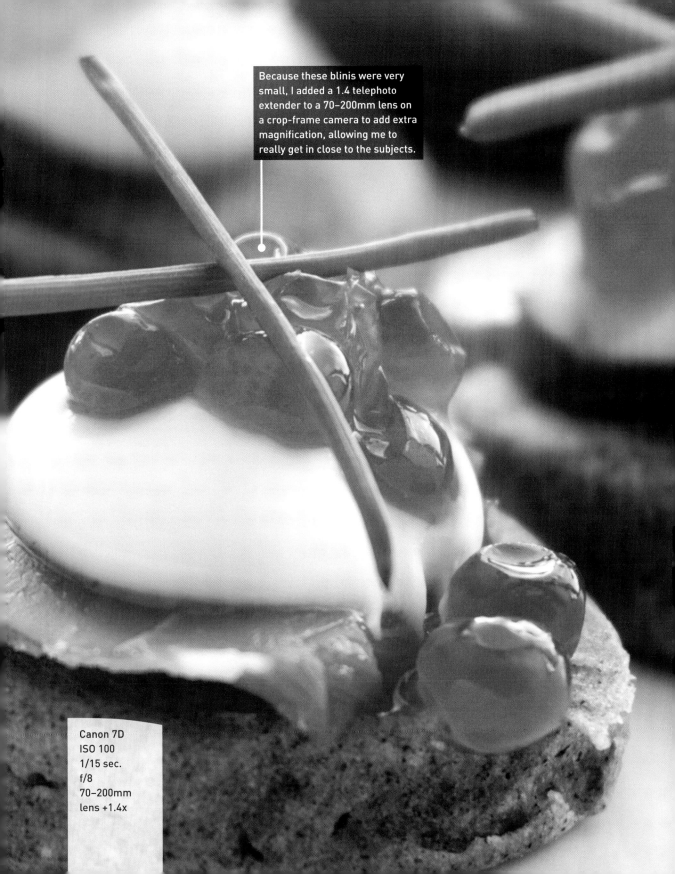

Because these blinis were very small, I added a 1.4 telephoto extender to a 70–200mm lens on a crop-frame camera to add extra magnification, allowing me to really get in close to the subjects.

Canon 7D
ISO 100
1/15 sec.
f/8
70–200mm
lens +1.4x

DIGITAL CAMERAS

There are a lot of cameras out there. A LOT. New ones pop up on the market every year, and the technology keeps improving and changing—sometimes so quickly that it's difficult to keep up with. The two types of cameras that you're likely familiar with (and might already own) are P&S (point-and-shoot) and Digital SLR (single lens reflex).

P&S VS. SLR

The point-and-shoot camera is pretty much summed up by the name—"point-and-shoot." There are honestly too many on the market these days to count, and they're all different in their own unique ways. Some are very simple, with few options or settings to choose from, and others are so complicated and advanced that they are virtually on par with an SLR camera.

You may be wondering whether you can get a good photograph, more specifically, a good *food* photograph, from a point-and-shoot. My answer is…maybe. On occasion you can get a very similar photograph from a point-and-shoot when compared to an SLR (**Figures 2.1** and **2.2**), but because of the nature of a P&S, you will have much less control over the camera (specifically with depth of field) than you would with an SLR.

FIGURE 2.1
This image was photographed with a digital SLR camera.

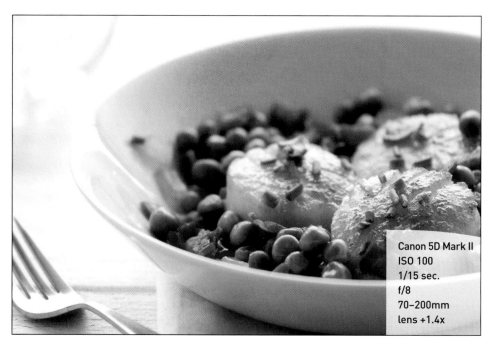

Canon 5D Mark II
ISO 100
1/15 sec.
f/8
70–200mm
lens +1.4x

The main reason that P&S cameras are so limited is that the lens is permanently attached to the camera body. They also have a very small sensor, which can equate to a lower-quality image when compared to an SLR. Another downside to P&S cameras is that they typically give you very little control with your exposure, and possibly even with your focus point. You're usually limited to choosing among several different "auto" modes that select your shutter speed and aperture—some cameras have some of the manual and semi-manual modes, but many don't offer those options.

The SLR camera, on the other hand, is the preferred camera of most serious photographers. SLR cameras offer the photographer an enormous amount of control with exposure, focus point, and lens choice. What's also great about them is that when you look through the viewfinder, you are seeing the exact photograph you will be taking. This may not be a big deal these days, however, since most digital cameras offer live-view options that allow you to see through the lens by looking at an LCD monitor on the back of the camera.

Another advantage to an SLR camera is its larger sensor size. Digital SLR cameras come with either a full-frame sensor or a crop sensor—keep reading to learn the differences between the two different types of sensors available on today's SLR cameras.

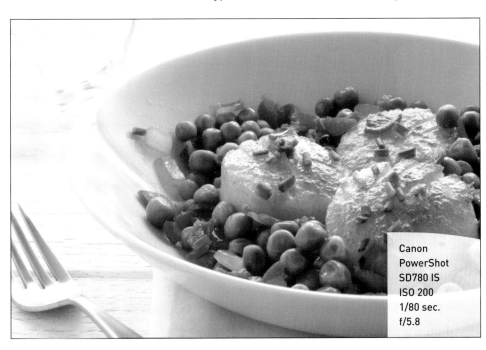

Canon
PowerShot
SD780 IS
ISO 200
1/80 sec.
f/5.8

FIGURE 2.2
This is the same scene as in Figure 2.1 but photographed with a point-and-shoot camera. There are noticeable differences in the depth of field, and if you were to look closely at the image on a computer, you would see a lot more noise and artifacting (which looks like unsightly jaggies and blotchy pixels) than in the photograph taken with an SLR.

FULL-FRAME VS. CROP SENSOR

Digital SLR cameras typically have one of two different types of sensors: full-frame or crop (**Figure 2.3**). All **full-frame** sensors have an area of 36 x 24 mm (the same size as a 35mm negative). A **crop** sensor is approximately 23 x 15 mm (the exact dimensions will differ based on camera brand and model).

FIGURE 2.3
This is a representation of the difference between a full-frame sensor camera (the entire image) and a crop-sensor camera (the red square in the center).

It's important to understand the distinctions between these two types of sensors, because there are significant differences in how each of the sensor sizes affects focal length and even image quality. You see, when you use a 200mm lens on a full-frame sensor, what you are seeing through the viewfinder is actually at 200mm (**Figure 2.4**). When you use the same lens on a crop-sensor camera, you are seeing the equivalent of a 320mm lens (**Figure 2.5**). So with a crop-sensor camera, you're basically seeing a "cropped-in" or "magnified" version of what you would see with a full-frame camera.

Canon 5D Mark II
ISO 100
1/80 sec.
f/5.6
70–200mm lens

FIGURE 2.4
This image was
photographed on
a tripod with a
full-frame sensor
camera at a focal
length of 200mm.

Canon 7D
ISO 100
1/80 sec.
f/5.6
70–200mm lens

FIGURE 2.5
This is the exact
same setup as Fig-
ure 2.4 (on a tripod,
same position,
and at 200mm),
except this image
was photographed
with a crop-
sensor camera.

As always, both cameras offer advantages and disadvantages. First of all, with a full-frame camera you have a much larger angle of view, so you can capture more information in your photograph—this is particularly useful with wide-angle lenses, since you can get *really* wide when using these lenses. You're also likely to have more megapixels with full-frame cameras, and those megapixels are spread out over a larger area, which can result in lower noise and higher image quality when you look closely at the pixels.

With crop-sensor cameras, as I mentioned above, your area of view is "cropped in," so each lens you use has a higher *effective focal length*, or the focal length you're actually seeing through the lens. For example, if you were using a 100mm lens on a crop-sensor camera with a crop factor of 1.6, its effective focal length would be 160mm.

I find them both useful, and different. For some photographers, the "advantages" of the full-frame may seem like a disadvantage if they prefer tighter, more zoomed-in crops of their images. Most of the "pro" camera bodies are full-frame, while the entry-level and "semi-pro" bodies tend to be crop-sensor, but don't let those labels sway you when deciding what to use for your food photography.

WHAT CAMERA SHOULD I BUY?

This is one of the questions most asked by new photographers. If you're brand new to this industry, you're probably scratching your head with confusion— there are just so many cameras to choose from! My advice would be to start small. If you have a few requirements for a camera, then stick with those, but don't spend money on the most expensive camera on the market. Often those models are expensive for a few specific features—such as high speed (the number of frames it can photograph in one second) or the number of megapixels—features you may not even need.

On the other hand, if you definitely want an SLR, don't buy a point-and-shoot camera just because it's less expensive. Once you start really getting into photography, you'll slowly understand your photographic style and be able to tailor-fit a camera that suits your specific needs.

It's also important to understand that while you'll probably go through several camera bodies in your lifetime as a photographer, you're likely to keep the same lenses. Good, quality lenses (also referred to as "glass") are usually considered more important to photographers than the camera body they're using. So read on for more information on the different types of lenses and focal lengths you can use.

LENSES AND FOCAL LENGTHS

The lens is the "eye" of the camera—it determines the widest aperture you can use, and the quality of the glass in the lens determines the sharpness and overall clarity of your final image.

Lens choice is a personal decision, and lenses can often help photographers develop their own unique style. I know that I have my favorites when it comes to food photography, but I also carry other lenses in my camera bag "just in case."

WIDE-ANGLE

Wide-angle lenses have an extremely wide angle of view. They're very popular in landscape photography and on those occasions when you need to show a lot of information in a scene. They cover a field of view from about 110 degrees to about 60 degrees; focal lengths of 35mm and smaller are considered to be "wide" lenses.

When it comes to food photography, I honestly don't use wide-angle lenses very often. You have to be extremely careful if you do, since wide-angle lenses can add distortion to an image, an effect that is usually not pleasing with food (**Figure 2.6**). Another consideration is that wide-angle lenses are going to have a greater depth of field when compared to longer focal lengths. So if you're going for a soft, background-out-of-focus look, then using these lenses is probably not your best choice.

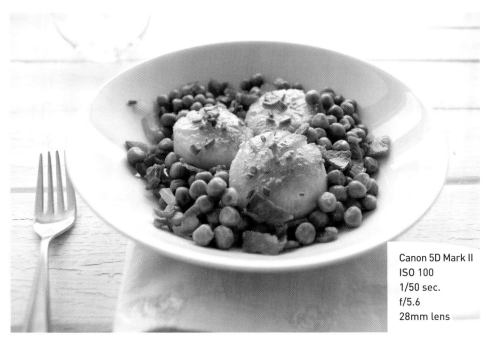

FIGURE 2.6
This is the same food setup as in Figure 2.1, but this image was photographed with a much wider lens, adding distortion to the bowl of food.

Canon 5D Mark II
ISO 100
1/50 sec.
f/5.6
28mm lens

FIGURE 2.7
This image was
photographed with
a 50mm lens on a
full-frame camera.

Canon 5D Mark II
ISO 100
1/125 sec.
f/4
50mm lens

NORMAL

The focal length of a normal lens can be anywhere between 35mm and 80mm, with 50mm being the most common (**Figure 2.7**). The perspective you see with these lenses is very natural and will introduce very little (if any) distortion to your photographs.

With normal focal lengths, you can usually create shallow depth of field to blur the background, depending on the aperture setting and the distance between the subject and its background. I think that everyone should have at least one 50mm prime lens in their camera bag—you can usually find a relatively inexpensive, wide-aperture version that some people like to call the "nifty fifty" because of its cost and the flexibility it offers in low light. It might not be the best-quality glass out there, but I guarantee that it will be a useful lens.

PRIME AND ZOOM LENSES

A **prime** lens is a lens at a fixed focal length, like 50mm or 85mm. Some photographers prefer to use only prime lenses, because they can create sharper focus points and are much faster to focus. A **zoom** lens, on the other hand, is a lens that has a range of focal lengths, like 18–55mm or 70–200mm. Because zoom lenses have more moving parts than prime lenses, they can create a softer focus and may be slower. But on the flip side, their different focal lengths offer a lot of flexibility.

MACRO LENSES

Macro lenses are lenses that allow you to get very close to your subject, and they are available at many different focal lengths. These are useful in food photography when you are photographing small items and want them to "fill the frame," or if you're using a full-frame sensor camera and you need to get in a little bit closer.

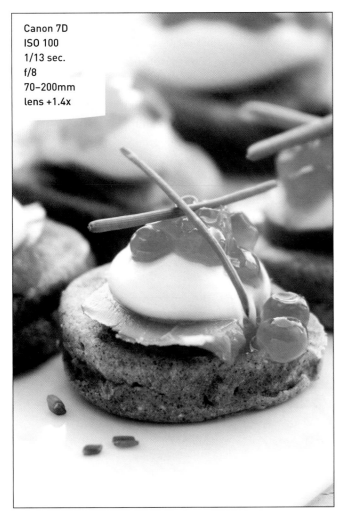

FIGURE 2.8
I used a telephoto zoom lens at 200mm on a crop-sensor camera to photograph this appetizer, and I added a telephoto extender (1.4x) to add more magnification to the image and get in very close to the subject.

TELEPHOTO

Telephoto lenses are great when you want to photograph something that is far away but make it appear very close. The focal lengths of these lenses usually start at 100mm and go all the way up to what is considered "super telephoto"—300mm and beyond. Telephoto lenses are popular in portrait, wedding, and nature photography.

It's very likely that you won't have much of a need for a *super* telephoto lens with food photography, but you might find that a lens at the lower telephoto range can add a nice amount of blur to your photographs because of the shallow depth of field they can create (**Figure 2.8**). I photograph a lot of my food at the 200mm range because I love the compression—the ability to alter the perspective of a photo and make the background appear closer to the subject—and blur that it adds to the backgrounds. (See Chapter 5 for more information on how to compress an image using a longer focal length.)

To further increase the focal length of a lens, you can also use a telephoto extender. This adds extra magnification to your lens so that it will "reach" a little bit further. Be aware that you might lose a little bit of sharpness in your photograph, and it also will change the maximum aperture setting on your lens. For example, if you have a lens that opens up all the way to ƒ/4 at the largest setting, adding a 1.4x converter to the lens will change it so the widest aperture will be ƒ/5.6.

SPECIALTY LENSES

Along with standard lenses, you can choose among a variety of "specialty" lenses to add a unique twist to your images, especially when it comes to depth of field. The following two lenses are both fun and can add some creative blur to your food photography.

The first is a tilt-shift lens. This lens was created to correct distortion in images and is widely used in architectural photography to keep the lines of buildings straight. Another fun side effect of this lens is the unique blur it can add to photographs when used at wide apertures. This lens is commonly used to create diorama (miniaturized) effects in photographs. When it comes to photographing food, I've definitely enjoyed using this type of lens because of the different kinds of bokeh—the out-of-focus areas and "fuzzy dots" in the background—that it can create (**Figure 2.9**). One downside to this lens is its cost—they are pretty expensive, and because they're very specialized, you might not have as many uses for them as you would standard lenses.

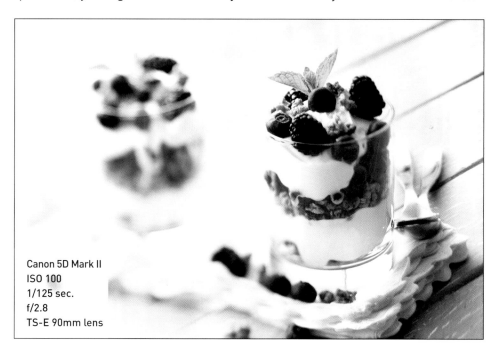

Canon 5D Mark II
ISO 100
1/125 sec.
f/2.8
TS-E 90mm lens

FIGURE 2.9
A tilt-shift lens can add a unique blur to a food photograph.

Another fun lens that I like to use is the Lensbaby. This lens can mimic the effects of a tilt-shift lens, but it also introduces a very unique blur to images. The Lensbaby creates a "sweet spot" within the frame where the focus lies, and it then stretches the blur across the rest of the image. The blur effect is more exaggerated the wider the aperture gets. This can be a fun lens to experiment with in food photography (**Figure 2.10**), and what's great about it is that it's very inexpensive when compared to most specialty lenses.

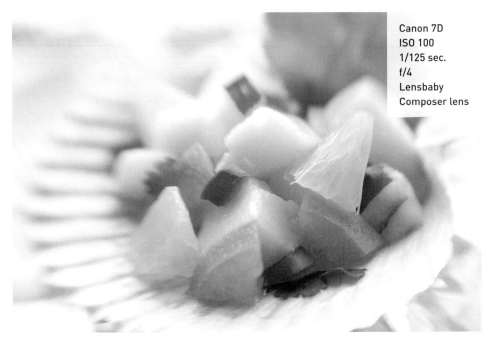

FIGURE 2.10
This image was photographed with a Lensbaby lens. The focus is on the small piece of lime on the right side of the photograph, and the blur "stretches" out from that point.

Canon 7D
ISO 100
1/125 sec.
f/4
Lensbaby
Composer lens

TRIPODS AND ACCESSORIES

With photography and camera gear, there will always be those "extra things" that you'll find useful when creating your photographs. Some of them are essential, and others are just for fun. Here are a few that I use regularly when photographing food.

TRIPODS

The tripod is an invaluable piece of equipment with almost any type of photography. Some photographers use them more frequently than others, and you'll probably hear other food photographers say that they use a tripod for most of their work. While

I have been known to hand-hold my camera for some of my food photographs, I almost *always* use my tripod when I'm working with diffused window light, since the shutter speed will usually be too slow for handheld photography. A tripod is also useful when you have a specific composition in mind and need to stage your scene carefully.

There are many, many different types of tripods, all with different purposes. Some tripods are very heavy, some very light, and some of them fall in the middle. Just as you would with a camera, you'll want to determine what your specific needs are before deciding what to get. The heavier the tripod, the more difficult it is to transport, but it will also be a lot sturdier and will keep your photographs camera-shake free. Lighter tripods, such as a very well-built carbon fiber tripod, can be handy when you want to carry them around, but they will also be more expensive. However, tripods that are very light (think "made of plastic") are more likely to introduce camera shake into images, and some are even too light to hold many of the large DSLR cameras and lenses that many photographers use.

My inventory of tripods consists of an extremely heavy tripod that pretty much stays put and doesn't get lugged around too often, unless it's from point A to point B with very little carry-time in between (in other words, I wouldn't take it on a hike). I also have a much lighter carbon-fiber tripod that I travel with a lot. I use both of them, and I actually prefer the larger, heavier one for my food photography because of its sturdiness.

TRIPOD HEADS

If you're using a tripod, then you're also going to need a tripod head. The tripod head is an accessory that mounts to the top of the tripod and is the place where you will actually attach your camera. As with everything else, a lot of options are available, and you usually get what you pay for. You can find them in many varieties—ballheads, video heads, pan heads, and so on. I recommend stopping by your local camera store to check them out and see how they all work.

I've found that although quality is an important consideration (you don't want your camera sliding around on its own!), ergonomics is almost equally important. You want to find a tripod head that is easy for you to maneuver and position. My current favorite is a three-way pan/tilt head that allows me to adjust each axis separately. This gives me the exact control I need, especially when creating an intricate food setup.

CABLE RELEASES

A cable release is a cord that attaches to your camera and allows you to trip the shutter without actually touching the camera, a very useful tool when your camera is attached to a tripod (**Figure 2.11**). When you're using a slow shutter speed, just pressing the shutter button can shake the camera enough to blur your photograph; a cable release pretty much guarantees that this won't happen. If you don't have one, you can always use your camera's self-timer mode, but even though you have to wait just a few seconds for each photograph, you'll probably become impatient and want to get a cable release. Plus that gorgeous food won't look beautiful forever— every second counts!

FIGURE 2.11
A cable release is a useful accessory when photograph- ing food from a tripod. (Photo by Rich Legg)

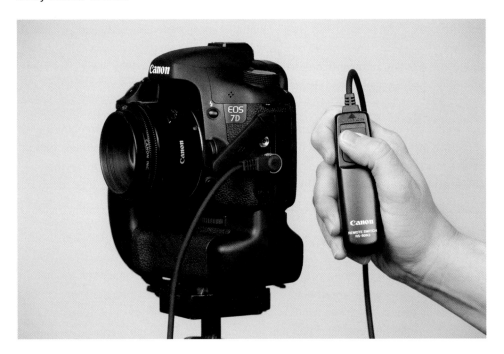

LIGHTING EQUIPMENT

Before we jump into *how* to light food, let's go over a few of the basic pieces of lighting equipment that can be used in food photography. Lighting food doesn't usually require a lot of equipment, but there are still some items that you're going to want to have (or at least know about) before you get started.

REFLECTORS

A reflector is a very simple and basic, yet essential, piece of equipment that you need to create your food photographs. The way it works is that a reflector bounces light back onto your subject to add light into an area that is too dark or shadowed (**Figure 2.12**).

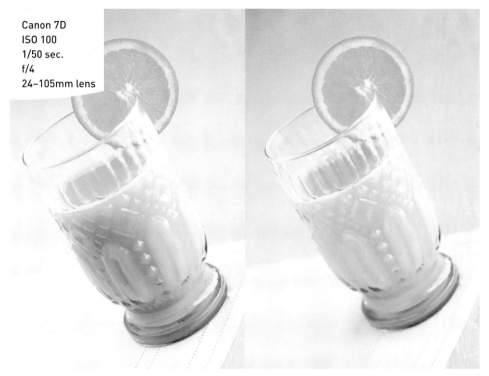

Canon 7D
ISO 100
1/50 sec.
f/4
24–105mm lens

FIGURE 2.12
The image on the left was photographed without the use of a reflector or any fill light. For the image on the right I added a reflector, which eliminated the shadow from the left side of the glass.

The great thing about reflectors is that you don't have to break the bank to get one that does the job well. A "proper" reflector is not too expensive, but if all you need is a shiny, bright reflective surface, why not make your own? Take a large piece of cardboard and tape tinfoil around one side, and you end up with a bright, reflective surface that will bounce a lot of light from it. You could also go to the craft store and pick up some large pieces of white foam board, which will reflect a nice soft light in your image.

LIGHTS

There are two basic types of photographic lights: continuous and strobe. And lights, like cameras, come in all shapes, sizes…and prices. If you're considering using off-camera artificial light for your food photography, it's a good idea to understand each type of light and how it works. (More details on lighting food for photography are in the next chapter.)

Let's start with continuous lights. These are lights that are on all the time—pretty simple, really. The upside to using these is that they are usually inexpensive, and you can easily see how the light is affecting the subject ("what you see is what you get"). The biggest downside is that some types of continuous lights can get *really* hot, which isn't ideal when photographing food. A hot light will make the food you're working with expire much more quickly, so you would have to photograph your setup quickly. There are exceptions to this, such as LEDs and kits that use cool fluorescent bulbs (see Chapter 3 for more information). Another important issue is that their color temperatures will vary, depending on the type you get. This means that you would need to adjust your white balance to whatever the appropriate color temperature is for the bulb you're using, and you will need to be wary of mixing different types of lights in the same room when photographing food (for example, using a tungsten continuous light setup in a room with overhead fluorescent lights). Doing so might introduce strange colorcasts to your photograph, since you only have the ability to adjust your camera's white balance to one type of light source.

Strobes, by contrast, are reliable and easy to control. When connected to your camera with a cable or radio, these lights will fire a flash each time the shutter button is pressed. In fact, a pop-up or embedded flash on a camera is one type of strobe light (although on-camera flash is generally not recommended for food photography). Strobes stay cool, are color balanced to daylight, and allow you a lot of control over your exposure and environment. However, strobe lights are generally more expensive than continuous lights, and there is a bit of a learning curve with them, especially if you're new to photography. But if you ask me, it's worth the time and effort if you want to photograph your food with good-quality off-camera strobe lights. (For more information on how to light a food photograph, please turn to Chapter 3.)

Chapter 2 Challenges

As you may already know (or have recently discovered), there's a *lot* of photography gear you can use with food photography. The items listed in this chapter are just the tip of the iceberg—you'll find out about even more tools and pieces of equipment on your own, and some additional items are mentioned throughout the remainder of this book. You may be tempted to get it all, but it's always best to start small and build your inventory as you discover your style and what tools you require to complete your vision.

P&S vs. SLR

If you happen to have both a point-and-shoot and an SLR, set up your own experiment to compare their differences. Create a scene that you can easily photograph with your SLR camera, and then try to create the same image with your P&S. Compare the images and note the differences in depth of field, focal length, and image quality when examined closely on a computer.

Using Different Lenses

If you have an SLR with more than one type of lens, pick a subject, get really close, and photograph it with each lens (at the same aperture and shutter speed, if possible). Note the differences in the depth of field (how much of the image is in focus), the distortion in the subject, and how much the background changes with each lens.

Share your results with the book's Flickr group!

Join the group here: flickr.com/groups/foodphotographyfromsnapshotstogreatshots/

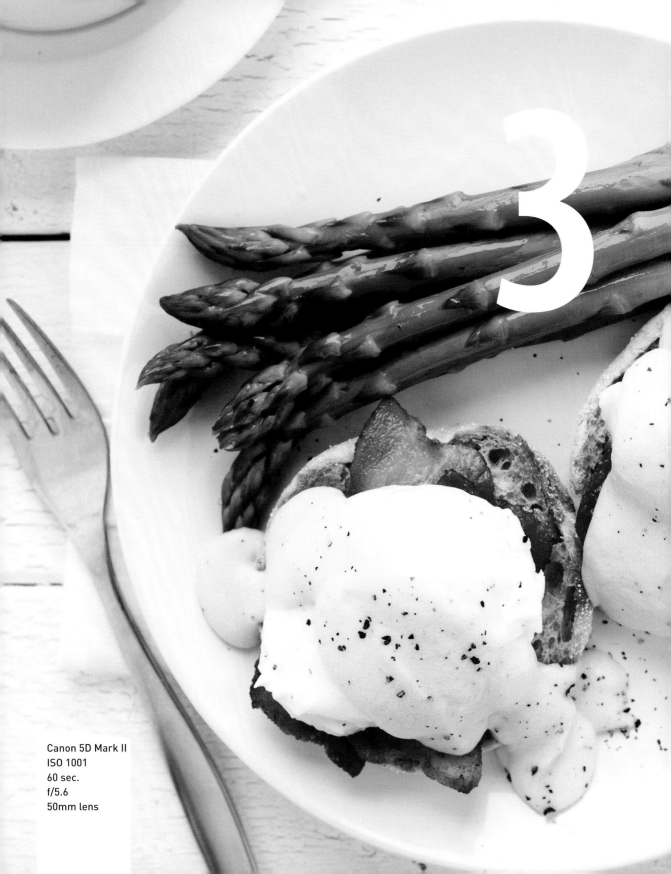

3

Canon 5D Mark II
ISO 1001
60 sec.
f/5.6
50mm lens

Lighting

TECHNIQUES FOR LIGHTING FOOD

Light is, hands down, the most important aspect of a photograph. The word photography literally means "to draw with light," so it won't come as much of a surprise when I tell you that this is probably the most important chapter in this book. But just because it's important doesn't mean it has to be overly complicated. I will often use a very basic, simple lighting setup for my food photographs and make slight changes depending on the texture, height, and angles of the food. Your goal is to make the food stand out and look its best, so turn the page and keep reading to find out more about lighting food for photography.

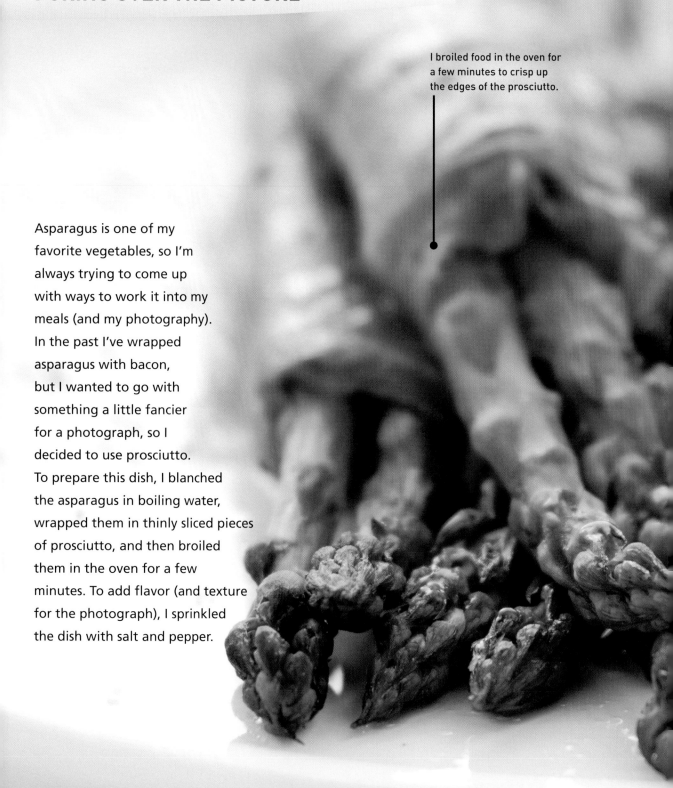

PORING OVER THE PICTURE

I broiled food in the oven for a few minutes to crisp up the edges of the prosciutto.

Asparagus is one of my favorite vegetables, so I'm always trying to come up with ways to work it into my meals (and my photography). In the past I've wrapped asparagus with bacon, but I wanted to go with something a little fancier for a photograph, so I decided to use prosciutto. To prepare this dish, I blanched the asparagus in boiling water, wrapped them in thinly sliced pieces of prosciutto, and then broiled them in the oven for a few minutes. To add flavor (and texture for the photograph), I sprinkled the dish with salt and pepper.

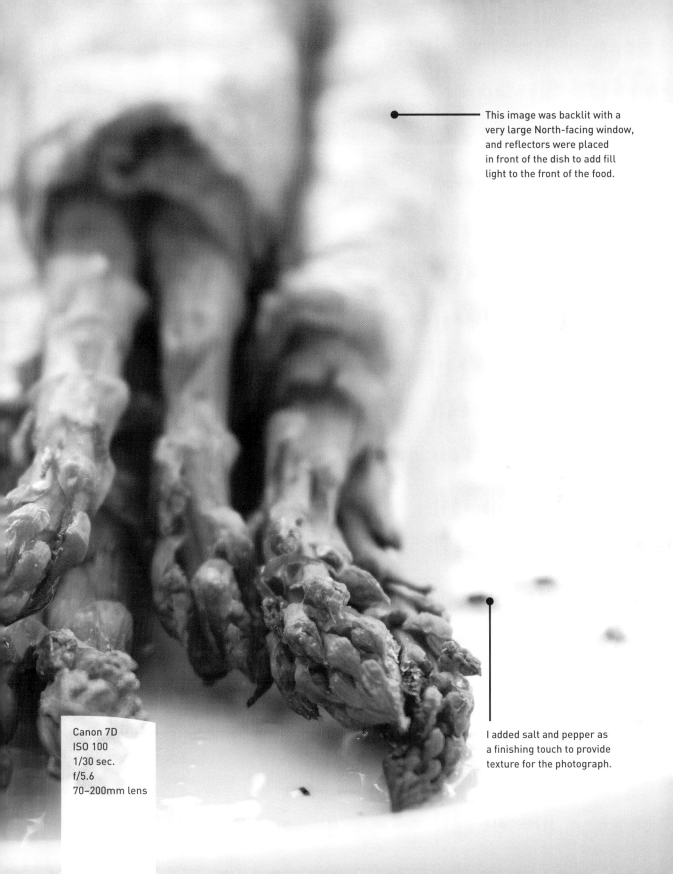

This image was backlit with a very large North-facing window, and reflectors were placed in front of the dish to add fill light to the front of the food.

I added salt and pepper as a finishing touch to provide texture for the photograph.

Canon 7D
ISO 100
1/30 sec.
f/5.6
70–200mm lens

PORING OVER THE PICTURE

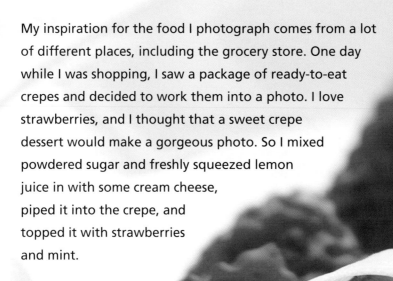

My inspiration for the food I photograph comes from a lot of different places, including the grocery store. One day while I was shopping, I saw a package of ready-to-eat crepes and decided to work them into a photo. I love strawberries, and I thought that a sweet crepe dessert would make a gorgeous photo. So I mixed powdered sugar and freshly squeezed lemon juice in with some cream cheese, piped it into the crepe, and topped it with strawberries and mint.

A piping bag was used to place the cream cheese inside the crepe to make it look smooth and creamy.

I used a blue tabletop to add a contrasting color to the scene.

Canon 7D
ISO 100
1/15 sec.
f/5.6
70–200mm lens

I added mint and lemon as garnish for a splash of color on the plate.

SEE THE LIGHT

When you create a photograph, just as when you cook a meal, the better your ingredients are, the better your results will be. One of these ingredients is light, and if you use high-quality light, you're much more likely to get a beautiful photograph.

Lighting food for photography is not rocket science. If you're new to photography, this topic may seem daunting and confusing, but trust me … it's not. At first the light used in a photograph might be overlooked. Our eyes see light every day; we take it for granted and don't always pay attention to the shadows, direction, intensity, color, and so on. Our brain fills in the details and makes everything look great, so we are likely to miss things, like unwanted shadows and bright spots, when using our cameras.

The biggest step that I can remember taking as a photographer is when I actually started to *see* light. I didn't just notice the things it was lighting or how bright it was—I could actually see where the light fell on people's faces, which direction it was coming from, how it faded and feathered the edges of shadows and reflected off buildings. It felt like I was using my eyes for the very first time.

Once your eyes are trained to see light everywhere, lighting a photograph becomes much less complicated and mysterious. You start seeing the golden glow that the "20 minutes before sunset" light can add to a person's face, or the amazing amount of light that exists in the shaded parts of a building. When you see light, "complicated" techniques, such as coupling strobes with light ratios, seem less intimidating. When light becomes a physical component in your image that you treat like a separate entity, you will be able to take more control over the look of your photographs.

With food photography, just like with other types of photography, there are different styles and ways of lighting an image. In this chapter, I'm going to give you as many tools as possible to take and use as you would like. My style for lighting food is a very bright, clean look, but that doesn't mean that you should light all of your food exactly like I do. I've done a lot of experimenting to get to where I am right now, and my style and lighting techniques are constantly changing and evolving. I highly encourage you to do the same to create your own unique photographs.

QUALITY OF LIGHT

All light is not the same. The light you see in the middle of the day looks very different when compared to the warm sunlight that shines an hour before sunset. The light coming from the fluorescent light bulb in your kitchen is not the same as the light coming from the tungsten light bulb on your nightstand. Different light sources create different colors, intensities, and moods.

Now, that doesn't mean that one type of light is better than another, but it may be true that certain light sources are better for certain types of photography. For portrait and landscape photography, the first hour and last hour of sunset are ideal times to create images outdoors, and studio photographers have ways of manipulating light with strobes to add drama or softness to their images. Each of these types of light creates a different mood, which is often referred to as the "quality" of the light.

COLOR

The color of light you use with food photography is extremely important. My advice is to stick to anything that is daylight balanced, like sunlight or strobes. In Chapter 1, I discussed how the "temperature" of light can affect the color and look of your photograph and how you need to compensate by adjusting your white balance, or by photographing in the RAW format and adjusting the white balance during editing (**Figure 3.1**). If you're using the JPEG file format, you need to be very careful of your white balance setting. If the color is off, it's likely that the orange-reddish cast from, let's say, a tungsten light source will remain, and a strange or unusual colorcast on a food photograph is just not very appetizing. Using the most beautiful (and appropriate) quality of light coupled with a proper white balance will ensure that the color of your photographs looks its best.

FIGURE 3.1
This photo was
taken in overhead
room light (tung-
sten) using the RAW
file format. The
image on the left
is what the photo
looks like when
set to the Tungsten
white balance set-
ting, and the image
on the right is the
color-corrected
version using RAW
editing software.

Canon 5D
Mark II
ISO 100
0.3 sec.
f/5.6
70–200mm lens

When it comes to the color of light, keep in mind that you want only one type of light in your photo. For example, if you're using a window to light your food, but you have another light nearby that's bright—enough to "contaminate" the light in the photograph—then you might get some funky colors going on that will be very difficult to correct. Since you can set only one white balance in your camera, it's best to make sure only one color of light is shining on your food.

INTENSITY

When selecting a light source for your food images, be sure to consider the intensity of the light you're using. Some light sources are stronger than others, and it's impor-tant to know how to work with the light you're using.

If you're photographing with diffused sunlight, you won't really need to worry about the intensity of the light, since the light is likely pretty soft. You will need to be aware of this, however, when using studio (strobe) lights. If you go for the "biggest, baddest, and most powerful" light you can find, you might realize that it's *too* pow-erful if you are planning to use a wide aperture to blur your background. As you'll find out later in this chapter, strobe lights have a maximum shutter speed they can be

set to (maxing out at around 1/250 of a second). If the light is too strong at its lowest setting (and you're already set to ISO 100), then the only other setting you can change is your aperture, and if your goal is to blur your background, you won't want to use an f-stop that is too small.

If you do happen to have a light that is too powerful, you can soften it so that it works better for your food photographs. One way is to diffuse the light. You can do this by using a modifier, like a softbox or shoot-through umbrella, or by placing any type of white translucent substance in front of the light source. If you happen to have a window that has only harsh sunlight coming through, you could try covering the window with something like white translucent vellum paper, or you could use a scrim, which is basically just a piece of translucent fabric, to soften and block the harsh rays of the sun (**Figure 3.2**).

FIGURE 3.2
When the outer fabric of this reflector (called a "five-in-one" reflector) is removed, it has a transparent white mesh inside that can be used to diffuse harsh sunlight.

DISTANCE

The location and distance of the light in relation to your subject will play a huge part in determining the softness or harshness of the light. One basic principle is that the bigger and closer the light is to your subject, the softer the light will be. If you want soft shadows, you can make your light bigger by attaching modifiers, such as light-boxes and shoot-through umbrellas, to diffuse the light source. Then, when you bring the nice big light close to your subject, you get a soft light with very few shadows.

The best way to understand this is to think of the sun. Now, the sun is a really, really big light source, but it's also *very* far away. Imagine it's a sunny day at 1:00 and you're standing outside on the sidewalk. You look down at your shadow and what do you see? A nice, crisp, dark shadow, right? Now picture that exact same scene but with an overcast sky. What does your shadow look like now? If there is one at all, it's probably faded and soft, but it's also possible that your shadow is gone. Those clouds basically made the sky into a giant softbox and diffused the light.

This is an extremely important concept to understand. If you want soft light with minimal shadows, you'll want to diffuse the light and get it as close to your subject as possible, and you can still turn down the intensity of the light to balance the exposure. If you're going for harsh shadows and intense, moody light, then all you have to do is move the light farther away from your subject.

WATCHING THE HIGHLIGHTS

When photographing food, you want to be extremely careful not to clip or "blow out" any of the areas of your image, especially on the food itself. If you're trying to create a very "bright" image with a lot of whites, it can be easy to overexpose the photograph and lose precious detail. Make sure that your white areas are actually white, but don't push the intensity of the light so much that you also lose the shadow detail and depth in these bright areas of the image.

There are a few things you can do to avoid overexposure in your photographs. The first is to set up your camera to enable a highlight alert (also known as "blinkies") when you play back your images on the LCD monitor. All cameras are different, but they pretty much all have this feature. What this will do is blink in the pure white areas (255, 255, 255 on the RGB color model) when you review or play back your images. Consult your camera manual (or a helpful friend) to enable this feature.

Another option is to take a look at the histogram on the info screen of your LCD monitor. If you have any clipped whites in the image, the histogram will be pushed all the way to the right and will look like it's going off the screen. **Figure 3.3** shows the differences between the histograms in an overexposed image with blown-out highlights and a properly exposed photograph.

If you see that you have blown-out highlights in your scene, there are many things you can do to bring back that detail: you can reduce the amount of light in the scene, make the aperture smaller, increase the shutter speed, or reduce your ISO. Choosing among these options really depends on the type of light you're using and, of course, your own creative vision of what you want the photograph to look like.

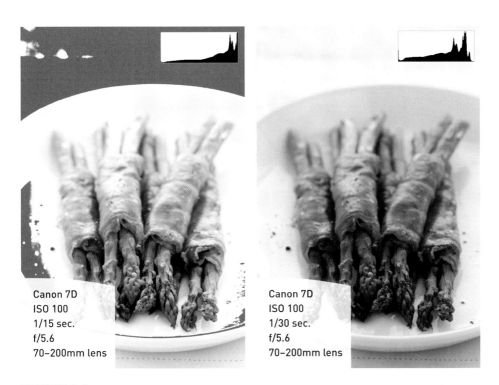

Canon 7D
ISO 100
1/15 sec.
f/5.6
70–200mm lens

Canon 7D
ISO 100
1/30 sec.
f/5.6
70–200mm lens

FIGURE 3.3

Both of these photos were taken straight out of the camera, as is, with no postprocessing
done on the computer. The image on the left has blown-out highlights, indicated by the red
areas in the photo. By looking at the histogram in the upper right of this image, you can see
that the values are pushed all the way to the right and off the screen, indicating areas of com-
plete white (255, 255, 255). These overexposed areas have lost all of their detail and likely
cannot be recovered. The photo on the right, however, has a balanced exposure with no loss
of detail. It is slightly dark but can be brightened easily by using photo-editing software.

BACKLIGHT IS BEST

Most food photographers agree that the best light for food photography is back-light. To get a pleasing backlit look, place the light either directly behind your subject (**Figure 3.4**) or in the back and off to the side (**Figure 3.5**).

Backlight adds texture and depth to an image, and (my favorite) it rim-lights your subject and brightens up certain food items like mint leaves or slices of citrus (**Figure 3.6**). Keep in mind that while it's sometimes nice to keep your light soft, having some shadows in your photo isn't necessarily a bad thing. Don't be afraid of a little bit of contrast; just make sure you are constantly aware of how the light is affecting your subject.

One important thing to keep in mind is that if you want your food photographs to have substance and definition, *please* stay away from using any type of harsh front-lighting such as on-camera flash, which creates an extremely flat light (**Figures 3.7** and **3.8**).

Regardless of what direction the light is coming from, it's important to watch how it's affecting *everything* in your photograph. In **Figure 3.9** I used a bamboo placemat to add some texture, lines, and color to the background of the photograph. The main light was placed behind and to the left of the food, and I noticed that it was adding a lot of reflection in the bamboo. I played around with different angles and found that just slightly rotating the placemat removed the unsightly reflection (**Figure 3.10**). The same principle goes for dishes, silverware, and so on.

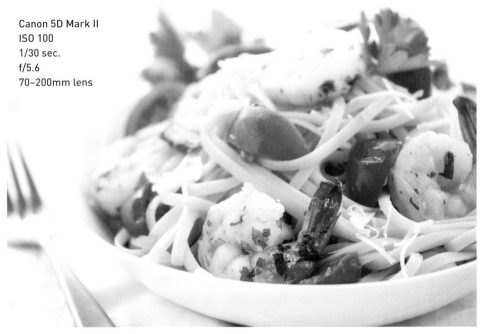

Canon 5D Mark II
ISO 100
1/30 sec.
f/5.6
70–200mm lens

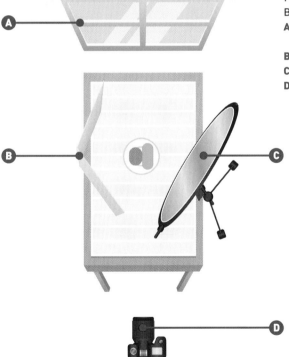

FIGURE 3.4

Behind the scenes: Backlighting

A North-facing window,
diffused sunlight

B White foam board

C 42-inch silver reflector

D Canon 5D Mark II

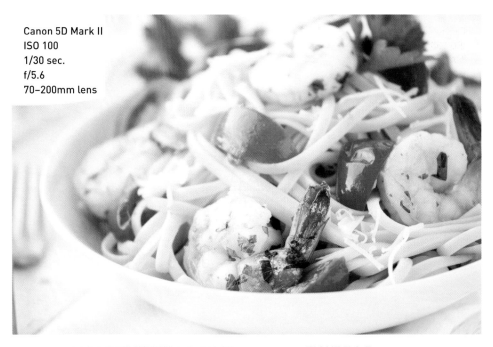

Canon 5D Mark II
ISO 100
1/30 sec.
f/5.6
70–200mm lens

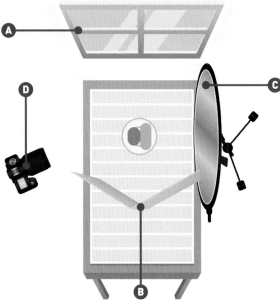

FIGURE 3.5
Behind the scenes:
Back- and sidelighting
A North-facing window, diffused sunlight
B 42-inch silver reflector
C White foam board
D Canon 5D Mark II

Canon 7D
ISO 100
1/40 sec.
f/5.6
70–200mm lens

FIGURE 3.6
Using backlight-
ing in this image
helped make the
limes glow and
really stand out.

FIGURE 3.7
For this photograph
I used the Canon
7D's pop-up flash,
which added a
lot of flat, harsh
light to the front
of the dish.

Canon 7D
ISO 100
1/10 sec.
f/5.6
50mm lens

FIGURE 3.8
This photograph
was lit with dif-
fused window
light (similar to
the behind-the-
scenes setup
in Figure 3.4).

Canon 7D
ISO 100
1/6 sec.
f/5.6
50mm lens

Canon 7D
ISO 100
1/125 sec.
f/5.6
70–200mm lens

FIGURE 3.9
A large studio
light to the left of
the dish lights up
the ridges in the
bamboo placemat.

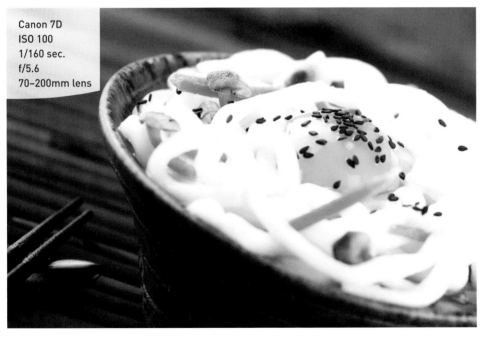

Canon 7D
ISO 100
1/160 sec.
f/5.6
70–200mm lens

FIGURE 3.10
By changing the
angle of the bam-
boo placemat and
my position while
photographing the
dish, I was able to
remove the bright
light falling across
the bamboo.

BLOCKING LIGHT FOR PROPER EXPOSURE

There may be times when the backlight you're using is properly exposing the subject but is too intense for the background. In these cases, you'll want to find a way to partially block the light to avoid overexposing the background.

In this example, I was using window light and two reflectors to fill the front of the food. In the first photo (**Figure 3.11**), a lot of the image's background was overexposed, so to balance out the exposure and block some of the light, I used a piece of black foam board behind the subject at the bottom part of the window. The final photograph (**Figure 3.12**) lost a little bit of light on the subject, but by blocking out the light I was able to retain the detail in the background.

FIGURE 3.11
The red areas in the photo indicate the areas of overexposure.

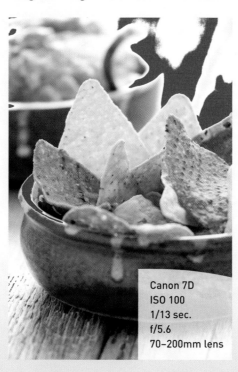

Canon 7D
ISO 100
1/13 sec.
f/5.6
70–200mm lens

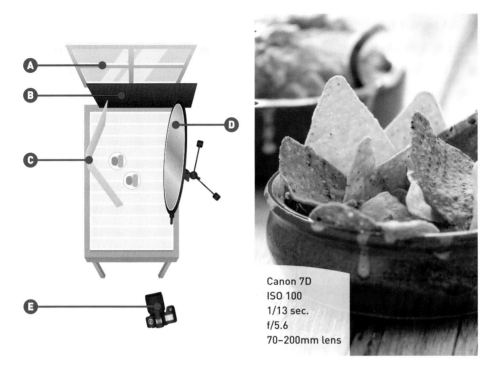

Canon 7D
ISO 100
1/13 sec.
f/5.6
70–200mm lens

FIGURE 3.12

By placing a piece of black foam board at the base of the window, I was able to block a lot of the intense light falling on the background of the photo.

Behind the scenes: Blocking light with black foam board

A North-facing window, diffused sunlight
B Black foam board
C White foam board
D 42-inch silver reflector
E Canon 7D

Canon 7D
ISO 100
1/40 sec.
f/5.6
70–200mm lens

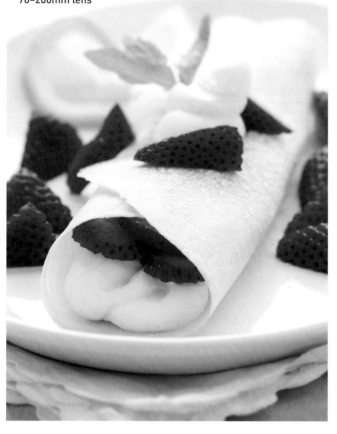

FIGURE 3.13
This image was photographed with diffused sunlight coming from a large North-facing window in my living room.

TYPES OF LIGHT

The great thing about lighting food for still photography is that a basic, simple lighting setup will create amazing results. You don't need a bunch of fancy or expensive equipment or an elaborate lighting setup to create your photographs. Often, just one light is all you need to beautifully light a mouthwatering plate of food.

NATURAL LIGHT

Sunlight is, hands down, my favorite light source when photographing food. It's soft, natural, clean, bright, free, and easy to use. I use natural light as much as I can—it really fits my style of food photography well, and I love its simplicity (**Figure 3.13**).

If you want to try using this type of light, the first thing to do is find a window with indirect, diffused light coming in. By diffused, I mean light that is not brightly shining in through the window. A North-facing window is great (if you're in the Northern hemisphere), or even an East-facing window (as long as you don't photograph when the sun is still shining through). You'll just want to stay away from harsh sunbeams shining in on your food.

As with everything, there are limitations to using natural sunlight. First of all, you have only certain hours of the day that you can utilize it, which can be inconvenient if you work a day job and come home just before the sun goes down. Another "inconvenience" is that even though there might be a lot of light coming in to light your food, there may not be enough for you to handhold your camera, depending on your settings. I find that with a typical camera setup (my lens set to *f*/5.6 at ISO 100), when photographing with window light my shutter speed is slow enough that I always have to use a tripod.

USING WINDOW LIGHT IN A RESTAURANT

There may be times when you're in a restaurant and want to photograph the food you ordered (**Figures 3.14** and **3.15**). If you're lucky enough to be in a restaurant with window light, here are a few tips to get some great photographs:

- Ask to sit by the window where there's diffused light. It might not hurt to visit the restaurant when they're not as busy, so you don't have to wait too long for a table.

- Tell the server that you want to photograph your food—there's a good chance that they'll pass the information on to the chef and make the food look extra pretty.

- Be aware of any other light sources lighting up the table. Another light source could skew the white balance and make the colors look off.

- Instead of using a standard reflector, you can fill in the shadows with a napkin or even a menu (like I did in these photos, since the napkins at the table were black).

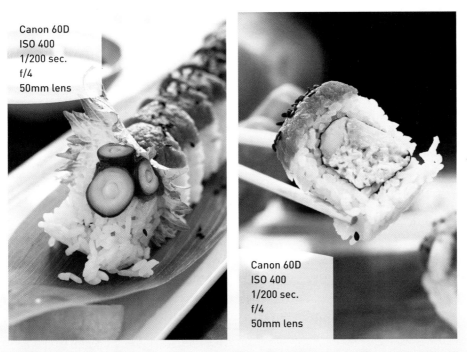

Canon 60D
ISO 400
1/200 sec.
f/4
50mm lens

Canon 60D
ISO 400
1/200 sec.
f/4
50mm lens

FIGURES 3.14 AND 3.15
To get the best lighting that I could in this sushi restaurant, I found a table next to a large window with diffused light coming in.

STROBE LIGHTS

While I use a lot of natural light with my food (mostly because it's easy and I have a nice setup), I do from time to time use studio lights. What's great about photographing with artificial light is that it allows you a lot of flexibility in regard to when and where you create your photographs. When you use sunlight, you obviously have to create your photos sometime during the day in a location that has good-quality diffused sunlight, and you also will probably have to use a tripod. With strobe lights, you have complete control of when and where you create your photographs, which at times can be a necessity. Also, since you can usually use a faster shutter speed with strobes, you have the flexibility of handholding your camera, which can be especially useful if you like to experiment with different angles and compositions. This faster shutter speed and burst of light can make for some interesting effects in your photographs, just like with this "cracking an egg" photo (**Figure 3.16**).

FIGURE 3.16
This image was lit with two large studio lights. A faster shutter speed, along with the pulse of the light, allowed me to partially freeze the motion of the egg as it fell from the shell.

Canon 7D
ISO 100
1/160 sec.
f/4.5
70–200mm lens

There are two basic types of strobe lights: small flashes (**Figure 3.17**) and studio lights (**Figure 3.18**). My preference is for studio lights, mostly because I'm more familiar with them and I always have them readily available. I also prefer their broader options of modifiers (such as softboxes) that you can attach to diffuse the light. With that said, small flashes can be just as powerful and can create a similar quality of light

to a studio strobe. They are also portable and lightweight, and since they only use batteries you don't have to search for an outlet, making them useful when photographing outdoors or on location.

FIGURE 3.17
Canon 430EX Speedlite

FIGURE 3.18
AlienBees B800 Flash unit

SYNC SPEED

When using any type of strobe light (studio or small flash), you need to keep in mind that its sync speed is limited to a maximum of about 1/250 of a second (this number can differ depending on the brand and model of your camera). This means that you can't set your camera's shutter speed to be faster than whatever your sync speed is. If you were to accidentally set it too fast, you would either get an underexposed image or most of your photo would be black.

FIGURE 3.19
PocketWizard Plus II Transceiver

You need to be able to connect your strobe light to the camera so that the light knows when to fire. With studio lights you can usually connect a cable directly from the light to the camera, but sometimes you will need (or want) to attach a radio to both your camera and the light so you can wirelessly trigger the light.

A popular brand of radio trigger is Pocket-Wizard (**Figure 3.19**). However, there are many different options, and some lights even come with their own radio trigger already installed. To use it, just connect one radio to your camera and one to your light. When you press the shutter button, it "talks" to the light so that it fires at the same time. These are very useful tools for anyone who frequently photographs with studio lights.

CONTINUOUS LIGHTS

If you don't have access to studio lights or diffused window sunlight, another option is to use a continuous light. Continuous lights are easy to use in the sense that they are a WYSIWYG ("what you see is what you get") type of light. You can watch where the light falls on your subject and where to place other accessories, like reflectors, to fill in the shadows.

When using continuous lights, keep in mind that they can get very hot, which could potentially heat up the food you're photographing. Even if your food is hot to begin with, there will likely be some items on the plate, such as fresh herbs or garnishes, that will start to look bad when they get warm. The heat from the light will rapidly spoil the look of the food, so you'll need to work quickly to get a fresh-looking food photograph.

Another thing to consider is the color of light created by continuous lights. If you can find a daylight-balanced light, your chances of producing an image with proper color balance are much greater than when using fluorescent or tungsten light bulbs. See Chapter 1 for more information on selecting a proper white balance for your food photographs.

LIGHTING MODIFIERS AND ACCESSORIES

Whether you're using sunlight or strobes, you'll probably need a few extra items, such as reflectors, softboxes, or umbrellas, to help light up your image. With food photography, it's very easy to keep things simple; you don't have to go overboard with accessories and gear to get a great photograph. Keep on reading to learn about some useful tools you can use with your food photography.

REFLECTORS

If you had to choose only one accessory to use when photographing food, I highly recommend a reflector (or two or three). A reflector is basically anything that will reflect light. In photography they're primarily used as fill lights to fill in areas that look dark or overly shaded.

When you are photographing food and backlighting your subject, you'll probably place a reflector or two in the front of the image. Just like with any type of light, the closer your reflector is to your subject, the brighter it will be, and the larger your reflector is, the softer the light will be. Also, the color of your reflector is extremely important, since that color will reflect back onto your subject. I recommend using a silver or white reflector to ensure that you don't add any strange colorcasts to your photograph.

FIGURE 3.20
The Lastolite TriGrip reflector is one of my favorite lighting accessories, because it can be easily used with just one hand.

I have a standard setup when using natural light with a reflector. I use a 42-inch silver reflector propped up on a stand, and I lean it at an angle to fill in the top and side of the food I'm photographing. Also, since my camera is usually on a tripod and I'm using a cable release to trip the shutter, I'll often hold another reflector or piece of white foam board on the opposite side to brighten up the food even more (**Figure 3.20**).

The great thing about reflectors is that they don't have to be fancy or expensive. I use a lot of standard photographic reflectors with my food photography, but I also find that simply using a large piece of white foam board that you find at any craft store is an effective way to fill in the shadows with a nice, soft light. I like to take the piece of foam board, cut it in half, and tape it back together to form a sort of bookend that can be propped up on its own next to the food, as I did with the photo in the behind-the-scenes setup in **Figure 3.21**.

Canon 7D
ISO 100
1/50 sec.
f/5.6
70–200mm lens

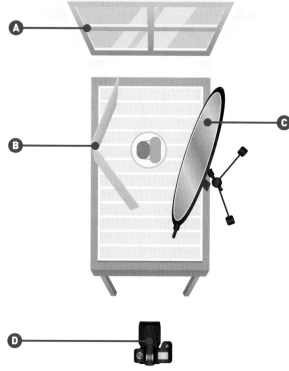

FIGURE 3.21
The foam board bookend to the left of the crepe adds a nice, soft, and diffused fill light to the food.
A North-facing window, diffused sunlight
B White foam board
C 42-inch silver reflector
D Canon 7D

SOFTBOXES

If you decide you want to use studio lights or even small flashes for your food photography, I highly recommend adding a softbox to your inventory of photography equipment (**Figure 3.22**). Softboxes diffuse the light so that it's soft and can wrap around your subject. They are a must if your goal is to minimize the harsh shadows in your photographs.

The *bigger* the softbox, the *softer* the light will be. When I photograph food with a studio light, I use a very large softbox placed behind the subject for soft backlight (**Figure 3.23**). I'm typically going for a diffused light with minimal shadows (in an attempt to mimic natural light), so the bigger the softbox I can use, the closer I'll get to the look I'm trying to achieve.

If you are using a small flash as your main light source, it's still possible to use a softbox. There are specially made softboxes designed for flashes (**Figure 3.24**). They do a great job of diffusing the light, and they're also very portable.

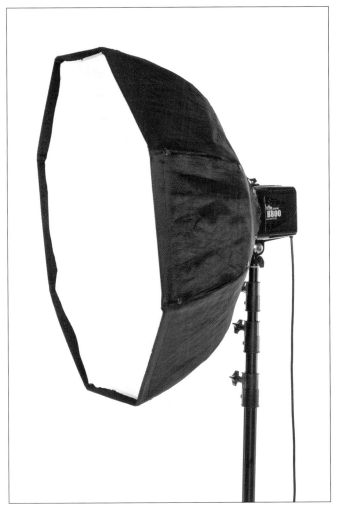

FIGURE 3.22
AlienBees B800 Flash unit with medium octabox

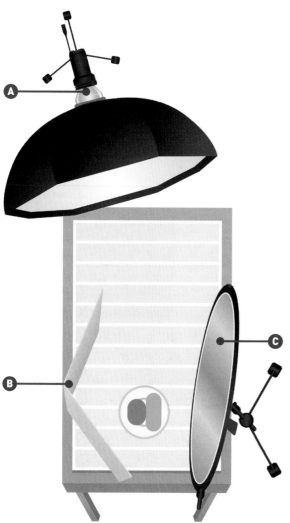

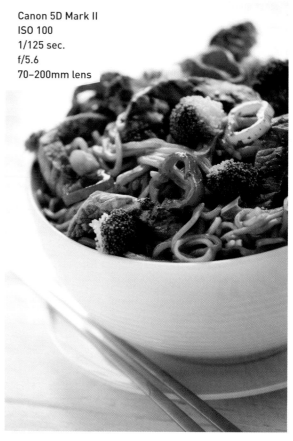

Canon 5D Mark II
ISO 100
1/125 sec.
f/5.6
70–200mm lens

FIGURE 3.23

Behind the scenes: Softbox
A AlienBees ABR800 with 56-inch Moon Unit
B White foam board
C 42-inch silver reflector
D Canon 5D Mark II

FIGURE 3.24
Canon 430EX Speedlite with small softbox

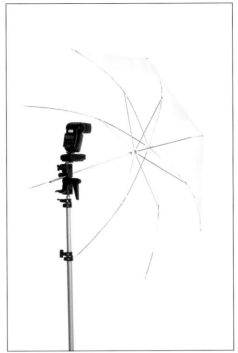

FIGURE 3.25
Canon 430EX with white shoot-through umbrella

UMBRELLAS

If you don't have a softbox, another good alternative would be to use an umbrella. There are two basic types of umbrellas: reflective or shoot-through. A *reflective* umbrella is angled so that the strobe is firing into the umbrella and the light bounces back onto the subject. A *shoot-through* umbrella is set up so that the strobe fires through an umbrella made of white, translucent material (**Figures 3.25** and **3.26**).

Figure 3.26 and **Figure 3.27** show the different setups using shoot-through and reflective umbrellas.

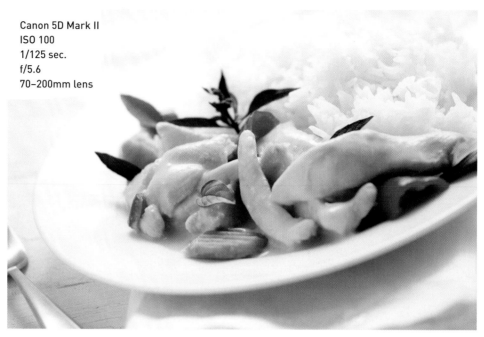

Canon 5D Mark II
ISO 100
1/125 sec.
f/5.6
70–200mm lens

FIGURE 3.26
Behind the scenes: Shoot-through umbrella
A Canon 430EX Speedlite with shoot-through umbrella
B White foam board
C 42-inch silver reflector
D Canon 5D Mark II

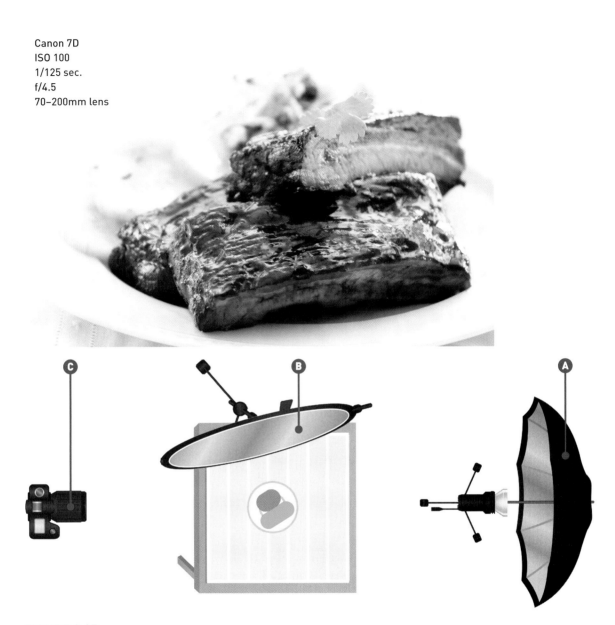

Canon 7D
ISO 100
1/125 sec.
f/4.5
70–200mm lens

FIGURE 3.27
Behind the scenes: Reflective umbrella
A Speedotron Brown Line flash with reflective umbrella
B TriGrip reflector
C Canon 7D

Chapter 3 Challenges

Now that you're familiar with many different ways to light your food photographs, here are a few lighting challenges to try out on your own.

Colors of Light

To experiment with the different colors of light, create a basic tabletop setup (food or any other small item) and photograph it in two different types of light, at least one of which is a daylight-balanced light (such as window light or a flash). Then, photograph the same setup with a tungsten or fluorescent light. Try setting your white balance to match the appropriate color temperatures, and then view them on your computer. Pay attention to the different color hues in each photograph and how they compare to the actual colors of the item you were photographing.

Using the Highlight Alert and Histogram on Your Camera

Use your camera's user manual (or a helpful friend) to enable the highlight alert on your camera. Then, take a few different photographs of the same subject at different exposure settings, doing your best to overexpose one photo and properly balance the exposure on another. Review the images on your LCD monitor and see if there are any blinking areas in the overexposed image. Next, take a look at the histogram of this photo and compare it with the histogram of the properly exposed photograph. Notice how the tones in the histogram of the overexposed photo are pushed far to the right (and probably clipped off at the edge), whereas the properly exposed photo's histogram shows the entire "mountain range" of tones.

Using a Reflector

Place an item near a window with diffused natural light, and set it up so that your subject is back-lit with the light from the window. Then take a look at your scene and pay careful attention to the amount of shadow in the front of your subject (just with your eyes—you won't need a camera for this first part). Next, use a reflector (or a large piece of white foam board) and place it in front of your subject. Move it back and forth and watch how it fills in the shadows in the front.

Grab your camera and photograph the scene with a balanced exposure and your camera mode set to Manual. First, take a photo without using the reflector. Then take another photo without changing your settings, but this time use the reflector to fill in the front of your subject. Compare the two images on your LCD monitor and watch how the light comes and goes and how adding a reflector fills in the front of the image to brighten up the shadows.

Share your results with the book's Flickr group!

Join the group here: flickr.com/groups/foodphotographyfromsnapshotstogreatshots/

4

Canon 7D
ISO 100
1/125 sec.
f/4
70–200mm lens

Styling & Props

THE ART OF PRESENTATION

One of the reasons I love food photography is that I truly enjoy styling and crafting the food, and one of the biggest compliments I get from people who see my images is that they made them hungry! When we eat food, all of our senses are at work—we see, smell, touch, and taste the food—but when we look at a photo, we can only use our eyes. Styling food is one way to capture its flavors, aromas, and textures and to communicate them to viewers. Creating an amazing-looking dish is an art, whether you eat it or photograph it, and you can do a lot of little things to enhance the look of the food and (hopefully) make people salivate when they view your photographs.

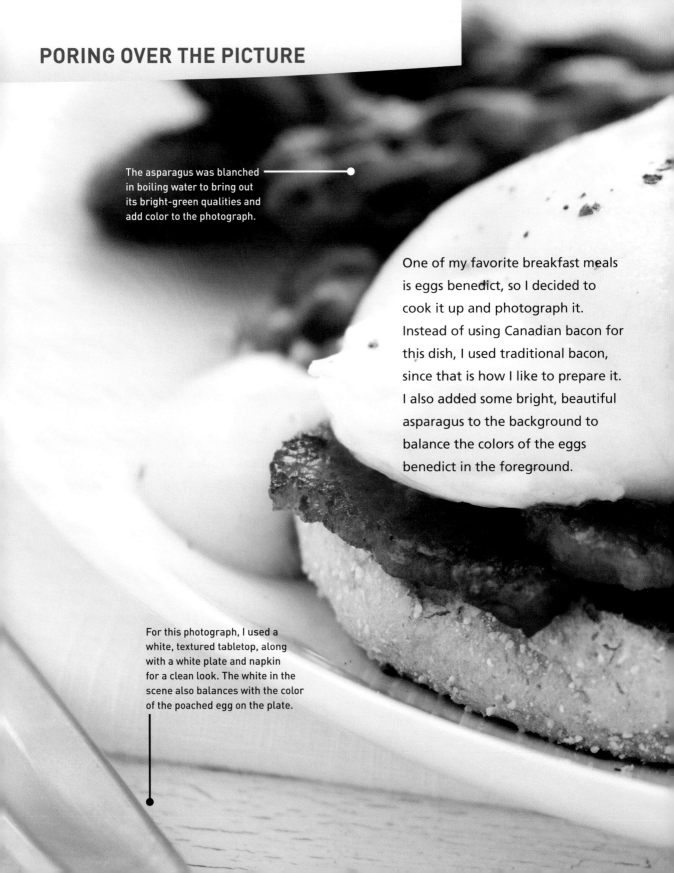

PORING OVER THE PICTURE

The asparagus was blanched in boiling water to bring out its bright-green qualities and add color to the photograph.

One of my favorite breakfast meals is eggs benedict, so I decided to cook it up and photograph it. Instead of using Canadian bacon for this dish, I used traditional bacon, since that is how I like to prepare it. I also added some bright, beautiful asparagus to the background to balance the colors of the eggs benedict in the foreground.

For this photograph, I used a white, textured tabletop, along with a white plate and napkin for a clean look. The white in the scene also balances with the color of the poached egg on the plate.

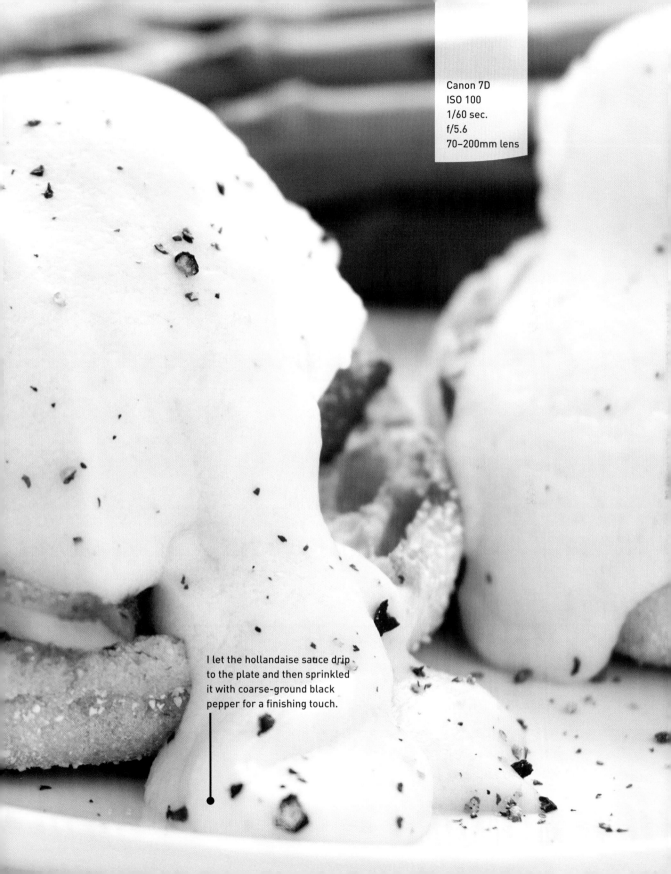

Canon 7D
ISO 100
1/60 sec.
f/5.6
70–200mm lens

I let the hollandaise sauce drip to the plate and then sprinkled it with coarse-ground black pepper for a finishing touch.

PORING OVER THE PICTURE

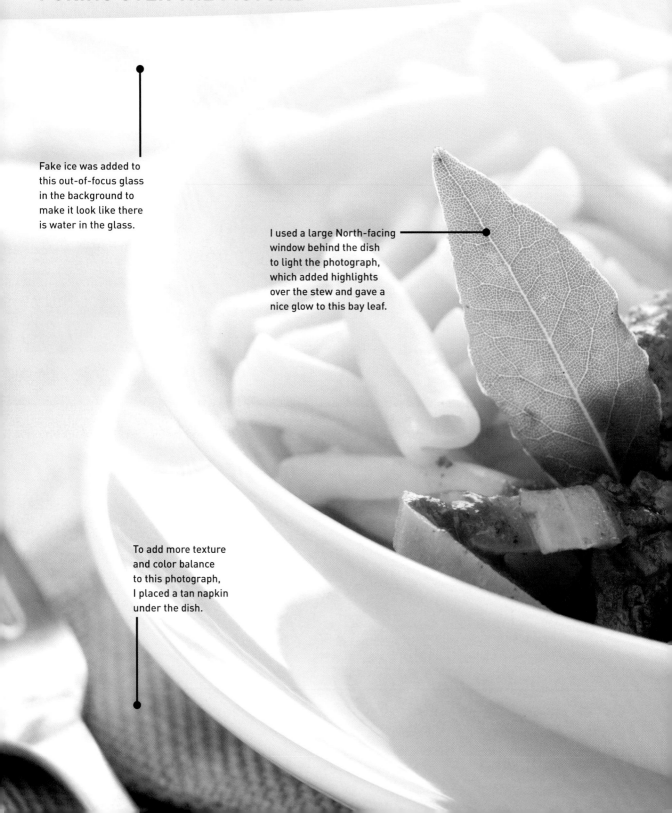

Fake ice was added to this out-of-focus glass in the background to make it look like there is water in the glass.

I used a large North-facing window behind the dish to light the photograph, which added highlights over the stew and gave a nice glow to this bay leaf.

To add more texture and color balance to this photograph, I placed a tan napkin under the dish.

Canon 5D Mark II
ISO 100
1/8 sec.
f/8
70–200mm lens

To add color to an otherwise brown and boring meal, I blanched some of the vegetables in boiling water to make their color pop before adding them to the finished dish.

I don't use my slow cooker very often, but I decided to try it out on a simple beef stew that I could photograph for this book. To add color to the dish, I used brightly colored vegetables and placed them in the bowl, and I added some pasta next to the stew to bring it all together.

STYLING CONSIDERATIONS

When we photograph our food, we want it to look beautiful, mouthwatering, and delicious. But there are several issues to consider before you go full speed.

USING A FOOD STYLIST

Food stylists are extremely talented artists, most often with a culinary background. Their job is to make food look fresh and appetizing for the camera, so an understanding of how food acts and behaves is a must. They know all the tricks and techniques to create beautiful-looking dishes and use their skills to make the food look as delicious as it tastes. But do I think that every food photographer needs to work with a food stylist? My answer is: it depends.

If you are the photographer for a big production (one with a very large budget or for a high-profile company), it's necessary to have a stylist. Even if you have the chops to style the food yourself, doing both the photography and the styling would be overwhelming. Styling food on set is a one- or maybe two-person job, so when you are in an environment where time is limited (or there are several food items to style and photograph), then you are probably better off working with a professional food stylist.

On the other hand, if you're a food blogger or you just want to photograph food for fun, then it's likely you don't have the budget to hire a bona fide food stylist. In that case, it's up to you to learn how to style your food and present it so that it not only looks appetizing, but also looks good on camera.

ETHICAL CONSIDERATIONS

When it comes to styling food, there are some "legal" restrictions that you must adhere to, mostly when you're photographing food for commercial purposes. The basic guideline is that if you're photographing food for advertisements (such as an ice cream image for a specific brand of ice cream), then you need to photograph the actual product, which in this case would be ice cream. You can't photograph fake ice cream and pass it off as the real thing.

But let's say you are photographing the sprinkles and toppings that go on top of the ice cream, and the product that is being advertised is *not* the ice cream itself. In this case it should be OK to use fake ice cream, since ice cream is, after all, one of the more difficult things to style and photograph. With all that said, I am not a lawyer, so if you find yourself in an unclear situation, it's best to seek legal advice.

STYLING . . . VS. NOT STYLING

So what exactly is food styling? If you ask me, it has a broad range of definitions. Some people may consider food styling to encompass only the "weird" things that can be done to food, such as using motor oil on pancakes or soap bubbles in coffee. My own definition is much more liberal, since I think that we all style our food. Every intentional adjustment you make to your dishes, whether it's for food you're going to eat or to photograph, is styling. When chefs prepare meals at restaurants, they also style their dishes. Presentation is extremely important with food, especially when it's going to be photographed; when you can't smell the food, hear it sizzle, or hold it in your hands, its appearance is everything.

You see, styling food doesn't mean you need to compromise the integrity of the dish and contaminate it with non-food items in order to create a stunning photograph. To me, nothing is more beautiful than real food, but it still takes a bit of work to make that food look good for a photograph (**Figures 4.1** and **4.2**). You can also create your entire dish and do a bit of "editing" to the plate, which can be as basic as taking what is in front of you and moving things around to make it look more appealing.

Canon 5d Mark II
ISO 100
1/125 sec.
f/5.6
70–200mm lens

Canon 5d Mark II
ISO 100
1/125 sec.
f/5.6
70–200mm lens

FIGURE 4.1
This food was cooked to be eaten and I did no styling to the dish. While it doesn't look bad or unappetizing, you can see a clear difference between it and Figure 4.2.

FIGURE 4.2
The food in this photograph was fully cooked, but it was styled and prepared to look bright and colorful.

The way you style and present your food is up to you, and the ultimate purpose of your photograph will also play a role in the presentation. If you run a Web site that showcases recipes and food, you might want to make your dish look as real as possible and only edit or style it so that you represent the recipe as truthfully as possible. Or, if you just love food and want to create beautiful dishes for the love of photography, sneaking in a few "tricks" may not be such a bad thing. There's no right or wrong way to style food; just do what fits the purpose of your photography and your personal style.

ENSURING FOOD QUALITY

When you cook a meal, you want to use quality ingredients to get the best flavors possible, right? When photographing food, you want to make sure that you follow the same principle, while ensuring that the way each ingredient *looks* is just as important as its *flavor*. It's simple, really—find only the most beautiful food to photograph.

USING FRESH INGREDIENTS

The key to achieving a high-quality look for the food in your photographs is to use the freshest ingredients possible. Food doesn't last forever, and its beauty usually dissipates before it spoils or loses flavor. Herbs and veggies sitting in a refrigerator have a very limited lifespan, so make sure you plan your photographs in advance and buy your food *the day of* or *the day before* it's photographed.

To ensure that the quality of my food is up to par, I shop only at certain grocery stores and markets. I know that some locations will have, for example, a really great selection of seafood, so I go to one of those stores when I'm shopping for that ingredient. I also like to go to the local farmers market to buy seasonal produce and fruit, and sometimes I'll conceive the look of a dish based on the freshest ingredients I can find while I'm shopping.

I also prefer to use fresh food rather than canned food, especially when it comes to vegetables (I will, from time to time, use frozen vegetables, as they hold their shape and color well after being cooked). The guideline I use is that if I can buy it fresh (in the produce section of the grocery store), then I buy it fresh and stay away from anything in a can. This also gives me a lot more control over the shape, color, size, and texture of the food. I make exceptions to this, of course, such as when I want to use something like canned mandarin oranges or water chestnuts. The bottom line is that if the food looks good enough to photograph, whether it's fresh or comes out of the can/bag/jar, then go ahead and use it.

SHOPPING SMARTLY

When purchasing the ingredients for your dish, you need to be extremely selective. Choosing the very best-looking ingredients (also referred to as the "hero" food) is essential to a great-looking dish. It's also a good idea to buy more than you need (you can always eat the leftovers!). Having more than one of each item gives you options for the look of the ingredient, and it's also insurance in case anything goes wrong with your first pick.

I think every department at my local grocery store knows by now that I'm a food photographer. Each time I buy an item that needs to be packaged (like seafood or sliced deli meat), I specifically tell them that the food is going to be photographed. When I recently purchased some shrimp that was going to be the "star" of a photo, I asked for only the shrimp with the most beautifully intact tails. I also spent what felt like ten minutes searching through peppers to look for the perfect one (**Figure 4.3**), and I've shopped at more than one store in one trip because the mint selection at the first was old-looking and too crumply for a photograph. Never compromise the look of an ingredient if you don't have to.

With all of your handpicked ingredients in your basket, you'll also want to be careful when they are being bagged or boxed at the checkout. If you want to be über-gentle, bring a separate box for the items to prevent things squishing together in grocery bags. Or you can do what I do and go through the self-checkout line. I still use bags, but I'm careful with what goes where so nothing gets damaged.

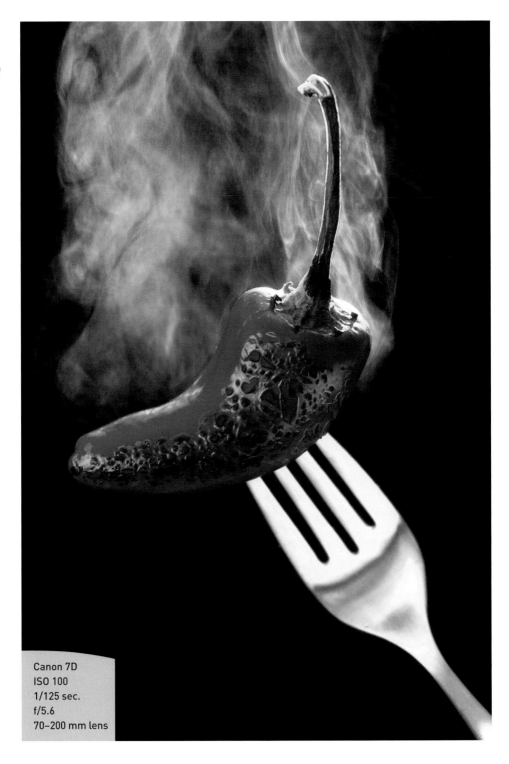

FIGURE 4.3
I spent several minutes in the produce section of the grocery store searching for this chili pepper.

Canon 7D
ISO 100
1/125 sec.
f/5.6
70–200 mm lens

FOOD STYLING BASICS

There is no single right way (or wrong way) to style food, but there are some things that many food stylists and photographers do to make the food look its best. Before I get into the how, I'll start with the what—in other words, some of the gadgets and tools you can use to make it all happen (**Figure 4.4**).

GADGETS AND TOOLS

I use a lot of little gadgets and tools when styling food, and many of them are just everyday kitchen utensils. Here is a list of some of the basic tools I use often and wouldn't want to be without:

- **Tweezers:** I use tweezers to place small items (such as mint leaves or sesame seeds) or to reposition things on the plate.

- **Prep bowls or ramekins:** These are really useful for holding garnishes and sauces near your dish or workspace. You can also place them upside-down in bowls to add bulk to foods.

- **Plastic spoons:** These are useful for mixing and stirring, and also for applying things like sauces, sour cream, or any kind of liquid. Because they are extremely light and thin, I find that they give me more control than using metal spoons.

- **Paper towels:** I always have a full roll of paper towels sitting near my workspace when styling food. They're handy for cleaning drips on plates, and if you're styling food in the spot where it will be photographed, you can place them under the plate to catch accidental spills.

FIGURE 4.4
These are a few of the tools I use regularly when styling food.

- **Brushes:** I often like to add shine to food items such as cooked veggies or meat, so I'll add some oil to a prep dish and use a brush to "paint on" the oil.
- **Spray bottle:** I have a little spray bottle filled with water to add mist to food like salad or fresh fruits and vegetables.
- **Grater and peeler:** These are great for preparing garnishes, such as Parmesan cheese or lemon zest.

USING STAND-INS

If you're familiar with movie or television production, you know that the lights need to be set for each scene, which usually takes quite a while. So, instead of having the main actors sit or stand on the set while the lights are being moved and measured, "stand-ins" (people who have a similar look to the actors) take their place so the actors can relax, have their makeup fixed, memorize their lines, or simply stay in character. A similar method is used in food photography.

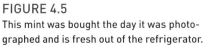

Canon 5D Mark II
ISO 100
1/8 sec. at f/8
70–200mm lens

FIGURE 4.5
This mint was bought the day it was photographed and is fresh out of the refrigerator.

Canon 5D Mark II
ISO 100
1/8 sec. at f/8
70–200mm lens

FIGURE 4.6
This was photographed 30 minutes after I photographed Figure 4.5.

When you style and photograph food, you usually have to work very quickly so the food stays fresh. All food has a limited lifespan, which is even more apparent when you're photographing it. Shiny food loses its luster, oils and sauces soak into cooked meats, and foods such as herbs and lettuce wilt away very quickly (**Figures 4.5**, **4.6**, **4.7**, and **4.8**).

When I photograph food, I always use a stand-in. I do this so I can set the lights, composition, props, and so on ahead of time so the food doesn't lose its luster by the time everything is ready to go. I don't even do any cooking, styling, or preparations until the light is ready. That way, once the food is prepared I can drop it into place, make a few minor adjustments, and start photographing within seconds of the food being placed on set.

A stand-in can be anything. An extra piece of food that doesn't require cooking (such as a hamburger bun) usually makes a good stand-in. Or you could use something

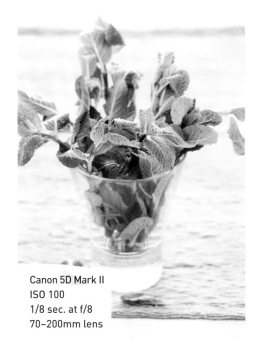

Canon 5D Mark II
ISO 100
1/8 sec. at f/8
70–200mm lens

Canon 5D Mark II
ISO 100
1/8 sec. at f/8
70–200mm lens

FIGURE 4.7
This was photographed 45 minutes after I photographed Figure 4.5.

FIGURE 4.8
This was photographed 1 hour after I photographed Figure 4.5.

totally random that has similar tonal qualities as your prepared food will have (**Figure 4.9**). Try to use something that is the same shape, width, or height so you can set your composition in the camera (especially handy if you are using a tripod).

FIGURE 4.9
Because their color is similar to the "hero" food, I used a pile of small sweet peppers as the stand-ins for this scene.

Canon 7D
ISO 100
1/250 sec.
f/5.6
70–200mm lens

Canon 7D
ISO 100
1/250 sec.
f/5.6
70–200mm lens

MAINTAINING A CLEAN ENVIRONMENT

When I'm preparing a plate of food for a photograph, I do most of the work away from the location where it will be photographed, usually on my kitchen counter or at a table that sits nearby. This is so I can get very close to the dish and have all of my tools, food, and garnishes nearby, and it doesn't matter if I make a mess.

There will be times, however, that you won't be able to do all of your plating off set and will need to style the dish as it sits in front of the camera. In those instances, you need to be very careful to protect the environment from drips and spills. A perfectly prepared photo setup can easily be tainted with an unwanted stain. The simplest solution is to place a few paper towels around the area, which will likely save you from having to quickly re-create your scene (**Figure 4.10**). This also allows you to focus on the look of the food without worrying about making any messes.

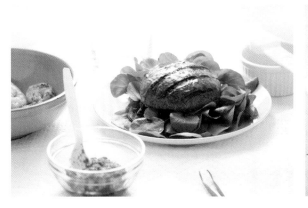

FIGURE 4.10
Before adding the final touches to these dishes, I placed paper towels under and around the plates to catch any spills that would stain the tabletop and napkin.

STYLING FROM CAMERA VIEW

When photographing food, the only area of the food that you need to really pay attention to is the side that's being photographed. It's always best to put yourself in the position of the camera and style the food from that perspective. If you're photographing the front part of a dish, it doesn't matter what the back of the dish looks like, so long as it's not in the image.

Another useful way to style food (and set up the overall scene, too) is to use the Live View feature on your camera (most of the newer DSLR models will have this as a standard feature). Using Live View makes it so easy to place things in the scene, add garnishes, and even just frame and compose the photo. The downside to Live View

is that it drains the battery more quickly than just looking through the viewfinder. It also will sometimes cause interference when firing strobes and flashes wirelessly. If you run into that problem, you'll need to turn off Live View temporarily to trip the shutter and create the photograph.

FOLLOWING YOUR INSTINCTS

Overall, much of styling food involves using what works for your situation. There is no one way to do everything, and, depending on how the food was prepared or how you want it to look, you'll probably have to get creative.

You also need to make sure that you are deliberate in your approach to creating your food and developing its overall appearance. When I style food, everything that ends up in the photograph is there because I want it to be there. A crumb that looks like it landed naturally on the plate may have been placed with small tweezers, or it crumbled off on its own and I just liked the way it looked. Often it's the things that may be considered small and unimportant that can actually take a photo from average to amazing.

STYLING TIPS AND TRICKS

There are a lot of techniques you can use when styling your food to enhance its appearance. Here are some simple tips and tricks to help you make your food look great when it's being photographed.

ADDING BULK

When you place food in a bowl, often it will sink to the bottom and lie flat (especially with foods like pasta and chunky soups or stews). There are a few ways that you can bulk up food in a bowl. The first is to take a dome of Styrofoam, set it in the bottom of the bowl, and then place the food on top of it (**Figure 4.11**). This usually works best for slippery foods that won't stay put, but one downside is that if you're planning to eat the food after it's photographed, you're out of luck (unless you want little bits of plastic foam in your meal). Another method is to take a smaller bowl, such as a prep dish or small ramekin, and place it upside-down in the bowl and then pile the food on top. This keeps your food fresh and does a really good job of adding a little extra bulk.

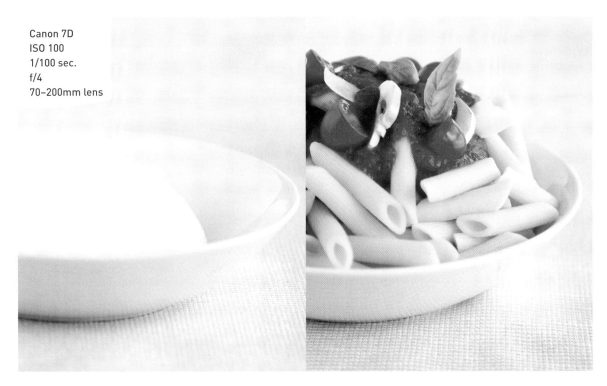

Canon 7D
ISO 100
1/100 sec.
f/4
70–200mm lens

FIGURE 4.11
For these pasta dishes I used a dome of Styrofoam to bulk up the food. Pasta can be slippery, so Styrofoam works well if I'm using the food only for photography (and not to eat afterward).

Another quick tip is that if you're photographing a bowl of soup with ingredients such as noodles, veggies, or meat, try adding a handful of decorative rocks to the bottom of the bowl to push up all the tasty ingredients to the top. I prefer to use clear rocks to avoid any potential colorcast in the image, especially in a clear or broth-based soup. That way instead of being sunk to the bottom, they're hanging out at the top of the bowl in clear view of the camera (**Figure 4.12**).

FIGURE 4.12

I used some clear decorative rocks at the bottom of this bowl to push the noodles and vegetables to the top of the dish.

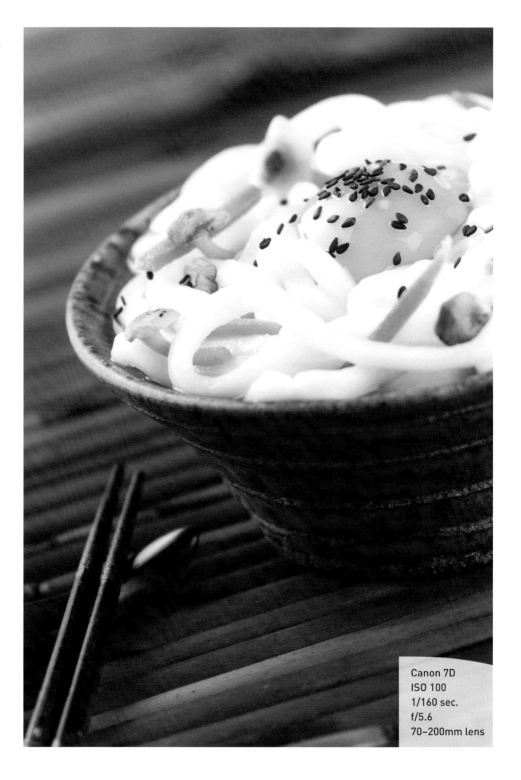

Canon 7D
ISO 100
1/160 sec.
f/5.6
70–200mm lens

If you're photographing a sandwich, one easy way to keep the sandwich from looking flat is to place small pieces of cardboard or foam board between each layer. You can also stick pieces of toothpicks into the cardboard to push up and heighten the sandwich even more (**Figure 4.13**).

FIGURE 4.13
By adding small pieces of cardboard and toothpicks inside the sandwich, I was able to bulk it up and give it fullness so that it looks more appetizing.

Canon 7D
ISO 100
1/250 sec.
f/2.8
50mm lens

Canon 7D
ISO 100
1/320 sec.
f/2.8
50mm lens

USING GARNISHES

Adding a touch of color to a dish can do wonders, and I often do this by adding garnishes such as fresh basil, cilantro, or any herb that is appropriate to the food and its ingredients (**Figure 4.14**). This can make it look livelier and more appealing, just as adding herbs and spices will enhance flavor when cooking the food.

FIGURE 4.14
I used basil in this dish when it was cooked, but I wanted to make the colors more pronounced. Adding small basil leaves to the bowl added a color and vibrancy that didn't show through in the original photo.

Canon 5D Mark II
ISO 100
1/30 sec.
f/8
70–200mm lens

This technique also helps create your point of focus. By adding a bright, colorful food item to the dish, you will draw the viewer's eyes to that location. And it's the perfect spot to focus on with your camera (there'll be more on focus and composition in Chapter 5).

KEEPING IT REAL

One thing to keep in mind when you're creating your dishes is that they don't always have to look perfect. A few crumbs or drips to the side of the food, or even a dish where the food has already had a fork dig into it, makes the food look more real and attainable to the viewer (**Figure 4.15**). It can also add balance to the composition of the photograph. A little mess is OK; just pay attention to your crumb placement so that it still looks appealing and delicious.

Canon 5D Mark II
ISO 100
1/50 sec.
f/5.6
70–200mm
lens +1.4x

FIGURE 4.15
I added a few crumbs and berries to the side of this yogurt parfait to balance the dish and give it a more natural look.

PUTTING IT ON ICE

I use fake ice in many of my photographs (**Figure 4.16**). In fact, any time there's a water glass in the frame (often in the out-of-focus background), I've also added some fake ice to the cup, usually without even adding water. The reason that I use fake ice so frequently is that real ice has two major flaws: it melts quickly, and it can look very foggy when photographed (**Figure 4.17**). Fake ice, on the other hand, will hold its shape and stay shiny and crystal clear (**Figure 4.18**).

FIGURE 4.16
I used a drinking glass with fake ice in the background of this photo.

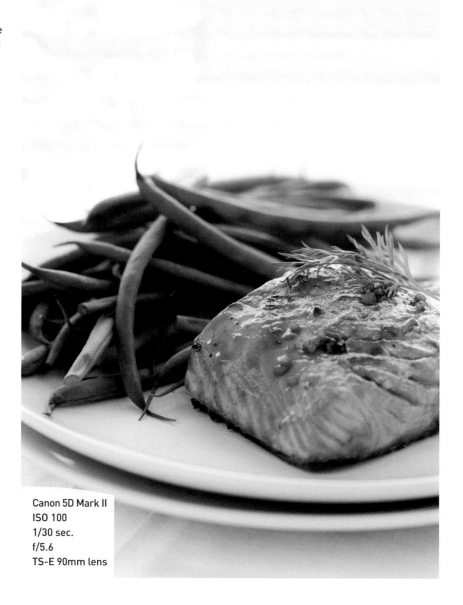

Canon 5D Mark II
ISO 100
1/30 sec.
f/5.6
TS-E 90mm lens

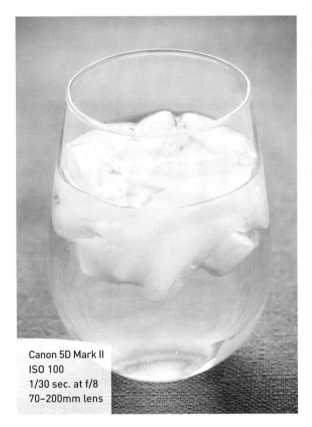

Canon 5D Mark II
ISO 100
1/30 sec. at f/8
70–200mm lens

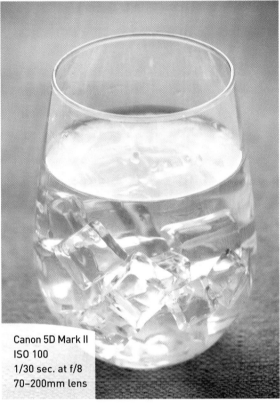

Canon 5D Mark II
ISO 100
1/30 sec. at f/8
70–200mm lens

FIGURE 4.17
For this photo I used **real** ice, backlit with diffused sunlight coming through a window.

FIGURE 4.18
For this photo I used **fake** ice, backlit with diffused sunlight coming through a window.

While there are some places that create custom, very realistic (and expensive) acrylic ice cubes, the ice I use is relatively inexpensive and purchased through an online retailer. If you are creating photographs that require ice and you don't have a big budget, this is probably a good option for you as well.

FAKING GRILL MARKS AND CHARRING FOOD

If you want to add realistic grill marks on cooked food but don't have the luxury of owning a grill (or you just want the grill marks to look really good), another option is to add them after the food is cooked. I like to use an electric charcoal starter, which is a handheld device that has a big loop of metal attached to a handle (**Figures 4.19** and **4.20**). You could also use a grill pan with a ribbed bottom to get a similar effect.

Canon 5D Mark II
ISO 100
1/50 sec.
f/8
70–200mm lens

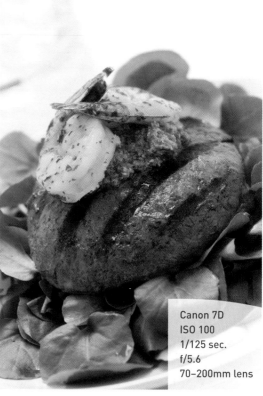

Canon 7D
ISO 100
1/125 sec.
f/5.6
70–200mm lens

FIGURE 4.19
By using a charcoal starter, I was able to add grill marks to this already-cooked chicken breast.

FIGURE 4.20
I used the same method as in Figure 4.19 to add grill marks to this piece of steak.

If you have food that is already cooked but needs a little more visible cooking to be done on the surface, you can use a crème brûlée torch to "cook" specific areas of the food (**Figure 4.21**). This is also handy if you want to add charring to a food item to give it the appearance of being cooked, as I did to the asparagus in **Figure 4.22**.

Canon 5D Mark II
ISO 100
1/125 sec.
f/8
70–200mm lens

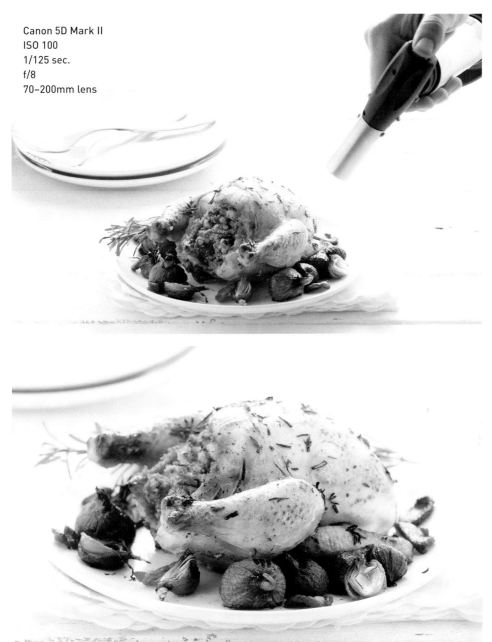

FIGURE 4.21
This Cornish hen
was fully cooked,
but it needed just a
bit more brown-
ing on the side
that was being
photographed.

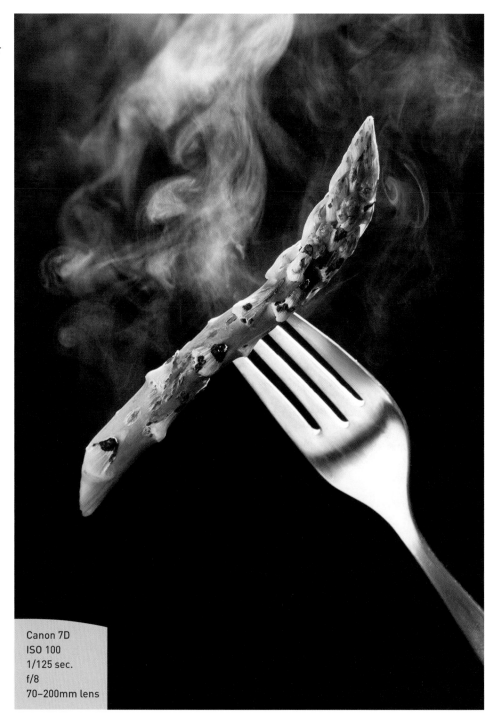

FIGURE 4.22
I used the crème brûlée torch to char the asparagus to make it look as if it had been grilled.

Canon 7D
ISO 100
1/125 sec.
f/8
70–200mm lens

ADDING STEAM

Food looks tastier when it's fresh, and if it's hot, it is more appealing if you can *see* that it's hot. Food that is fresh out of the oven or right off the pan usually has steam rising from it, but once it sits for a minute or two the steam dissipates. If you want to keep that "freshly cooked" look, you can always add the steam yourself.

A fun (and easy) way to add steam to a food item is to use a hand steamer. They are typically used for steaming and straightening clothes, but they work very well with food photography. In **Figure 4.23** (left), I show how I used a hand steamer to give this shrimp the appearance that it is still hot and fresh, and after a few attempts I got the perfect "steamy" look (**Figure 4.23**, right). (See Chapter 7 for a behind-the-scenes on creating a similar "steam" photograph).

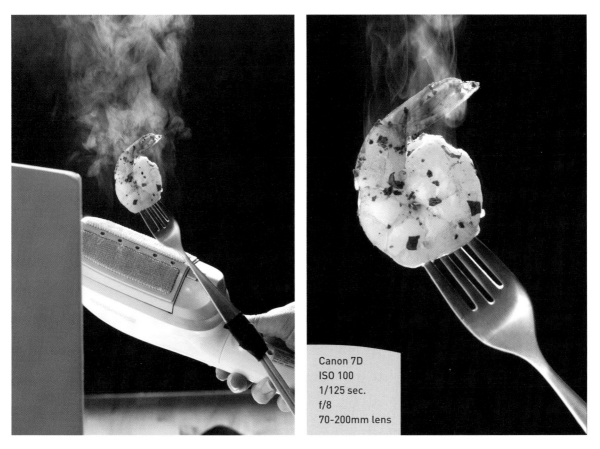

Canon 7D
ISO 100
1/125 sec.
f/8
70-200mm lens

FIGURE 4.23
I used a portable hand steamer to add steam to this shrimp on a fork.

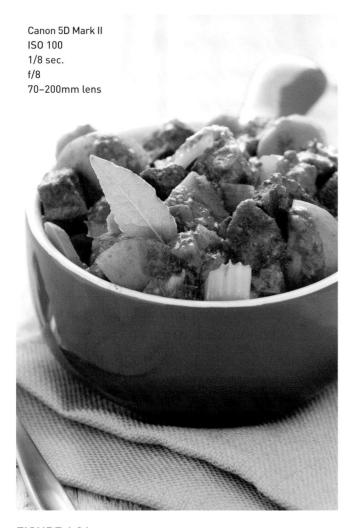

Canon 5D Mark II
ISO 100
1/8 sec.
f/8
70–200mm lens

MAKING VEGETABLES BRIGHT

If you want to give your vegetables a burst of color, the best way to prepare them for a photograph is to blanch them in boiling water immediately before you photograph them. Blanching is a cooking method wherein food is boiled very briefly (30 seconds to a minute or maybe more) and then cooled in cold water to stop the cooking process. When you blanch vegetables, you will end up with very bright colors that photograph beautifully. This is also a good way to add color to an otherwise boring-looking dish (**Figure 4.24**).

PROP STYLING

In really big food photography productions, along with a food stylist there is likely to be a prop stylist. This person is in charge of the plates, napkins, tablecloth, and anything else added to the scene that is not food. If you're styling and photographing your own food, then this job falls on your shoulders. And though it might not seem important at first, the props you use can really make or break a food photograph.

How you style the area around your food can greatly affect the mood and overall impression of the photograph (**Figure 4.25**).

FIGURE 4.24
On its own, this beef stew was colorless, since the meat and vegetables had turned brown during the cooking process. To liven it up, I blanched some of the ingredients separately and placed them in the dish to add color to an otherwise boring-looking dish of food.

The props can suggest the location, time of day, season, and perhaps even who might be about to enjoy the meal. All of this can be achieved through the colors, textures, and shapes of your dishes, textiles, and props. The possibilities are endless.

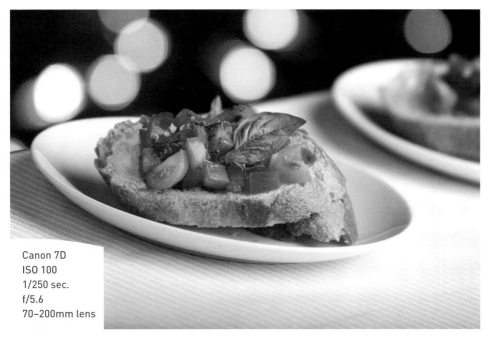

FIGURE 4.25
To make this dish appear as if it were on a table at a fancy restaurant (or outdoors in a romantic setting), I added large string-lights to a black background to convey the sense of a darkened room.

Canon 7D
ISO 100
1/250 sec.
f/5.6
70–200mm lens

RELEVANCE AND SIMPLICITY

When adding props to a scene, imagine yourself sitting down at the table to eat the meal you are photographing. Picture the utensils, food, and dishes that might be set around you, things that you would actually use in real life. Then, take that information and apply it to your photograph.

Just remember, if it doesn't *add value* to your image, it's likely that it's *taking away* from your image. You want the props to be relevant, but you don't want them to draw attention *away* from your main subject. Keeping the scene uncluttered and simple is usually a good start, since you want to showcase your main dish. Some examples of appropriate props and additions to your scene might include silverware, prepared food (such as side dishes or ingredients from the main dish), drink glasses, and napkins. Also, when photographing a finished, prepared meal it's also best to avoid placing in your scene unprepared food items, such as whole peppers, potatoes or onions. If it's something you wouldn't normally eat in its entirety (or in an uncooked state), then it's probably not going to seem very appetizing in a photograph.

Canon 60D
ISO 800
1/60 sec.
f/4
50mm lens

FIGURE 4.26
Here is a sampling of some of the dishes I use for food photography. As you can see, I prefer white or light-colored dishes.

DISHES AND ACCESSORIES

When selecting the plates and utensils to use in your photograph, you want to match them to your food. My general style is to use a lot of white, clean dishes—the meals I prepare tend to have a lot of color in them, and I don't want to compete with the food with a bright or busy pattern on the plate or bowl (**Figure 4.26**). However, if the food is very basic and simple (like mashed potatoes or a slice of cake), then I would probably use a colored plate, or maybe even something with a simple pattern. There's really no rule to this, though—just go with what you think fits your style and your food.

The size of the dish is also important. I collect a lot of smaller plates and bowls and use them often in my photographs. Putting food on a plate that is a little smaller than one you might normally use to eat on gives the appearance that there is more on the plate and that the food item is larger than it actually is. This also works well with silverware—I will often use salad forks and smaller spoons off to the side of my dishes to give the appearance that the food is bigger than it actually is.

There are a lot of great places you can find dishes, cups, and utensils for your photographs. I like to shop at stores where I can buy individual items, instead of having to buy an entire set (since I'm typically only using one or two of the same dish in a scene). Thrift stores and yard sales are also good places to score unique dishes and accessories for really great prices. Another place I like to shop is craft stores. They often have interesting glassware and decorative items that are intended for other purposes (candles, for example) but that can be used as cups or bowls in photographs. I'm also learning to create my own dishes, as you can see in **Figure 4.27**.

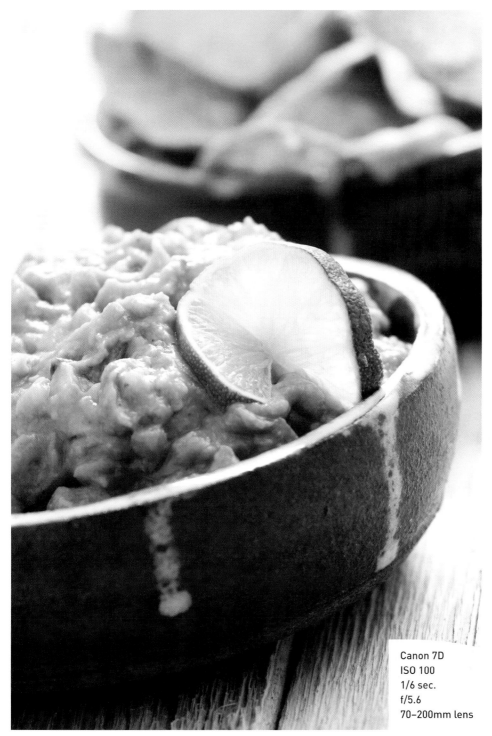

Canon 7D
ISO 100
1/6 sec.
f/5.6
70–200mm lens

TEXTILES AND TEXTURES

Adding texture to a photograph is a good way to lend a sense of depth and realism to the scene, and there are many ways to add texture with food photography. I do this by using textiles, such as napkins and tablecloths, and also creating my own textured tabletops (**Figure 4.28**).

One way to create easy-to-use tablecloths for your scene is to take fabric, iron it out so it's nice and flat, wrap it around foam board, and then secure it with tape in the back. This makes the tablecloths easy to store and transport without wrinkling.

Canon 5D Mark II
ISO 100
1/160 sec.
f/6.3
50mm lens

FIGURE 4.28
Creating premade cloth tables is an easy way to keep them ironed and easy to use.

Canon 5D Mark II
ISO 100
1/30 sec.
f/8
50mm lens

FIGURE 4.29
I like to use boards and two-by-fours to paint my own unique tabletops for my food photographs.

If you want to use a textured tabletop, they are pretty easy to make on your own (**Figure 4.29**). You just need a thin piece of wood big enough to cover the table, a few different colors of paint, and some "crackle" paint (you can usually find all of this at hardware or craft stores). Then just follow the instructions on the crackle paint container to get a nice aged/distressed paint finish. You can also scour yard sales and antique stores for old wooden doors, or just use any other type of old wood that you can find lying around the house (**Figure 4.30**).

FIGURE 4.30
These boards are pieces of an old fence a friend was getting rid of. I like to use them for a rustic "picnic table" look in my photographs.

Canon 5D Mark II
ISO 100
1/100 sec.
f/4
50mm lens

Chapter 4 Challenges

There are a lot of different ways you can add to the look of your food photographs through styling and adding props, so here are a few challenges to get you started.

Styled vs. "Ready to Eat"

Cook up one of your favorite meals and prepare two servings. Style one of the servings so that it looks really great (try using some of the tips in this chapter), and then take a photo of it. Next, prepare the second serving in a dish as you would if you were going to eat it. Photograph it in the same light and location as your first image. Compare the two and note the differences.

Fake Ice vs. Real Ice

If you have some fake ice, this exercise is fun to try. Using a clear water glass, create two photographs of the same glass filled with water—one with real ice and one with fake ice. Compare the differences between the two images. Note the fogginess in the real ice compared to the clear shininess of the fake ice.

Creating Your Own Tabletops

If you want to use something other than your existing tabletop, use some of the techniques in this chapter to create your own. Take foam board and a large piece of cloth to make a flattened tablecloth, or grab a big, flat piece of wood and some paint and get creative. Try adding texture or using different colors on the same tabletop for a unique look.

Share your results with the book's Flickr group!

Join the group here: flickr.com/groups/foodphotographyfromsnapshotstogreatshots/

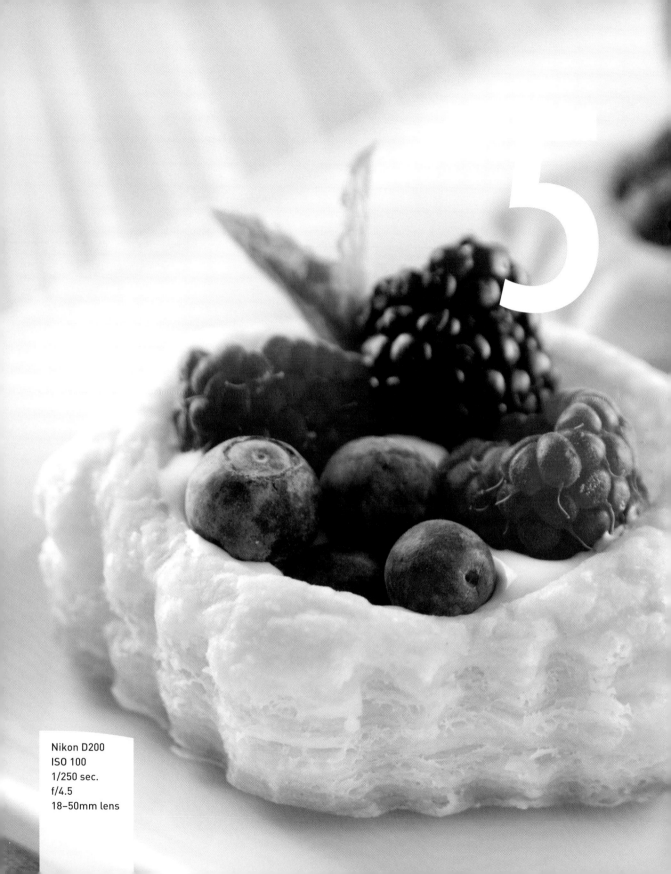

5

Nikon D200
ISO 100
1/250 sec.
f/4.5
18–50mm lens

Framing & Composition

IMPROVE YOUR PHOTOS WITH SOUND COMPOSITIONAL ELEMENTS

To make a beautiful food photograph, you need more than just knowledge about your camera and what settings to use—you should also have a good understanding of how to compose your images. Being able to create beautiful compositions is an extremely useful skill and is sometimes more important than the nitty-gritty technical aspects of photography. Just knowing one or two tricks isn't enough, but learning several methods and piecing them together will help you to create great food photographs. In this chapter, we will examine how you can add interest to your photos by utilizing common compositional elements.

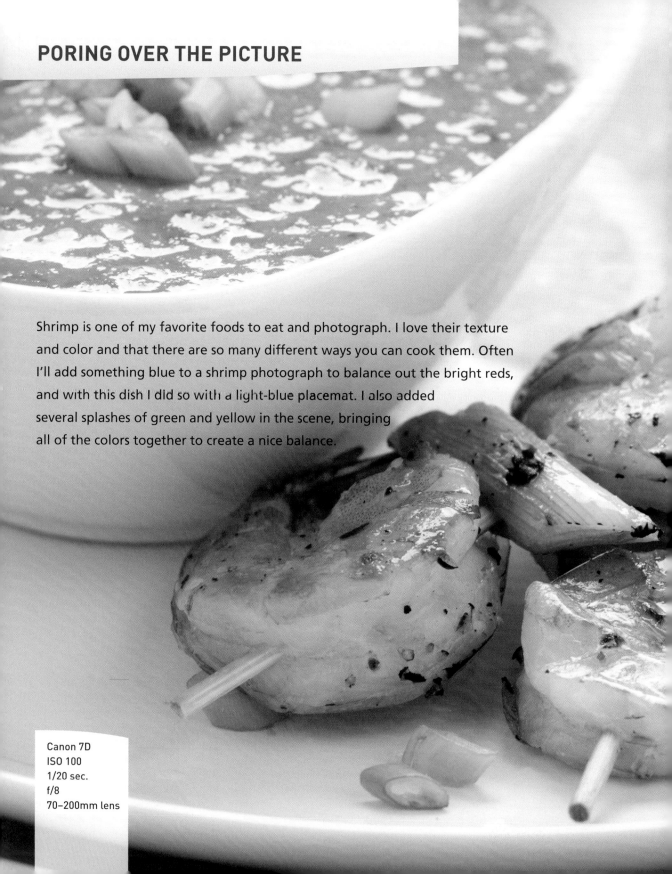

PORING OVER THE PICTURE

Shrimp is one of my favorite foods to eat and photograph. I love their texture
and color and that there are so many different ways you can cook them. Often
I'll add something blue to a shrimp photograph to balance out the bright reds,
and with this dish I did so with a light-blue placemat. I also added
several splashes of green and yellow in the scene, bringing
all of the colors together to create a nice balance.

Canon 7D
ISO 100
1/20 sec.
f/8
70–200mm lens

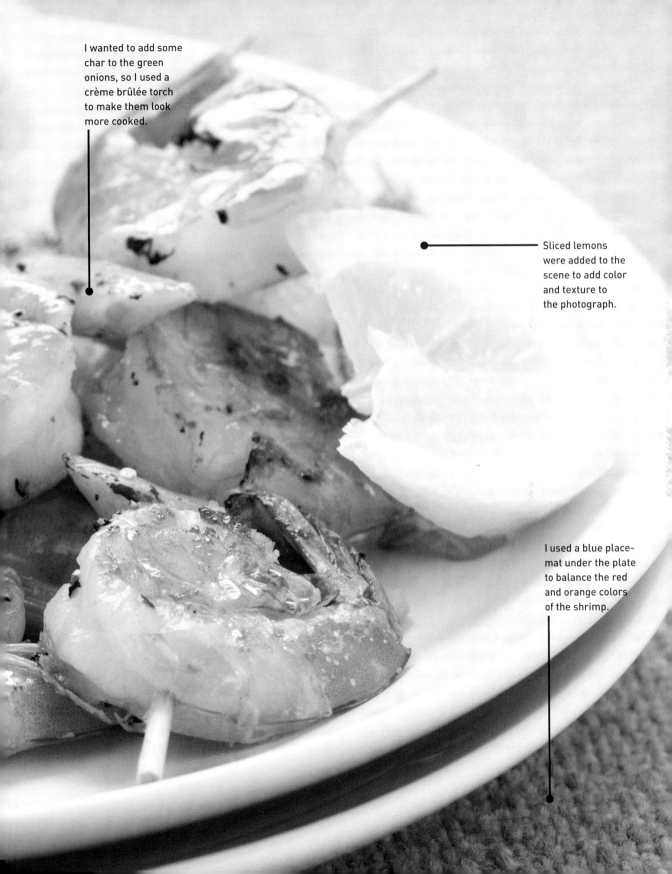

I wanted to add some char to the green onions, so I used a crème brûlée torch to make them look more cooked.

Sliced lemons were added to the scene to add color and texture to the photograph.

I used a blue place-mat under the plate to balance the red and orange colors of the shrimp.

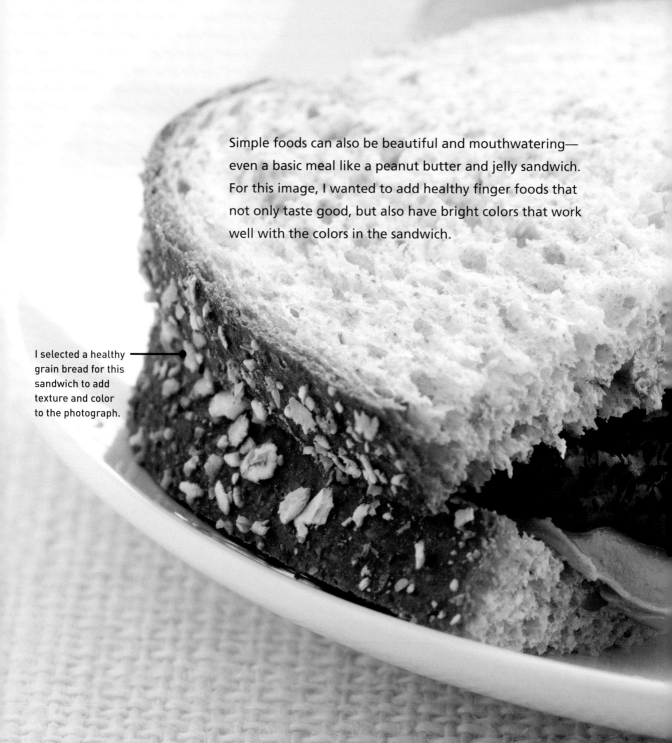

PORING OVER THE PICTURE

Simple foods can also be beautiful and mouthwatering—
even a basic meal like a peanut butter and jelly sandwich.
For this image, I wanted to add healthy finger foods that
not only taste good, but also have bright colors that work
well with the colors in the sandwich.

I selected a healthy
grain bread for this
sandwich to add
texture and color
to the photograph.

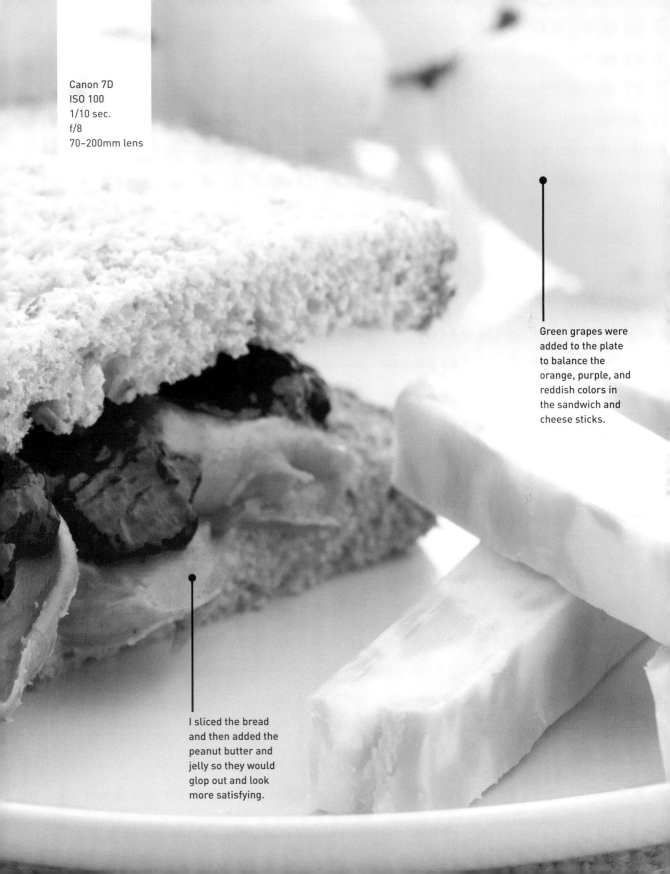

Canon 7D
ISO 100
1/10 sec.
f/8
70–200mm lens

Green grapes were added to the plate to balance the orange, purple, and reddish colors in the sandwich and cheese sticks.

I sliced the bread and then added the peanut butter and jelly so they would glop out and look more satisfying.

FINDING BALANCE

There are really no solid rules when it comes to photography as a whole, but there are standard techniques you can apply to a photograph to make it more attractive. When I photograph food, I am always trying to find balance—this can be with the placement of items within the frame, the angle of my lens, the distance I photograph from, and so on. Here are a few basic guidelines that will work for many food photographs.

Canon 7D
ISO 100
1/30 sec.
f/5.6
70–200mm lens

THE RULE OF THIRDS

One way to balance an image is to position a main focal point on a "third-line" in the frame. The "rule of thirds" is a basic composition principle that exists in all forms of art, and using it can often result in a pleasing, well-balanced image. To picture what the rule of thirds is, imagine a tic-tac-toe grid placed over your image. "Proper" placement of your subject would be along any of the lines in the image (**Figure 5.1**) or on any of the four intersecting points within the frame (**Figure 5.2**).

Now, this doesn't mean that putting the food in the middle of the frame won't look good (**Figure 5.3**). Symmetry—as well as asymmetry—can also be beautiful. There is no right or wrong way to compose a photograph, but there are always ways that will make a specific subject or setup look better. Since all photos are unique, it's a good idea to experiment with your subject to see what type of framing works best.

FIGURE 5.1
I placed the focus point along the lower third-line of this photograph.

Canon 5D Mark II
ISO 100
1/8 sec.
f/8
70–200mm lens

FIGURE 5.2
The focus point
was along the left
side of the photo,
ultimately ending
on the upper-left
intersecting line
on the grid.

FIGURE 5.3
Sometimes plac-
ing your subject
in the center of
the frame can
result in a pleas-
ing composition.

Canon 5D Mark II
ISO 100
1/60 sec.
f/5.6
50mm lens

BACKGROUND & FOREGROUND

When composing your food photographs, don't forget to pay careful attention to the background and foreground elements. Items that are not featured or in focus within the photograph can still have a significant impact, so it's important that you are aware of them. You not only want these items to look good; you also want to make sure that their placement is appropriate and pleasing.

When placing the background or foreground elements in your photograph, one thing to pay attention to is *where* these items are going out of the frame. I will often move things around so that they are positioned in the corners of the image (**Figure 5.4**). I find that this gives balance to the main subject without drawing too much attention to the background.

FIGURE 5.4
I positioned the glass of milk in the upper-left corner of the frame to balance out the photograph.

Canon 5D Mark II
ISO 100
1/30 sec.
f/5.6
70–200mm lens

USING TRIANGLES

Finding or adding triangles in a scene is another very simple way to add balance to a food photograph. This doesn't mean that you are actually adding triangle-shaped items to your image, but that you are placing elements within the frame so that they form a triangle shape when you "connect the dots." This is easy to do when styling your food, such as with a garnish, or even with the number of objects you are photographing, like muffins or pieces of fruit. You can even deliberately place small items, or even crumbs and drips, on a plate to create subtle triangle shapes in your photograph.

The reason that triangles are pleasing in an image, regardless of how subtle they are, is that they keep the viewer's eyes on the photo, since in following a triangle with their eyes, they are basically circling around the image, looking at all the elements. In **Figure 5.5** the basil leaves are the boldest color, so a person's eyes will probably be drawn to that part of the image first. By following their eyes from one basil leaf to another, they are "fooled" into looking at the entire photo.

Canon 7D
ISO 100
1/15 sec.
f/5.6
24–105mm lens

FIGURE 5.5

The basil leaves in the pasta create a triangle shape when you connect them, which balances the dish and keeps the viewer's eyes on the subject.

PERSPECTIVE & FRAMING

Sometimes a well-lit scene and beautifully styled dish just aren't enough—finding the best position from which to photograph your food can make a big impact on the look and feel of the image.

VERTICAL AND HORIZONTAL

There are two ways you can frame your photograph: vertically or horizontally. Most types of foods photograph well both ways, especially if you're photographing something on a plate or in a bowl (**Figure 5.6**). I experiment with different framing positions for my images and usually end up finding several ways to photograph one setup.

Canon 5D Mark II
ISO 100
1/50 sec.
f/5.6
70–200mm lens

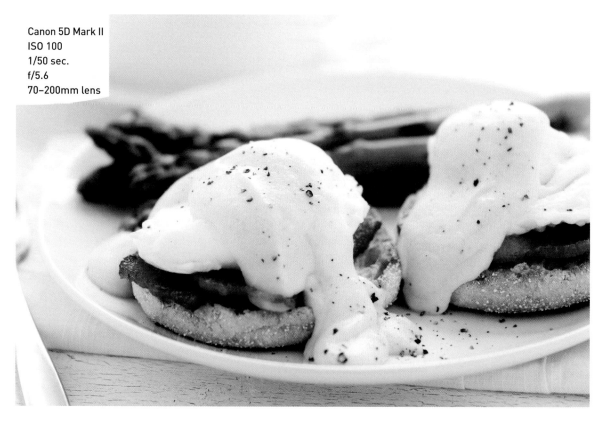

FIGURE 5.6
This setup of eggs Benedict allowed me to photograph the scene both vertically and horizontally.

Canon 5D Mark II
ISO 100
1/50 sec.
f/5.6
70–200mm lens

FIGURE 5.7
The height of this
cup of tapioca
pudding made
photographing
it vertically the
best option.

Canon 5D Mark II
ISO 100
1/30 sec.
f/4
70–200mm lens

As a general rule, if I'm photographing something really tall it will end up being vertical (**Figure 5.7**). And if I'm photographing something wide and want to capture the entire object, I'll photograph it horizontally (**Figure 5.8**). Yet there may be times when you need to break the rules (perhaps when photographing for a cookbook or magazine) and frame your food a specific way. This is when you'll have to get creative with your perspective, positioning, and maybe even styling to ensure a working setup for the framing of the final output.

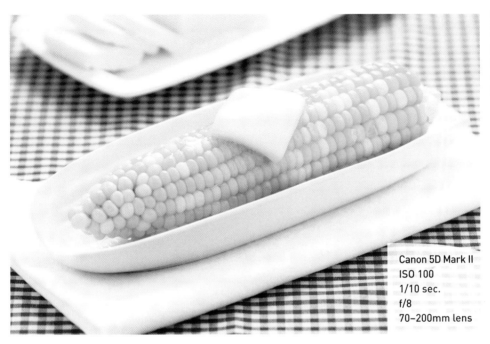

FIGURE 5.8
In order to photograph the entire length of the corncob, I photographed it horizontally.

Canon 5D Mark II
ISO 100
1/10 sec.
f/8
70–200mm lens

THREE-QUARTERS & LEVEL

The three-quarters angle is a very pleasing one for food. It's similar to looking down at food from the same angle you would if you were about to eat it, which is probably why I use this perspective a lot—I find that it showcases the food well. Using a three-quarters angle is almost necessary with food inside a bowl, or for any kind of dish that has depth, because you want to be sure that the food is visible, and by partially looking down on the dish you can see it clearly (**Figure 5.9**).

Another technique you can use is to position yourself at eye level to the table. This angle works best when photographing very tall food items, and I will almost always use this when I photograph beverages, since I want to showcase the height of the glass.

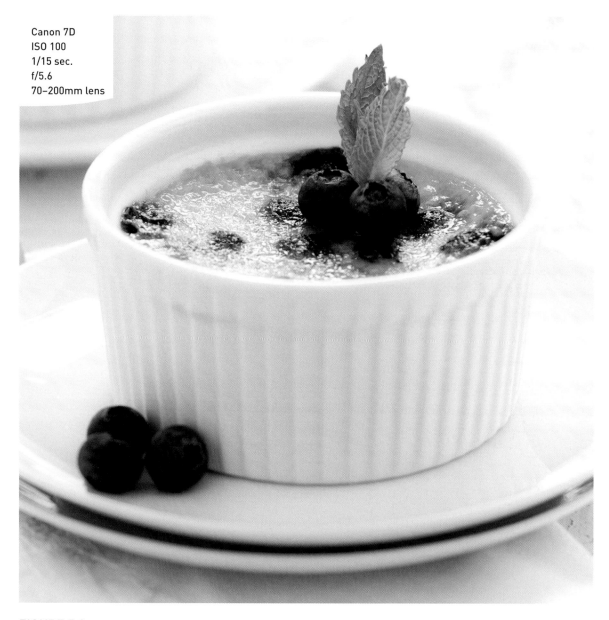

Canon 7D
ISO 100
1/15 sec.
f/5.6
70–200mm lens

FIGURE 5.9
Photographing this ramekin of crème brûlée at a three-quarters
angle allows you to see the food inside the dish.

OVERHEAD VIEW

Using an overhead view, or photographing straight down on your subject, is a good angle if you want to show a lot of things at once, like all the ingredients for a dish or one of the steps of a recipe. This also works well with items that are short, since having very little distance between the tops of your food and the other items means you're more likely to have everything in focus, even at a wide aperture (**Figure 5.10**).

Canon 5D Mark II
ISO 100
1/50 sec.
f/4
50mm lens

FIGURE 5.10
Even though I used a wide aperture for this photograph (*f*/4), the depth of field is still great enough to show focus and detail in the entire image, because there is little distance between the top of the food and the tabletop.

USING POINT OF VIEW TO YOUR ADVANTAGE

The point of view in a photograph can really make an image unique. It can hide unnecessary details or background elements, reveal characteristics of the subject, and highlight certain aspects of the food. Just by slightly changing your angle, you can crop out walls, reflectors, lights, parts of the background, and so on (**Figures 5.11** and **5.12**). Through point of view, you can also add your own vision and style to a photograph.

FIGURE 5.11

In this photograph, because of the angle, you can see the top edge of the napkin that the plate of pasta is sitting on.

Canon 5D Mark II
ISO 100
1/15 sec.
f/5.6
70–200mm lens

Canon 5D Mark II
ISO 100
1/15 sec.
f/5.6
70–200mm lens

FOCAL LENGTH, LENS COMPRESSION, & DEPTH OF FIELD

The choices you make regarding gear, settings, and so on have a great impact on the composition of an image. One of these choices is focal length, since the lenses you choose affect the look of the background elements of your photographs. Keep on reading to learn how you can alter the composition and compress the background of an image just by changing your focal length.

WHAT IS LENS COMPRESSION?

Lens compression is a way of distorting an image so that objects that are located behind or in front of the main focal point appear to be closer and larger than they really are. But don't let the word "distortion" scare you away. It doesn't distort the actual subject you're photographing, like a wide-angle lens would, but rather it affects the background and foreground of your images by bringing them closer to the main subject. Adding compression to food photographs is something I do all the time, and it's actually one of my favorite techniques in photography.

WHY FOCAL LENGTH MATTERS

The focal length of your lens makes a big difference in the amount of lens compression you will see in a photograph. Basically, the longer the lens is, the more compression you can introduce.

As you can see in the overhead photo (**Figure 5.13**), I positioned the items in a line so that there is 1 foot between each one and the next, for a total distance of 2 feet between the apple and the orange. In **Figure 5.14**, I photographed the same setup at four different focal lengths—28mm, 50mm, 100mm, and 200mm. The aperture for each photograph is set to f/16 so you can see the difference in the depth of field between the four focal lengths. The orange in the photo taken at 28mm is very small compared to the orange in the photo taken at 200mm. You can also see how the foreground (the table) in the photo appears to get closer to the apple as the length of the lens increases.

FIGURE 5.13
This is the setup for Figure 5.14.

Canon 5D Mark II
ISO 100
1/40 sec.
f/8
50mm lens

1 ft 1 ft

28mm

Canon 5D Mark II
ISO 100
0.4 sec. at f/16
28mm lens

50mm

Canon 5D Mark II
ISO 100
0.4 sec. at f/16
50mm lens

FIGURE 5.14
There is a total of two feet between the apple and the orange, and each piece of fruit remained in this exact position for each of these photos.

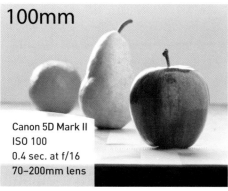

100mm

Canon 5D Mark II
ISO 100
0.4 sec. at f/16
70–200mm lens

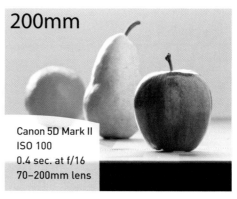

200mm

Canon 5D Mark II
ISO 100
0.4 sec. at f/16
70–200mm lens

You can also use lens compression to add creative flair to a photograph. When you introduce compression to an image, you can significantly decrease the depth of field, giving you a softer bokeh and beautifully out-of-focus background (**Figure 5.15**). The easiest way to compress and blur the background in your images is to use a long focal length coupled with a somewhat wide aperture (**Figure 5.16**). You should place a good amount of distance between the camera and the subject, and between the subject and its background, if you want to decrease your depth of field as much as possible.

FIGURE 5.15
I used a long focal length (200mm) and a wide aperture (f/4) to achieve a very blurred background with circular bokeh.

Canon 7D
ISO 100
1/40 sec.
f/4
70–200mm lens

f/4

Canon 7D
ISO 100
1/30 sec.
f/4
70–200mm lens

FIGURE 5.16

These photographs show how the background of an image can drastically change just by using a different aperture setting. For the background of these photographs, I used Christmas lights over a piece of orange cloth. In the wider apertures the small lights seemed to be very large, but as the aperture gets smaller you can start to see the details of the lights more clearly.

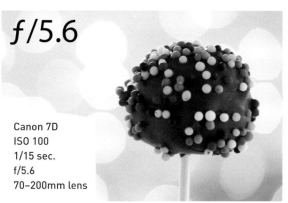

f/5.6

Canon 7D
ISO 100
1/15 sec.
f/5.6
70–200mm lens

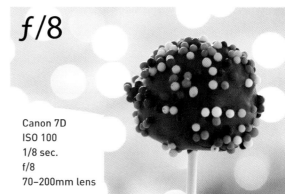

f/8

Canon 7D
ISO 100
1/8 sec.
f/8
70–200mm lens

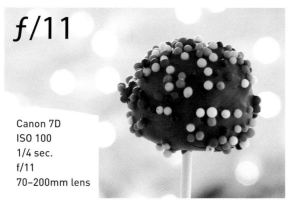

f/11

Canon 7D
ISO 100
1/4 sec.
f/11
70–200mm lens

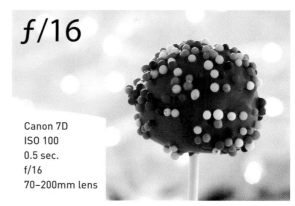

f/16

Canon 7D
ISO 100
0.5 sec.
f/16
70–200mm lens

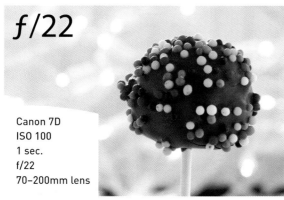

f/22

Canon 7D
ISO 100
1 sec.
f/22
70–200mm lens

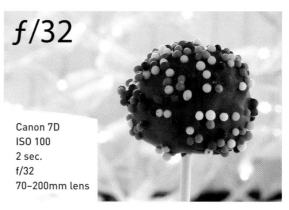

f/32

Canon 7D
ISO 100
2 sec.
f/32
70–200mm lens

FOCUS

Focus is a very important element in photography, yet with food photography it can be tricky to know exactly *where* to focus your lens. This is even more critical to grasp if you are using a wide aperture with a shallow depth of field, since much of the photograph will be out of focus, and the spot that is in focus will stand out even more. In this section I discuss how to determine where to place your focus point, along with some tips and tricks for focusing your lens to get very sharp, well-focused images.

FINDING THE BEST FOCUS POINT

It can be a challenge to decide where to put the focus point in your image. Often the best placement for focus is on one of the intersecting points of the rule of thirds, but this will vary from photo to photo. Some subjects will be trickier than others, so the best advice I can give is to try a few different placements, and then take a look at the photos to see which focus point works best. Viewing the image on a computer, or even on the LCD monitor on your camera, can help determine where the focus should be placed. Basically, if you're looking at your photo and your eyes are drawn to a certain point, that's probably where the focus should be.

Another general rule to follow is to focus on something in the photo that is close to you, as opposed to far away or in the middle of the dish. Even if there is a giant garnish on the top of a dish that really stands out, it might be the smaller garnish toward the front that our eyes are drawn to first (**Figures 5.17** and **5.18**). When I'm styling my food, I usually place a garnish deliberately as a specific point of focus and take a few photos with the focus on different areas around the dish just to make sure I have a nice, in-focus image that doesn't create too much tension for the viewer.

Canon 5D Mark II
ISO 100
1/30 sec.
f/8
70–200mm lens

Canon 5D Mark II
ISO 100
1/30 sec.
f/8
70–200mm lens

FIGURE 5.17
The focus for this image was placed on the basil garnish at the top of the dish.

FIGURE 5.18
The focus for this image was placed on the basil garnish in the front of the dish, nearest to the camera.

FOCUSING TIPS AND TRICKS

When I'm using a tripod to photograph food, I always use the Live View feature on my camera. This not only allows me to compose the image well; it also lets me zoom in to an area and focus on that specific spot. I also use manual focusing when on a tripod, because it allows me the most control.

Another thing you can do is tether your camera to a computer to ensure proper focus (one of the many advantages of tethering). This allows you to preview your images in full resolution, and when you view a photo on a larger screen you usually get a better feel for where your focus should be, so you can adjust it accordingly. On several occasions, I've finished photographing a dish, imported the images to my computer, and then discovered (much too late) that, while the image was in focus, I chose the wrong spot to focus on.

TETHERING TO A COMPUTER

If you have a laptop, or your main computer is near the location you photograph your food, then you should be able to tether your camera quite easily. Here's what you'll need to tether your camera to a computer:

- **USB interface cable:** This usually comes standard with most DSLRs, or you can find one at any store that sells electronics. It's a good idea to get a long cable so you can set up your computer at a comfortable distance from your camera.

- **Tethering software:** If your camera came with software, then you probably already have software you can use to tether your camera to your computer. There are also third-party options, one of my favorites being Adobe Photoshop Lightroom. This software works mainly with Canon and Nikon cameras, but it's a great alternative to the camera-brand-specific software, and it's very easy to use.

SHAPES, LINES, & COLORS

The shapes and colors of the elements in your photograph are just as important as the food itself. Being selective and aware of the types of dishes, napkins, garnishes, and tabletops you use, along with the framing of your scene, can help improve the overall look of your food photograph.

SHAPES

Paying close attention to the shapes in your image can help with your composition. This is one reason that I prefer to use circular plates for most of my dishes (**Figure 5.19**). I like the way the plate curves near the corners of an image, and you can more easily frame and compose your photos when you don't have to avoid the harsh corners of square plates and bowls.

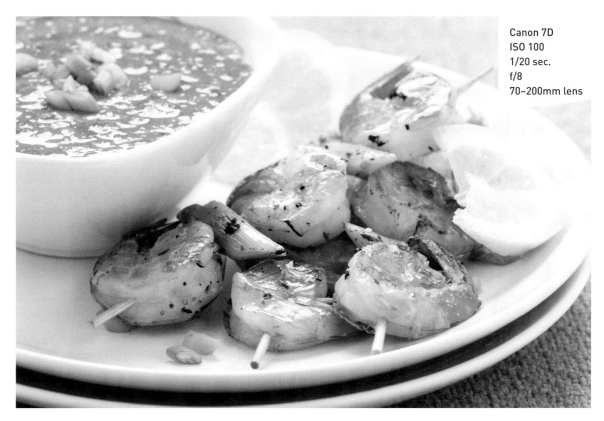

Canon 7D
ISO 100
1/20 sec.
f/8
70–200mm lens

FIGURE 5.19
I use circular plates and dishes in many of my photographs.

Canon 7D
ISO 100
1/60 sec.
f/4
70–200mm lens

FIGURE 5.20
I intentionally used many different circles in this photo of a cake pop.

Using repeating shapes in an image is another good way to bring the photo together. In **Figure 5.20**, I created a cake pop, which is a cake molded into a small ball, placed onto a lollipop stick, dipped in chocolate, and then decorated with circle-shaped sprinkles. I hung up Christmas tree lights in the background, and I used a very wide aperture to blur the lights so that the bokeh was enlarged and resembled large circles.

LINES AND CORNERS

As I mentioned earlier in the chapter, placing elements in the corners of your images can help with the balance of the photograph. Watch for lines in your images and for where they point and lead. It's a good idea to point these lines toward the corners of the dish. Lines may be created by the food, the silverware, or even the tabletop or background elements (**Figure 5.21**).

FIGURE 5.21
I angled the camera
so that the lines of
the tabletop
angled toward
the corners of
the image.

Canon 7D
ISO 100
1/160 sec.
f/5.6
70–200mm lens

BRIGHT COLORS

When we look at a photograph, our eyes are attracted to the brightest parts of the image first, and then they navigate throughout the rest of the photo. When you're photographing food, you probably have a main subject that you want to highlight, so it's important to set up your photo so that your viewer's eyes go straight toward the food and are not distracted by anything else.

Here's an example to explain my point. I cooked and photographed a very simple-looking dish, blueberry crème brûlée, and used white ramekins and plates for the dishes. Because this food has a lot of whites and soft yellows, it might be tempting to add color to other parts of the scene, such as with a brightly colored napkin (**Figure 5.22**). However, the napkin is so bright that it draws too much attention, leaving the food (the main subject) secondary. By replacing the bright napkin with a subtle, white napkin, you make the food the highlight of the photograph. Now the green mint garnish and the yellows of the crème brûlée stand out among the whites of the rest of the photograph (**Figure 5.23**).

Canon 7D
ISO 100
1/15 sec.
f/5.6
70–200mm lens

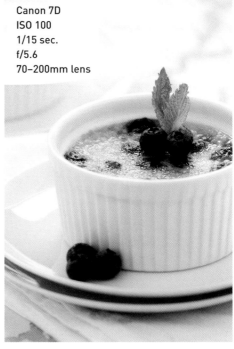

Canon 7D
ISO 100
1/15 sec.
f/5.6
70–200mm lens

FIGURE 5.22
The pink napkin is too bright for this setup and distracts from the main subject.

FIGURE 5.23
Using a neutral-colored napkin under the ramekin draws more attention to the yellow and purple in the crème brûlée.

COMPLEMENTARY COLORS

If you have a photograph in which the colors weigh heavily to one color group and it looks like it still "needs something," a good way to balance it out is to add a complementary color to the scene. A complementary color is one that sits opposite a given color on a standard color wheel (**Figure 5.24**). Using these opposite colors, even in very small quantity, can liven up a photo and make it "pop" (**Figure 5.25**).

You don't have to stick to the exact opposite color on the color wheel—staying within a general color group is a good guideline. You also don't even need to follow this at all. Using a contrasting color in your food image is usually best when the image looks unbalanced, with one dominant color.

FIGURE 5.24
A color wheel is a useful tool when you want to add color to a photograph.

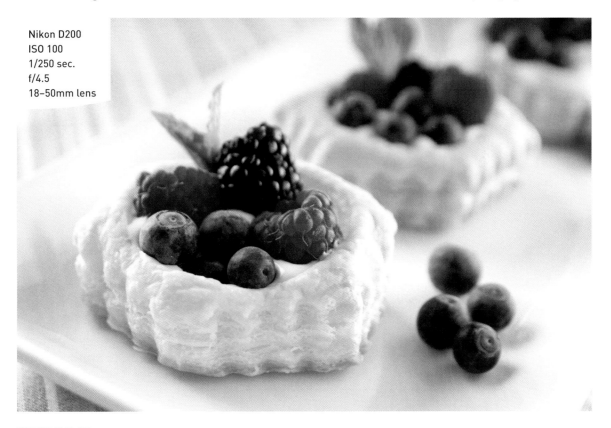

Nikon D200
ISO 100
1/250 sec.
f/4.5
18–50mm lens

FIGURE 5.25
In order to balance out the pinks and purples in this photograph, I added small mint garnishes to the top of each fruit tart.

REPEATING COLORS

There might be times when you want to exaggerate the colors of your dish by adding items of the same color around it. This could be done with silverware, tabletops, napkins, drinks, garnishes in the dish, and so on. In **Figure 5.26**, I chose to enhance the greens of the pesto pasta with green basil and a green napkin to bring it all together. The white plate helps balance it out (I don't think I would have used green dishes), but other than that and the pine nuts, there aren't really any other bright colors in this image.

FIGURE 5.26
I wanted to enhance the greens in this pesto dish by using a green napkin under the plate and adding a fresh basil garnish to the top of the pasta.

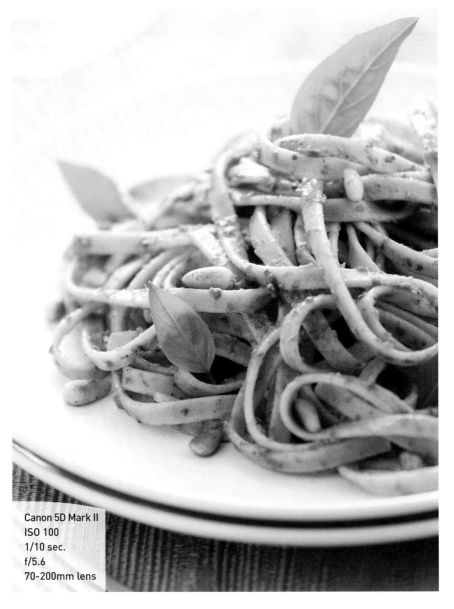

Canon 5D Mark II
ISO 100
1/10 sec.
f/5.6
70-200mm lens

Chapter 5 Challenges

Once you have a basic understanding of why an image looks good, you can apply that to your own photographs. Using different angles, shapes, and colors in your food images can enhance an already tasty-looking dish. Here are a few challenges to help you get started.

Finding and Creating Triangles

Cook up some food to photograph. As you are styling it, try to find triangle shapes while looking at the image in the camera's viewfinder. If you can't find any, use garnish, drips, crumbs, or any other elements in the scene to create triangles. Try taking before-and-after photographs of your setup with and without triangles to see which one is more appealing.

Framing and Using Different Perspectives

Set up a plate of food and photograph it both vertically and horizontally, regardless of your subject. Move things and position them on the table so that they look best for each setup. See which one you like best.

Next, photograph the same setup from three different perspectives: overhead, three-quarters, and eye level. Feel free to move the food or other items around to create balance. Watch how the background changes as you change your position, and how each perspective changes the overall feel of the photograph.

Using Lens Compression on an Image

If you have lenses of varying focal lengths, try creating your own versions of the compression examples I showed in Figure 5.16. Find two or more different items, place them on a table, and photograph them with different lenses (it's a good idea to use a tripod for this challenge). Try to keep the frontmost item the same size in the frame for each photo, which will require you to move your position forward or backward, depending on which lens you are using. Also, try keeping the aperture the same for each photograph so you can see how each focal length affects depth of field.

Playing with Color

Create a dish that has one dominant color, use the color wheel to find its complementary color, and then place something with that complementary color into the scene. Some examples of this would be adding cherry tomatoes to a green leafy salad, using a blue background or napkin with cooked shrimp, or placing a sprig of mint on a strawberry dessert.

Share your results with the book's Flickr group!

Join the group here: flickr.com/groups/foodphotographyfromsnapshotstogreatshots/

6

Canon 7D
ISO 100
1/30 sec.
f/4
24–105mm lens

Processing Images with Adobe® Photoshop®

BRINGING OUT THE BEST IN YOUR PHOTOGRAPHS

As digital photographers, we cannot avoid processing, or editing, our photos. The good thing is that when editing food photographs, you usually won't use a lot of "flair" or crazy, off-the-wall editing techniques. My philosophy is to keep my photographs clean and make them look like they were not edited. Ironically, extensive editing can sometimes make a photo look as if it hadn't been edited, but I usually use simple, basic techniques that I apply subtly.

While this entire chapter is about editing, and I included as much information as I could, this is not an all-encompassing lesson on Adobe Photoshop. It does, however, cover many of the basics specific to editing food photographs. There is no right way to edit any given image, but by using the techniques in this chapter you will be off to a good start in developing your own style and overall editing workflow.

ADOBE CAMERA RAW®

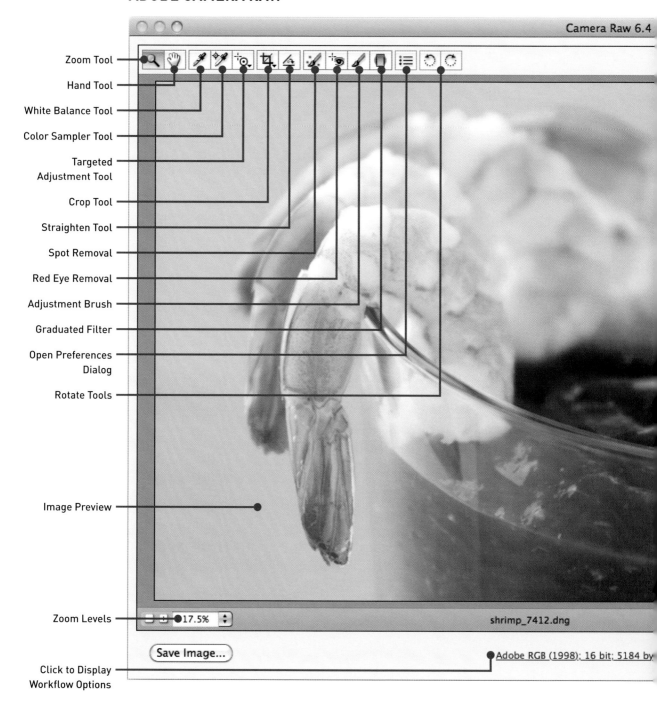

Camera Raw 6.4

Zoom Tool

Hand Tool

White Balance Tool

Color Sampler Tool

Targeted
Adjustment Tool

Crop Tool

Straighten Tool

Spot Removal

Red Eye Removal

Adjustment Brush

Graduated Filter

Open Preferences
Dialog

Rotate Tools

Image Preview

Zoom Levels

17.5%

shrimp_7412.dng

Save Image...

Adobe RGB (1998); 16 bit; 5184 by

Click to Display
Workflow Options

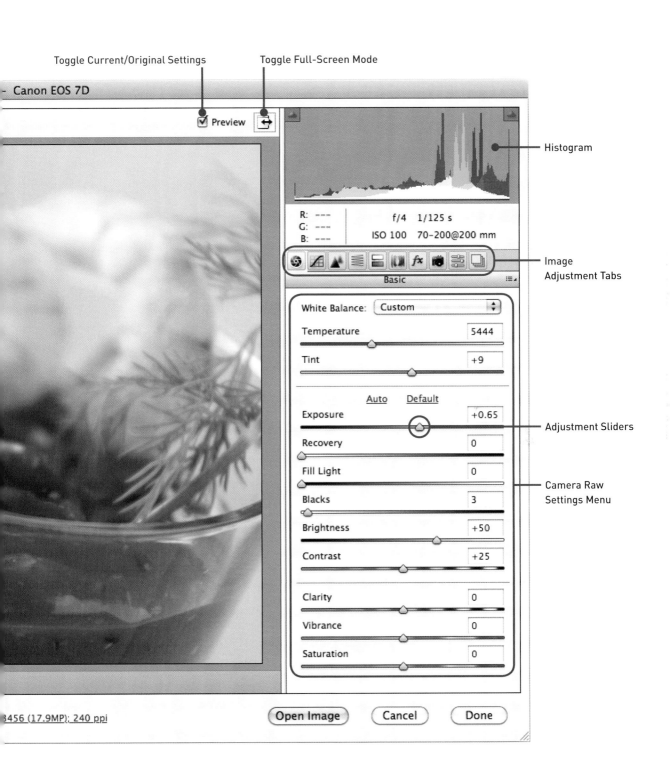

Toggle Current/Original Settings

Toggle Full-Screen Mode

Canon EOS 7D

☑ Preview

Histogram

R: ---
G: ---
B: ---

f/4 1/125 s
ISO 100 70–200@200 mm

Image Adjustment Tabs

Basic

White Balance: Custom

Temperature 5444

Tint +9

Auto Default

Exposure +0.65 ← Adjustment Sliders

Recovery 0

Fill Light 0

Blacks 3 ← Camera Raw Settings Menu

Brightness +50

Contrast +25

Clarity 0

Vibrance 0

Saturation 0

3456 (17.9MP); 240 ppi

Open Image Cancel Done

PORING OVER ADOBE PHOTOSHOP

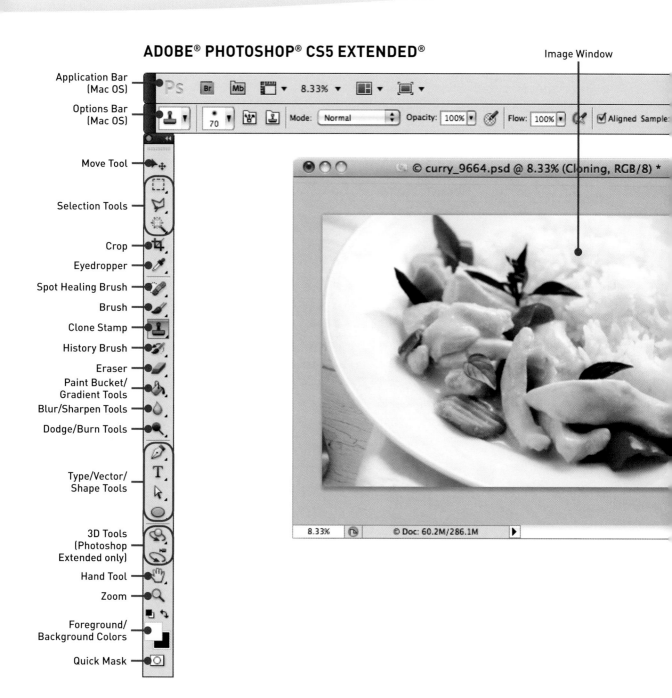

ADOBE® PHOTOSHOP® CS5 EXTENDED®

Image Window

Application Bar (Mac OS)

Options Bar (Mac OS)

Move Tool

Selection Tools

Crop

Eyedropper

Spot Healing Brush

Brush

Clone Stamp

History Brush

Eraser

Paint Bucket/ Gradient Tools

Blur/Sharpen Tools

Dodge/Burn Tools

Type/Vector/ Shape Tools

3D Tools (Photoshop Extended only)

Hand Tool

Zoom

Foreground/ Background Colors

Quick Mask

Ps Br Mb 8.33% ▼

Mode: Normal Opacity: 100% Flow: 100% ☑ Aligned Sample:

© curry_9664.psd @ 8.33% (Cloning, RGB/8) *

8.33% © Doc: 60.2M/286.1M

Layers Panel

ESSENTIALS DESIGN PAINTING PHOTOGRAPHY » CS Live ▾

Current & Below

LAYERS CHANNELS PATHS

Normal Opacity: 100%

Lock: 🔲 🖌 ✛ 🔒 Fill: 100%

👁 Color pop

👁 HP Sharpening

👁 CA

👁 dodge/burn

👁 Luminosity

👁 Color

👁 **Cloning**

👁 *Background*

🔗 fx. 🔲 ●. 📁 📄 🗑

NAVIGATOR INFO → Navigator Panel

8.33%

HISTOGRAM → Histogram Panel

ADJUSTMENTS MASKS → Adjustments Panel

Add an adjustment

Levels Presets
Curves Presets
Exposure Presets
Hue/Saturation Presets
Black & White Presets
Channel Mixer Presets
Selective Color Presets

HISTORY → History Panel

curry_9664.psd

Open

GETTING STARTED

Before you jump in to editing your photos, there are a couple of things that you'll want to understand to make the editing process easier—monitor calibration and photo-editing software.

CALIBRATING YOUR MONITOR

If you plan to share your photos on the Internet or through any type of computer interface, a color-calibrated monitor is essential to ensuring proper colors in your images. When you calibrate your monitor, you are setting up your screen so that it looks as balanced as possible. So if you edit a photo on your computer and post it on the Internet, other people looking at it on calibrated monitors will see identical colors and brightness in the image.

If you don't calibrate your monitor, you run the risk of colors or brightness skewing to one side of the spectrum. Things might appear normal on *your* screen, but they won't look the same on other computers.

The best way to avoid this is to use a display calibration device, which is a piece of hardware that plugs in to your computer. You run its software and it makes all of the adjustments for you (**Figure 6.1**). There are many different brands out there, with different levels of calibration, but you don't need to spend a lot of money to get one that works well. If you're serious about photography, it is a necessary investment.

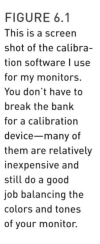

FIGURE 6.1
This is a screen shot of the calibration software I use for my monitors. You don't have to break the bank for a calibration device—many of them are relatively inexpensive and still do a good job balancing the colors and tones of your monitor.

PHOTO-EDITING SOFTWARE

There are a few big players when it comes to editing photos on a computer. The biggest one, and the one that will be demonstrated in this chapter, is Adobe Photoshop. Photoshop offers an enormous number of features and a lot of flexibility, and it allows you to do nearly anything you can imagine with a photograph. Photoshop is a pixel editor, meaning you can manipulate and change pixels, use layers, adjust specific parts of an image, change sizes, create composites…the list goes on and on. I use Photoshop nearly every day in my work, sometimes for simple, repetitive tasks, but also to get deep into the details of a photo and do some serious editing.

Other programs that you might be familiar with are specific to editing and organizing RAW files. The two big ones are Adobe® Photoshop® Lightroom® and Apple® Aperture®. These software programs allow you to edit and export your RAW files so they can be viewed in other forms, such as JPEGs for use on a Web site. In this chapter I'll be doing the RAW editing in Adobe Camera Raw (also known as ACR), a program that runs within Adobe Photoshop. Camera Raw has many of the same features and functions as Lightroom and Aperture, so by learning the techniques in this book, you should be able to transition to either of those programs with little difficulty if you choose to use them for your RAW editing.

A NOTE TO ADOBE® PHOTOSHOP® ELEMENTS USERS

Adobe also offers a scaled-down, less expensive version of Adobe Photoshop called Adobe Photoshop Elements. This software has some of the basic features of Photoshop and allows you to edit photos easily without having to spend a lot of money on photo-editing software.

Throughout this chapter, Adobe Photoshop CS5 Extended is used, but in many cases you can also achieve the same results using Elements. For a few techniques in this book, you won't be able to fully re-create the effects using Elements—for instance, when working with the "Blend If" section in Layer Styles and for a few techniques in Camera Raw. To make things simpler for you, I've added the icon (**PE**) next to the sections that are compatible with the Adobe Photoshop Elements software. Some of the specifics of the steps might be different (such as menu locations and keyboard shortcuts), but the end results are the same.

WORKING WITH RAW FILES

In Chapter 1, I discussed the differences between using RAW files and JPEGs when creating food photographs. One of the biggest advantages to using RAW files is the flexibility you have when editing your photos, but there is a small learning curve before you can take full advantage of photographing in the RAW format. This section will address those issues and show you how to edit RAW files using Adobe Camera Raw.

I won't get into every tab and adjustment setting in Camera Raw, just the basics that are key to editing most food photographs. These are the settings I use on a daily basis.

OPENING A FILE IN CAMERA RAW PE

Before you can start editing your images, you'll first need to know how to open RAW files (and even JPEGs) in Camera Raw using Adobe® Bridge.

STEP 1: ADOBE BRIDGE

Photoshop comes installed with a program called Adobe Bridge, which is at its core a way to view and organize your image files (similar to Finder in Mac, or Explorer in Windows). This program is integrated with Photoshop and Camera Raw so that they display image thumbnails properly. Bridge also allows you to interact with Photoshop more easily. To open Bridge, locate it on your computer and double-click to launch the application.

STEP 2: ADOBE CAMERA RAW

To open a RAW file in Camera Raw, select the image in Bridge and go to **File > Open**. RAW files should open in Camera Raw by default, so you could also simply double-click the file, or select it and press the Return or Enter key. Photoshop will launch, and you'll see your image appear in the Camera Raw window.

STEP 3: OPENING A JPEG IN CAMERA RAW

You can also use Camera Raw to edit JPEGs. You don't retain the same benefits of working with a RAW file, such as changing the white balance or limiting the damage to pixels when drastically changing settings, but you still have most of the same functionality.

To open a JPEG file in Camera Raw, click the JPEG to select it and then go to **File > Open in Camera Raw**. You can also right-click the JPEG and choose Open in Camera Raw from the context menu.

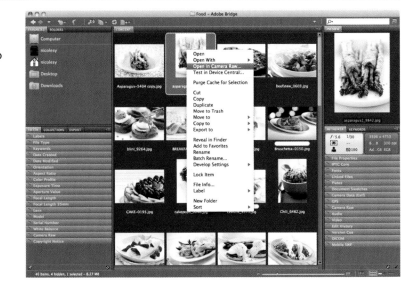

STEP 4: SETTING CAMERA RAW PREFERENCES

If the Open in Camera Raw setting is grayed out, go into the Camera Raw Preference settings and enable JPEG support.

ADJUSTING WHITE BALANCE PE

When you create a photograph, you select the white balance, or maybe you just set it to Auto. Either way, when you bring the image into Camera Raw it's likely that you'll want to make a few adjustments.

STEP 1: WHITE BALANCE SLIDERS

The white balance adjustments are located in the Basic tab in Camera Raw. There you'll see a drop-down menu where you can pick your color balance settings (similar to the settings in your camera), or you can set the color temperature and tint on your own using the sliders. The sliders give you a visual representation of the adjustments to your image. For example, if the photo looks too yellow, slide the Temperature slider to the left to add blue and balance those colors.

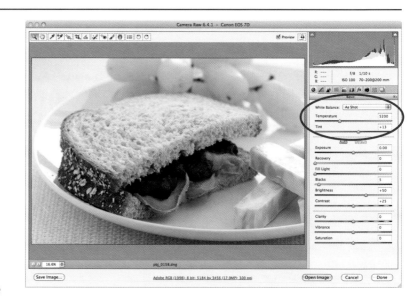

STEP 2: USING AUTO WHITE BALANCE

For food photographs, select the Auto setting from the White Balance drop-down menu. This will usually get you to a good starting place, and you can make small adjustments from there.

USING LIVE PREVIEW IN CAMERA RAW

When editing in Camera Raw, it's crucial that you watch the changes take place in your photo as you make them. To ensure that you are seeing a live preview of your photograph, select the Preview check box.

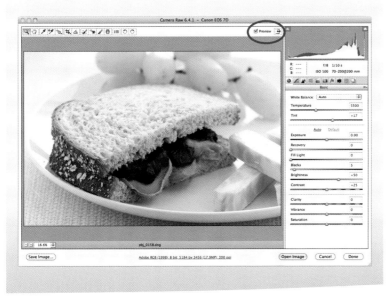

VIEWING CLIPPING WARNINGS IN ADOBE CAMERA RAW

Before getting started with basic adjustments, you need to check the clipping warnings that show which areas of a photograph contain pure whites and pure blacks.

STEP 1: VIEWING CLIPPING WARNINGS

The first thing you should do is click the triangles in the upper-right and upper-left corners of the histogram. This will show you the areas in your photograph that are clipped, meaning that the whites are pure white and the blacks are pure black. These clipped areas will be shown in the preview as colors—bright red for clipped whites, and bright blue for clipped blacks. When you click these triangles before editing, you probably won't see any changes, but if you move the Exposure slider to the right, you'll start seeing a bright red color appear in the overex-

posed areas of the photo. (Note that this color won't actually be in your photo; it's just an overlay to show you the areas of the photo that are clipped.)

STEP 2: WATCHING THE HISTOGRAM

You should also pay attention to the histogram itself. Notice that the histogram is pushed all the way to the right, showing that there are clipped whites in this photograph.

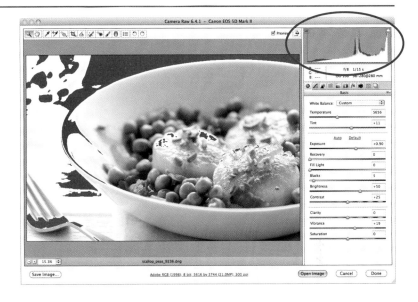

MAKING BASIC ADJUSTMENTS PE

The sliders beneath the white balance adjustments in the Basic tab are where most of the heavy editing takes place. In this section, I'll go through each of these settings from top to bottom.

STEP 1: OPENING A RAW FILE

Now that you are set up and ready, you can start adjusting the tones in your image. Each photo will need different levels of adjusting, so let's get familiar with each of the sliders. Start by opening a RAW file in Adobe Camera Raw.

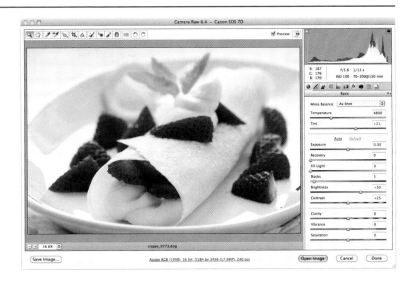

STEP 2: THE AUTO BUTTON

Before getting into the details of each of the sliders, a quick word of caution: Stay away from the Auto button. It tends to underexpose the image, so you're better off making the adjustments manually. With that said, it doesn't hurt to give it a try. If you don't like the results, you can always undo the changes by clicking Command+Z (Windows: Ctrl+Z).

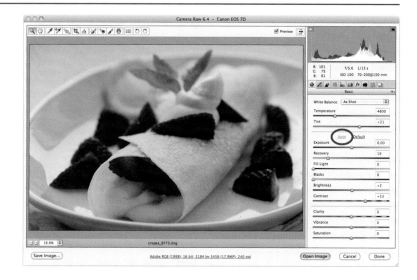

STEP 3: EXPOSURE

The Exposure slider adjusts the exposure of the image, making it brighter by sliding to the right, or darker by sliding to the left. It acts in the same way that your camera would if it overexposed or underexposed a photograph (each whole number on the slider acts as a "stop.") In this example, I increased the exposure by one-half f/stop.

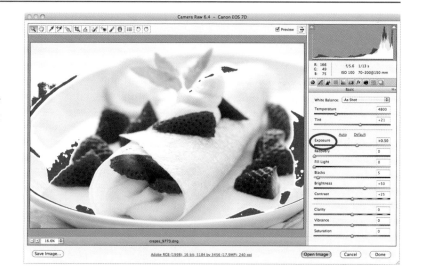

STEP 4: RECOVERY

The Recovery slider will recover detail in the image in areas that are overexposed. This is useful when your exposure is close to perfect, but a few spots in your image are clipped. Notice how moving the slider to the right makes many of the clipped whites disappear. My advice for this slider is to not push it too far to the right. Being too aggressive with it can add artifacts (ugly, blotchy pixels) to your photograph.

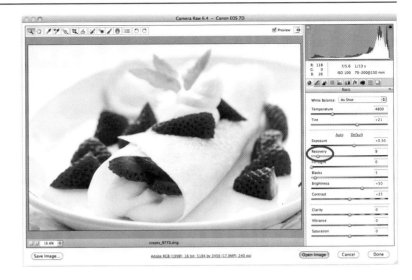

STEP 5: FILL LIGHT

The Fill Light slider adds soft light to the dark areas of the photo. This is similar to adding your own fill light while photographing, such as with a reflector or piece of white foam board.

STEP 6: BLACKS

The Blacks slider intensifies the black areas in the image and adds contrast.

STEP 7: BRIGHTNESS AND CONTRAST

The Brightness and Contrast sliders are self-explanatory. You can use these in conjunction with the other tonal adjustments, or you can stay away from the other sliders altogether and just play with these. They offer less control over the tones in the image but still do a pretty decent job of enhancing the tonal quality if you need to make only minor adjustments.

STEP 8: CLARITY

The Clarity slider adds a bit of contrast to the edges of an image, which enhances the image's texture and gives it the appearance of being sharpened.

STEP 9: VIBRANCE

The Vibrance slider is a subtle way to make the colors in your photograph pop, because it doesn't over-intensify them.

STEP 10: SATURATION

The Saturation slider boosts the saturation in your image, making the colors exaggerated and bold. You need to be careful with this adjustment and not push the slider too far to the right, because you could end up with clipped colors (as in this example).

THE ADJUSTMENT BRUSH

There may be times when you want to adjust specific areas of your image while still in Camera Raw. In these situations, the Adjustment Brush is an extremely useful tool.

STEP 1: THE ADJUSTMENT BRUSH TOOL

One of the drawbacks to some of the Camera Raw sliders is that they affect the entire image. If you want to localize an adjustment so it affects only a specific area in the image, the Adjustment Brush feature might be a good solution. You can access this tab by clicking the brush icon in the top part of the window or by using the keyboard shortcut **K**.

STEP 2: LOCALIZING ADJUSTMENTS

In this panel, you select your adjustment on the right and then paint with the brush wherever you want the adjustment to appear. In this example, I wanted to add some brightness to the jelly in the sandwich, so I increased the Exposure setting and painted over the jelly. Selecting the Auto Mask check box helps keep the adjustment within the area I am painting.

RESETTING YOUR ADJUSTMENTS PE

If you find that you want to start over with the settings you had when you opened the image in Camera Raw, all you have to do is hold down the Option key (Windows: Alt), and the Cancel button becomes a Reset button. Click Reset to clear out all recent changes made in Camera Raw.

SYNCING SETTINGS (AKA BATCH EDITING)

There may be times when you want to edit more than one RAW file using all of the same adjustment settings. This works well with a series of photographs of the same subject that were created in the same lighting. Here are the steps to syncing your settings using Bridge and Camera Raw.

STEP 1: OPENING MORE THAN ONE FILE IN BRIDGE

To get started, select the images you want to edit in Bridge and go to **File > Open** (or right-click, and select Open from the context menu).

SELECTING SEVERAL FILES IN BRIDGE

To select more than one file at a time, you can click one photo, hold down the Shift key, and then click another photo. Or, you can click one photo, hold down the Command (Windows: Ctrl) key, and click other individual files to select them.

STEP 2: SYNCHRONIZING FILES IN CAMERA RAW

When the Camera Raw window opens, you'll see a column of photos on the left. Start with the top image and apply the necessary adjustments. When you're finished editing the file, click the Select All button and then click Synchronize. Select the settings that you want to sync, and click OK. Now all of your images have the same RAW edits applied to them.

WORKFLOW OPTIONS

After you've completed your edits in Camera Raw, you'll need to open the file in Photoshop. Then you need to indicate what size and resolution (along with a few other settings) your image will be so that Photoshop will display it to correspond to your preferences. Here's how to make those changes.

STEP 1: SAVING CHANGES AND EXITING CAMERA RAW

If you've finished editing your RAW file and you want to continue editing the photo in Photoshop, click Open Image. Or, to save your settings and close the file, click Done. This will exit you out of Camera Raw into either Photoshop or Adobe Bridge.

STEP 2: CHANGING THE WORKFLOW OPTIONS

There are a few more settings that you may want to change before exiting Adobe Camera RAW. If you click the blue text below the image, you will be taken to a new window called Workflow Options. This section allows you to set the default color space, image size, and so on for all images you open and edit in Photoshop.

WORKFLOW OPTIONS SETTINGS

Space: This setting changes the color space in which you edit the image in Photoshop. Without getting too technical, the color space I recommend editing with (and use every day) is the AdobeRGB space. sRGB is another one you'll use, as it's the best color space to use for Web display, but not yet—it's best to edit your photos using a larger color space (like AdobeRGB) and then save a copy in a smaller space (like sRGB) when you are finished with the editing process.

Depth: Bit depth describes the number of colors a photo has. Digital photos contain millions of colors, most of which we can't see. For editing, the more colors in the photo, the more quality you will retain in that image. A 16-bit file contains more colors and will therefore retain more quality than an 8-bit file.

Does that mean that you should always use the 16-bit setting? Not necessarily. For my food photographs (and most of my other work), I use 8-bit. I'm not usually pushing the pixels too far beyond their capacity, and keeping the bit depth lower means a smaller file size, which also means that Photoshop will run faster and smoother.

Size: This is the overall pixel dimension of your photo. By default it is set to the native resolution of your photograph, and it's usually best to leave this setting alone.

Resolution: This setting determines the "pixels per inch/cm" of your photograph, and is mostly important when you print your image. The default is 240, which is a common print resolution. There is no need to change this default setting, since you can always lower it in Photoshop if you need to.

Sharpen For: This setting will apply sharpening to your photo upon export into Photoshop. Since we will be adding our own sharpening in Photoshop, there's no need to set this to anything other than None.

Smart Object: You can select this check box if you want your images to open as Smart Objects, allowing you to go back and re-edit the files in Camera Raw even after opening them in Photoshop.

PHOTOSHOP BASICS

Before I discuss some of the more complicated editing techniques, I'll need to cover the basics—the meat and potatoes, so to speak—of Photoshop. Once you grasp some of the simple concepts of editing, the rest is just piecing each of these small concepts together to create more elaborate, advanced techniques that can enhance your photos and save you a lot of time.

LAYERS `PE`

The ability to use layers is one of the most powerful features in Photoshop. Layers allow you to edit a photo nondestructively, meaning that you can keep the original image untouched when working on it but still make as many changes as you like.

STEP 1: THE LAYERS PANEL

If you're not familiar with how layers work, let's start by taking a look at a typical file of mine that's been edited in Photoshop. You can see that the Layers panel already contains several layers. (To view the Layers panel, go to **Window > Layers**.) Don't worry about what each layer in this example is right now—I'll get to that later in this chapter.

STEP 2: UNDERSTANDING LAYERS

To understand how each of these layers interacts with the image, imagine what the layers would look like if they were pieces of paper stacked on top of one another—in this example I'm using gray layers to represent each of the layers from the previous image. Each time you add a new layer, it is literally layered on top of the original image (which in most cases is called the *Background* layer).

WORK NONDESTRUCTIVELY BY USING LAYERS

When editing, you can work nondestructively with layers by retaining the Background layer intact. Doing this allows you to retrace your steps and make changes without affecting the original image. If you make a mistake, you can fix it without having to start all over with the RAW file.

MASKING PE

Masking is another powerful Photoshop feature. It may seem like a complicated concept to grasp at first, but once you understand how it works, you will discover how useful it can be.

STEP 1: INTRODUCTION TO MASKING

I'm starting with a very basic example. In the bottom layer (the *Background* layer) I have a photo of pasta, and to demonstrate how masking works I've added a new layer above it and filled it with the color blue. You can't see the pasta photo because the blue layer is hiding it.

STEP 2: ADDING A LAYER MASK

To add a mask to a layer, click the "Add layer mask" icon at the bottom of the Layers panel. A white box will appear next to your image in the Layers panel.

STEP 3: PAINTING WITH BLACK TO HIDE THE UNDERLYING LAYER

So, in this step I select the Brush tool (keyboard shortcut: **B**), set my foreground color to black, make sure the layer mask is selected (click the mask in the Layers panel to make it active), and then paint on the image.

STEP 4: PAINTING WITH WHITE TO REVEAL THE UNDERLYING LAYER

Now, nothing appears to have happened, and here's why. When you are using a layer mask you need to remember this simple phrase:

Black conceals, white reveals.

The entire layer mask you just added is white; therefore, it is *revealing* the entire layer. To hide certain parts of the image, all you have to do is add black to the layer mask.

Compare the image with the layer mask. Did you notice that the *Background* layer is showing through in the same area that the mask is painted black? If you make a mistake or paint an area with black unintentionally, it's a very simple fix. Just paint with white over the areas you want to recover. You will see the changes in both the mask and your image. You can paint with white and black as many times as you need to without losing image quality.

BLENDING MODES PE

Blending modes in Photoshop determine how a layer interacts with the layers below. All layers start out in the Normal blending mode, which means that there is no effect applied and you see the layer as is.

STEP 1: THE NORMAL BLENDING MODE

In this example, the bottom layer is a photograph of chicken curry, the top layer is filled with the color pink, and the blending mode is set to its default of Normal.

STEP 2: CHANGING THE BLENDING MODE TO COLOR

If you change the blending mode, you will immediately see a change in your photograph. In this example, I changed the blending mode of the top layer to Color, which tells the layer to blend only the *colors* of this layer through to the layer below. Because the top layer is filled with pink, it blends with the layer below, making the food look pink as well. Notice, however, that the *Background* layer in the Layers panel remains unchanged.

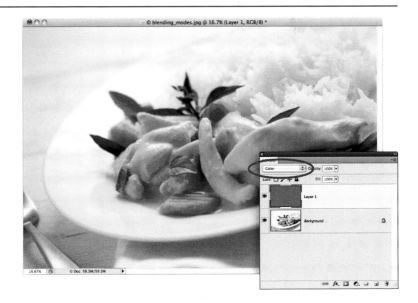

STEP 3: CYCLING THROUGH LAYER BLENDING MODES

Some of the blending modes are predictable, while others will give you unexpected results. The best way to see what they do is to experiment. You can cycle through all of the blend modes in the Layers panel quickly by using the keyboard shortcuts Shift++ (plus sign) and Shift+- (minus sign or hyphen). It's best to be in a "nonbrush" tool (such as

the Move tool or Crop tool) to use these keyboard shortcuts, or you will end up changing the blending modes of the *tool*, like you would with the Brush or Clone Stamp.

ADDING LEVELS ADJUSTMENT LAYERS PE

Making basic color and tonal adjustments in Photoshop is a very important skill to learn. Even if you make adjustments in Camera Raw, you still might need to make a few changes in Photoshop.

STEP 1: USING THE ADJUSTMENTS PANEL

There's an entire menu dedicated to making adjustments (**Image > Adjustments**), but in the spirit of keeping your images re-editable and nondestructive I'm going to use the Adjustments panel to edit the image with Adjustment Layers (**Window > Adjustments**).

STEP 2: ADDING A LEVELS ADJUSTMENT LAYER

This panel has a lot of different adjustments, but let's focus on the Levels adjustment. Click the "Create a new Levels Adjustment layer" icon in the Adjustments panel. A new layer appears above the previously selected layer, and the Adjustments panel changes so you can make adjustments on it.

STEP 3: EXPANDING THE VIEW OF THE ADJUSTMENTS PANEL

When I use Adjustment layers, I like to work with as large a panel as possible. By default, you'll see the Adjustments panel in "compact" view. To increase the size of the panel, select Expanded View from the drop-down menu in the upper-right corner.

STEP 4: INCREASING BRIGHTNESS WITH THE LEVELS ADJUSTMENT LAYER

To increase brightness in the image, move the white slider tab to the left.

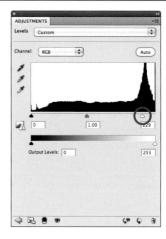

STEP 5: INCREASING BLACKS WITH THE LEVELS ADJUSTMENT LAYER

To intensify the blacks in the image, move the black slider tab to the right.

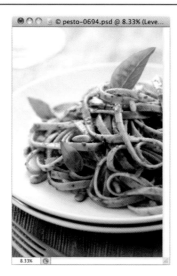

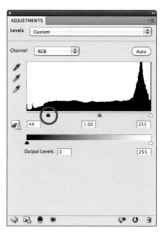

STEP 6: ADDING AND REDUCING FILL LIGHT WITH THE LEVELS ADJUSTMENT LAYER

The gray slider tab will darken the shadows in an image when moved to the right, and it will add fill light when moved to the left.

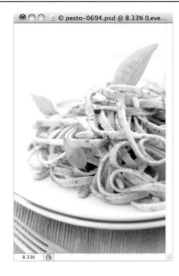

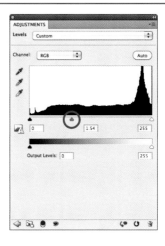

STEP 7: CHANGING THE LEVELS ADJUSTMENT LAYER'S BLENDING MODE TO LUMINOSITY

So far you've made adjustments only to the tonal quality of the image, but making global changes to an image with an Adjustment layer affects not only the luminosity (brightness and contrast) of the layer, but the colors of the image as well.

To demonstrate, this is an image with some subtle adjustments that were made using a Levels Adjustment layer. Changing this layer's blending mode to Luminosity allows the adjustment to affect only the brightness and contrast in the photograph, leaving the colors alone.

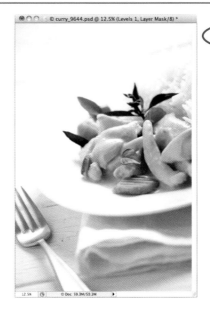

STEP 8: CHANGING THE LEVELS ADJUSTMENT LAYER'S BLENDING MODE TO COLOR

You can also make adjustments to the colors in a photo by using a Levels Adjustment layer. Click the Levels icon in the Adjustments panel, just like you did in step 2. Then in the Layers panel, change the blending mode to Color.

STEP 9: SELECTING CHANNELS IN THE LEVELS ADJUSTMENT LAYER

Now you'll need to determine what colors need adjustment. In the Levels adjustment, you can select from one of four channels: RGB, Red, Green, and Blue. When we made the luminosity adjustments in the previous steps you were working in the RGB channel, but to localize the color adjustments you'll need to be more specific.

STEP 10: ADJUSTING COLOR WITH A LEVELS ADJUSTMENT LAYER

Each color has an opposite color: Red/Cyan, Green/Magenta, and Blue/Yellow. So, if you need to add or subtract yellow from an image, you would select the Blue channel. To add yellow (or subtract blue), drag the black slider tab to the right. To subtract yellow (or add blue), drag the white slider tab to the left. (The adjustment in this example is exaggerated for demonstration purposes.)

RESETTING YOUR ADJUSTMENTS

If you need to reset the Levels adjustment back to its default setting, click the "Reset to adjustment defaults" icon in the Adjustments panel.

VIEWING CLIPPING WARNINGS IN PHOTOSHOP

In Camera Raw (and many other types of RAW editing software), you can easily view over- or underexposed areas of your photograph by way of clipping warnings. In Photoshop, the only tool immediately available is the histogram, but that doesn't mean you can't make those trouble spots stand out like they do in RAW editing software.

STEP 1: VIEWING AN OVEREXPOSED HISTOGRAM

Let's start with this image—you can tell by how the histogram is pushed all the way to the right that the Levels Adjustment layer I added to the image overexposed it and clipped the whites.

STEP 2: ADDING A SOLID COLOR FILL LAYER

To highlight the overexposed areas in the photograph, first add a Solid Color fill layer. To do this, click the Fill/Adjustment layer icon at the bottom of the Layers panel and select Solid Color. (If you have more than one layer, make sure that you add this layer to the very top of the Layers panel for it to work properly.)

STEP 3: SELECTING A BRIGHT COLOR

It's best to select a bright color (like a bright red) for this step so the clipped areas really stand out. Click OK.

STEP 4: ADDING A LAYER STYLE

Next you'll add a Layer Style to the red layer. Click the Layer Style icon (*fx*) in the Layers panel and select Blending Options.

STEP 5: MOVING SLIDERS IN THE BLEND IF SECTION

In the Blend If section at the bottom of the panel, reverse the black-and-white slider tabs so the white tab is to the far left and the black tab is to the far right.

STEP 6: VIEWING THE CLIPPED AREAS IN PHOTOSHOP

Now you see all of the clipped blacks and whites in your image as bright red. To hide this layer, click the eyeball icon next to the layer. To delete the layer altogether, click the trash can icon in the Layers panel.

PHOTOSHOP TIPS AND TRICKS

Knowing the basics is great, but applying them to your photos is even better! Here are some tips and tricks you can use to enhance the overall look of your food photographs.

FIXING CLIPPED HIGHLIGHTS

In the previous section, I showed you how to display clipped highlights in an image in Photoshop. In this step, I show you how to add a Layer Style to an Adjustment layer, brighten it up, and remove the blown-out highlights.

STEP 1: ADDING A LEVELS ADJUSTMENT LAYER

Let's start by adding a Levels Adjustment layer to a photo in Photoshop. In the Adjustments panel, click the "Create a new Levels Adjustment layer" icon.

STEP 2: BRIGHTENING UP THE IMAGE WITH LEVELS

Next, move the white slider tab to the left to brighten up the image. I usually just pay attention to the food item (or whatever the main subject is) instead of the entire image when making this adjustment and ignore areas that become overexposed (the background, for example).

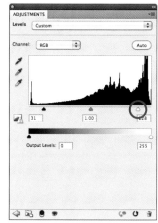

STEP 3: VIEWING THE CLIPPED HIGHLIGHTS

By adding a solid color Fill layer and changing the Layer Style to view the clipped areas, you can see that the background in this image is blown out. (Turn back a few pages to the section titled "Viewing Clipping Warnings in Photoshop" to learn how to apply this effect.) Hide this layer temporarily by clicking the layer visibility (eyeball) icon next to the layer in the Layers panel.

STEP 4: ADDING A LAYER STYLE TO THE LEVELS ADJUSTMENT LAYER

In the Levels Adjustment layer, double-click in the blank area surrounding the text to bring up the Layer Style window, which defaults to the Blending Options tab. You can also get there by highlighting the Levels layer and choosing **Layer > Layer Style > Blending Options**, or by clicking the "*fx*" icon at the bottom of the Layers panel and selecting Blending Options.

STEP 5: VIEWING THE BLEND IF SECTION IN LAYER STYLES

Here's where it gets exciting. In the bottom of the Layer Style window is a section called Blend If. Use the Underlying Layer slider to correct the over-exposed whites in this image. Moving the white slider tab to the left tells the layer to reveal the bottom layer (the *Background* layer) wherever the currently selected layer (the Levels Adjustment layer) is pure white, thereby hiding the overexposed whites that the Levels adjustment created.

STEP 6: REVEALING THE UNDERLYING LAYER

So let's try it out. Move the white slider tab to the left until the overexposed whites in the image are gone. You will notice, however, that this adds a strange effect to the image—showing the harsh transition between the bright whites of the adjustment layer and the background image. You'll want to soften this transition, which you'll do in the next step.

STEP 7: SPLITTING THE WHITE SLIDER

To fix the harsh edges, hold down the Option (Windows: Alt) key and click and drag the white slider tab all the way back to the far right so that it splits in two. You will now have removed most (if not all) of the overexposed whites and also softened the harsh edges that you saw in the previous step.

STEP 8: VOILÀ! THE IMAGE IS FIXED

If you go back to the Layers panel and click the eyeball icon next to the clipping warning layer, you see that the image no longer has any extreme over-exposed areas, yet the Levels adjustment still brightened up other parts of the photograph.

ADDING COLOR POP PE

Here's a fun technique to enhance and saturate the colors in your images.

STEP 1: DUPLICATING THE BACKGROUND LAYER

One trick I like to use in my food photographs is to add a subtle color pop to each image. To create this effect, start by duplicating the *Background* layer by dragging it to the "Create new layer" icon in the Layers panel. Or you can select the *Background* layer and press Command+J (Windows: Ctrl+J).

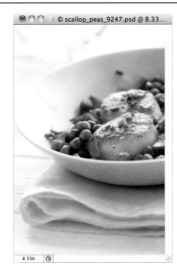

STEP 2: ADDING BLUR TO THE DUPLICATE LAYER

Next, choose **Filter > Blur > Gaussian Blur** and add a good amount of blur to the image. Here I have set the Radius field to 50 pixels.

STEP 3: CHANGING THE LAYER'S BLENDING MODE

In the Layers panel, change the blending mode to Overlay. You'll notice right away that the image looks saturated and glowing. To reduce this effect and make it subtler, reduce the opacity of this layer by clicking the Opacity drop-down menu. I usually set it to 20% or 30%.

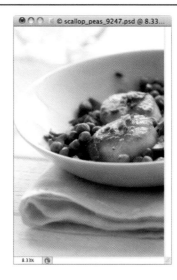

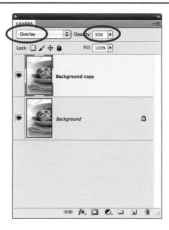

DODGING AND BURNING PE

If there are specific areas in your photo that need to be darker or lighter, you might want to try dodging and burning to lighten and darken the isolated areas.

STEP 1: THE DODGE AND BURN TOOLS

Photoshop has dedicated Dodge/Burn tools, which you could use directly on the *Background* layer, but using those tools will destroy pixels, and if you make a mistake, it's difficult to correct down the road.

STEP 2: ADDING A NEW, BLANK LAYER

Instead, try working nonde-structively with our image. Start by adding a new, blank layer by clicking the "Create a new layer" icon in the Layers panel.

STEP 3: FILLING THE LAYER WITH 50% GRAY

Fill the layer with 50% Gray by using the keyboard short-cut Shift+Delete (Windows: Shift+Backspace) and selecting 50% Gray from the Contents drop-down menu. Click OK.

STEP 4: CHANGING THE BLENDING MODE TO OVERLAY

Change the blending mode of this layer to Overlay by clicking the drop-down menu at the top of the Layers panel. The layer will seem to disappear in the image—this is because the Overlay blending mode makes anything that is set to 50% gray become transparent to the layers below.

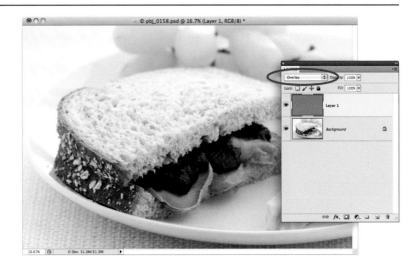

STEP 5: PAINTING ON THE LAYER WITH WHITE TO INCREASE BRIGHTNESS

Select the Brush tool from the tools palette, and change its Opacity setting to 20% (this setting is located in the Options bar near the top of your screen). You can paint with either black (to make an area darker) or white (to make an area brighter). In this photo, I selected white and painted repeatedly over the jelly in the sandwich to make it brighter.

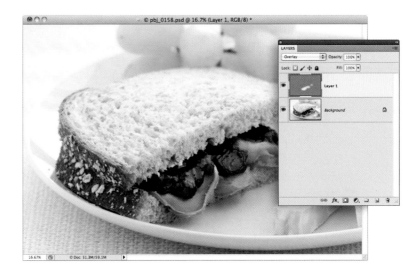

CLEANING THINGS UP WITH THE CLONE STAMP TOOL PE

The Clone Stamp tool samples from an area near the trouble spot and then paints over the spot with the area you sampled from. Let's give it a try.

STEP 1: ZOOMING IN TO THE TROUBLE SPOT

In this photo, there is a small speck of dust that needs to be removed from the side of a bowl. First, zoom in to the photo so that you are viewing at 100% zoom. You can get to this quickly by using the keyboard shortcut Command+Option+0 (zero) (Windows: Ctrl+Alt+0). Then, hold down the spacebar to use the Hand tool to move your view to the spot you need to clone out.

STEP 2: CLONING NONDESTRUCTIVELY ON A NEW, BLANK LAYER

To be sure we are working non-destructively (if you choose to do so), add a new, blank layer directly above the *Background* layer. Then, click the Clone Stamp tool in the tools palette, or use the keyboard shortcut **S**. In the Options bar at the very top, make sure that Current & Below is selected in the Sample drop-down menu. This will allow you to clone your image from a separate layer and easily go back and fix mistakes without affecting the original pixels on the *Background* layer.

STEP 3: SAMPLING AN AREA WITH THE CLONE STAMP TOOL

Before you start using the Clone Stamp tool, make sure that your Clone Stamp brush is set to 0% hardness (you can change this setting from the brush-size drop-down menu in the Options bar). This will soften the transition between the area you fix and the original image.

With the Clone Stamp tool selected and the new blank layer active, hold down the Option (Windows: Alt) key and click to sample an area that is similar in color, texture, and tone to the area you will be covering up.

STEP 4: PAINTING AWAY THE TROUBLE SPOT

Hover the mouse over the trouble spot and slowly paint it away. You'll immediately see the spot being covered by the area it was sampled from.

FINISHING TOUCHES

Before you share your photos with the world, there are two last steps that you should follow. One of them, sharpening, is usually the last thing you'll do to a photograph when editing. And, of course, you'll have to save all that hard work you put into your image. In this section, I discuss the steps you can take to sharpen and save your food photographs.

SHARPENING YOUR PHOTO

Photoshop offers several sharpening filters in the Filter menu that you can use to sharpen your images. In the following steps, I cover, well, none of them. Instead, I'm going to walk through the steps that cover a more hands-on, in-control, and nondestructive approach to sharpening images called High Pass sharpening.

STEP 1: DUPLICATING THE BACKGROUND LAYER

To get started, duplicate the *Background* layer by clicking the layer and using the key-board shortcut Command+J (Windows: Ctrl+J).

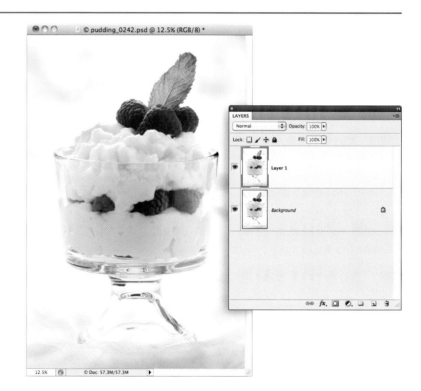

STEP 2: APPLYING THE HIGH PASS FILTER

Choose **Filter > Other > High Pass**. You want to set the radius so the edges of the objects in the photograph start to show and become very pronounced. I find that a setting of 5 pixels is a good starting point, and I change it from there as I need to. (This setting will depend on the megapixel size of your photograph—a larger image will require a higher setting, and vice-versa.) When you're finished, click OK.

STEP 3: CHANGING THE BLENDING MODE TO OVERLAY

In the Layers panel, change this layer's blending mode to Overlay. This blending mode will hide the gray in the layer and make the dark and light areas of the edges more contrasty, making the image appear to be sharpened. Click the layer visibility (eyeball) icon next to this layer to tem-

porarily hide the layer, and then click it again to bring the layer back and see the changes more clearly. If you like, you can scale down the effect by reducing the Opacity setting in the Layers panel. I usually set it to around 30% for High Pass sharpening.

STEP 4: USING MASKING ON THE SHARPENING LAYER

The final step is to localize the sharpening in one area so that only the point of focus is sharpened, not the entire image. To do this, we'll use masking. On the sharpened High Pass layer, hold down the Option (Windows: Alt) key and click the "Add layer mask" icon in the Layers panel. This will add a black layer mask to the layer, hiding it (for now).

STEP 5: PAINTING WITH WHITE TO REVEAL THE SHARPENING LAYER

Using the Brush tool (keyboard shortcut: **B**), paint with white over the areas of the image that are most in focus. Make sure your brush's Opacity is set to 100% (in the Options bar) and the brush hardness is set to 0%. You will see a white area appear in the layer mask, and that specific area within the image will now be sharpened.

In this example, I localized the sharpening to the leaves and raspberries on top of the pudding.

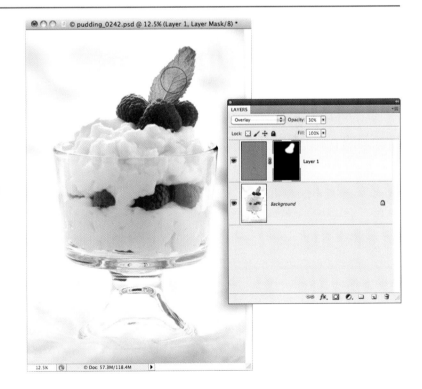

SAVING YOUR PHOTO PE

The last step in the photo-editing workflow is to save your file. There are several different formats you can use, and in this section I discuss saving a Photoshop file (PSD) and a JPEG, and also saving a version to use on the Internet.

STEP 1: SAVING A PHOTOSHOP FILE

Once you are finished editing your photo, it's possible that you have several layers with different adjustments. If you want to save this file as is, with all the layers intact, one solution is to save the file as a PSD (Photoshop) file. This would allow you to go back and re-edit the image in the future, but one downside is that the file will be very large and take up space on your hard drive.

To save a file as a PSD, go to **File > Save** and select the location where you want to save your file. Choose Photoshop from the Format drop-down menu, select the Layers check box, and click Save.

STEP 2: SAVING A JPEG

If you would also like to save this file as a JPEG, which is a compressed, smaller file that does not keep the layers intact (making the layers uneditable in the future), then go to **File > Save As**, select JPEG from the Format drop-down menu, navigate to the location you want to save your file, and click Save. (If JPEG is not an option in the Format drop-down menu, you need to click Cancel, go back into the file, go to **Image > Mode**, and make sure that 8 Bits/Channel is selected.)

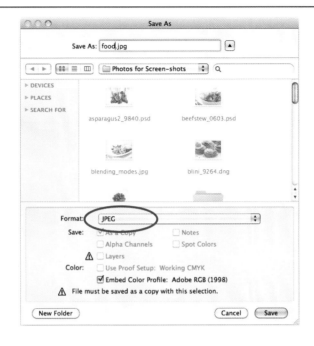

If after saving the JPEG version you no longer wish to keep the layered document, just close the image and, when it asks if you wish to save the changes, click the Don't Save button. *Do this only if you've already saved another version of the file, or you'll lose your work.*

STEP 3: RESIZING YOUR IMAGE FOR THE WEB

If you plan to share your images on the Internet, such as on a blog or food-sharing site, you should save a copy of your files specifically for the Web. This will ensure that the size and color profile is optimized for viewing on the Internet. You should always do this *after* and *in addition to* saving a full-resolution version of the photo, just as we did in steps 1 and 2.

Go to **Image > Image Size** and change the Width and Height settings to a smaller size. This will be the largest size that the image will be on the Internet. I usually use a Width setting of 600 pixels for my blog, but this will vary from person to person.

STEP 4: SAVING A WEB VERSION OF YOUR PHOTOGRAPH

Next, go to **File > Save for Web and Devices**. A new window will appear with several options, but you only need to pay attention to a few of them. I like to save my files as JPEGs, set the Quality to Maximum and 100%, and make sure that the Convert to sRGB check box is selected. Click the Save button and select the location you want to save your image to. Using this process for saving will also change the resolution of your file to

a more suitable resolution for the Web, 72 ppi (which can also be changed in the previous step if you prefer to do it manually). Your photo is now ready to upload and post to the Internet.

MANUALLY CONVERTING TO SRGB

If you prefer to convert the color profile manually before saving your Web version, you can go to Edit › Convert to Profile. Then select sRGB from the Destination Space drop-down menu. Save a copy of your image by selecting File › Save As.

Chapter 6 Challenges

The best way to learn how to edit photos using Photoshop is to jump right in and do it on your own. Here are some challenges to help get you on the right track.

Edit a Photo Using Adobe Camera Raw

Locate a RAW file on your hard drive and open it in Camera Raw. Move the Temperature and Tint sliders around until the white balance looks natural, and then work your way down the rest of the adjustments in the Basic tab to make the brightness, contrast, and colors pop as much as possible. Then, click Open Image to open the photo in Photoshop and continue with the editing process.

Apply a Levels Adjustment Layer to a Photograph

Using the Adjustments panel, add a Levels Adjustment layer to your image to add brightness and contrast in the RGB channel of the Levels Adjustment layer. Change this layer's blending mode to Luminosity. Then, add another Levels Adjustment layer, but this time change its blending mode to Color and choose either Red, Green, or Blue from the Channel drop-down menu. Make changes to the sliders and watch how the colors shift as you slide them around.

Save a Photo for the Web

Open a photo in Photoshop and, using the steps in this chapter, save it for the Web. First, resize it so it will fit within the context you want to use it in (a blog, a gallery, and so on). Then go to **File › Save for Web and Devices**, choose your settings, and save the image to your hard drive.

Share your results with the book's Flickr group!

Join the group here: flickr.com/groups/foodphotographyfromsnapshotstogreatshots/

7

Canon 5D Mark II
ISO 100
1/30 sec.
f/5.6
70–200mm lens

Behind the Scenes

FOOD PHOTOGRAPHY FROM START TO FINISH

Seeing a finished photograph and looking at a lot of images of food are great ways to learn how to improve your photography, or maybe just try new things. But seeing how the images were made can be even more helpful. In this chapter, we will go through the "behind the scenes" of creating a food image, starting with the styling, props, and lighting, and then going through the editing process in Adobe Photoshop.

PORING OVER THE PICTURE

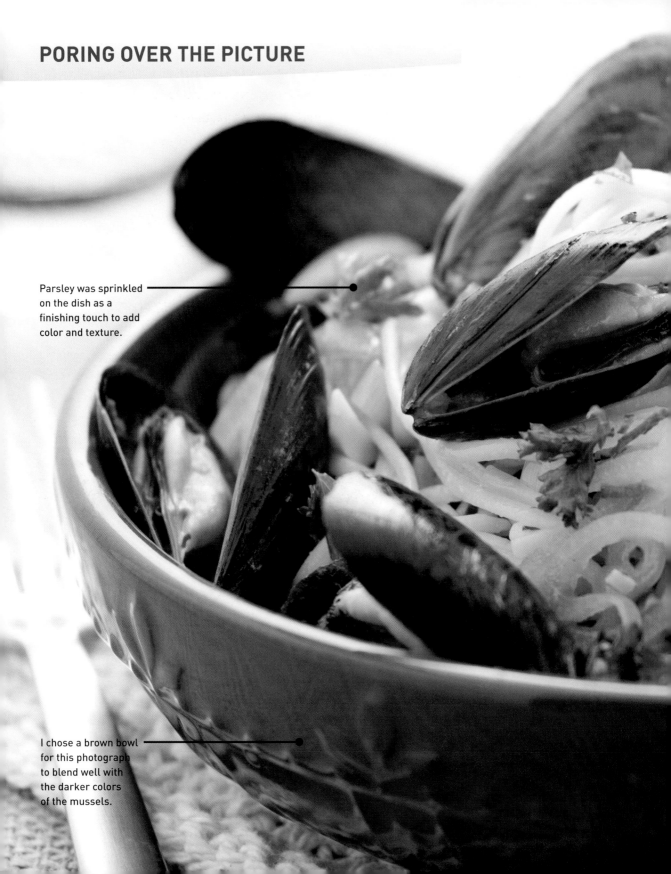

Parsley was sprinkled on the dish as a finishing touch to add color and texture.

I chose a brown bowl for this photograph to blend well with the darker colors of the mussels.

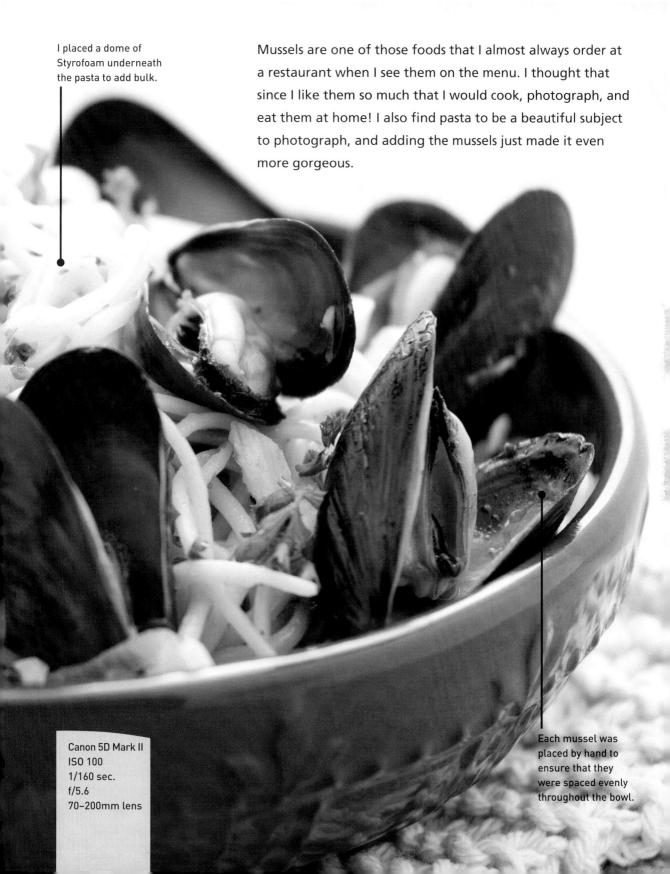

I placed a dome of Styrofoam underneath the pasta to add bulk.

Mussels are one of those foods that I almost always order at a restaurant when I see them on the menu. I thought that since I like them so much that I would cook, photograph, and eat them at home! I also find pasta to be a beautiful subject to photograph, and adding the mussels just made it even more gorgeous.

Canon 5D Mark II
ISO 100
1/160 sec.
f/5.6
70–200mm lens

Each mussel was placed by hand to ensure that they were spaced evenly throughout the bowl.

PORING OVER THE PICTURE

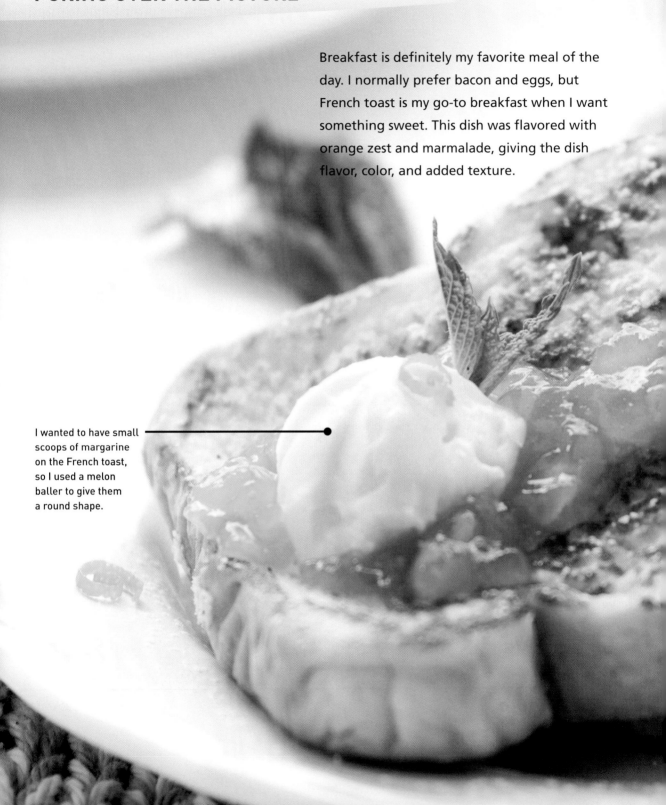

Breakfast is definitely my favorite meal of the day. I normally prefer bacon and eggs, but French toast is my go-to breakfast when I want something sweet. This dish was flavored with orange zest and marmalade, giving the dish flavor, color, and added texture.

I wanted to have small scoops of margarine on the French toast, so I used a melon baller to give them a round shape.

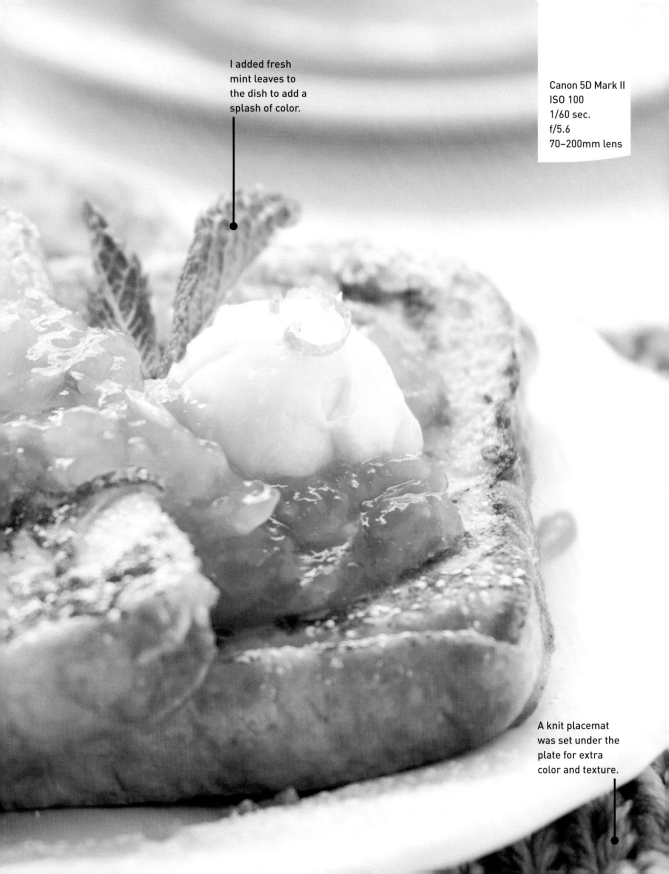

I added fresh mint leaves to the dish to add a splash of color.

Canon 5D Mark II
ISO 100
1/60 sec.
f/5.6
70–200mm lens

A knit placemat was set under the plate for extra color and texture.

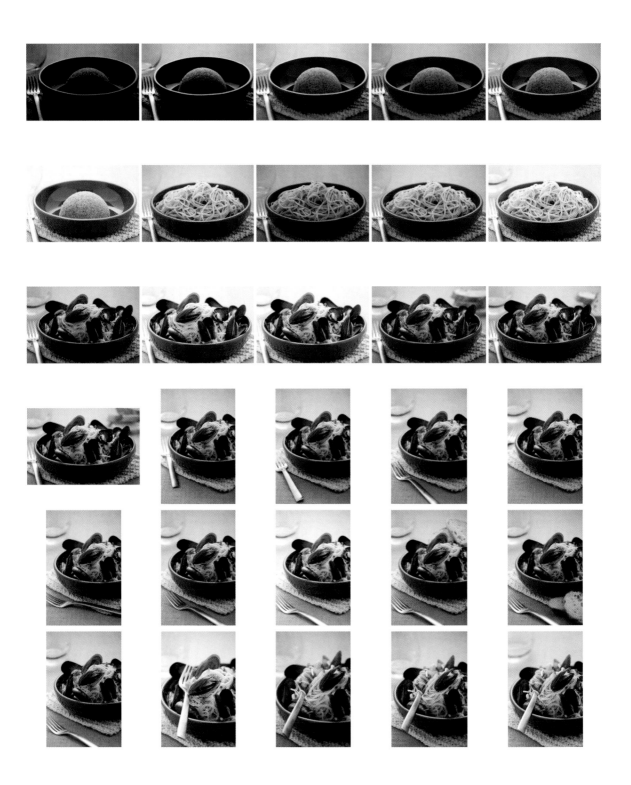

MUSSELS WITH LINGUINE

I love to photograph pasta—I think it's because of the texture that the noodles add to an image. I also love shellfish, and mussels are one of my favorite foods, which made this a tasty image to create.

STYLING AND PROPS

To prepare the food, I cooked the pasta and mussels just like I would if I were going to eat it (the leftovers were, after all, my dinner as well). I cut a Styrofoam ball in half and placed it in the dish, then put the cooked pasta in the bowl by hand (**Figures 7.1** and **7.2**). I added the mussels one by one, strategically placing them on the dish so they were spaced well and facing different directions (**Figure 7.3**). To finish it off, I added some of the leftover parsley to the dish for extra color (**Figure 7.4**).

I decided to go with a brown bowl to complement the colors of the mussel shells. I stuck with the earthtones theme by using cream-colored cloth underneath the dish. I filled a small wine glass with white wine and set it in the background. I used a simple fork and set it to the side of the bowl for many of the photos, but when I was finished with the basic images and could mess up the pasta a bit, I stuck the fork in the bowl and swirled some pasta around it to make it look like someone was digging in (**Figure 7.5**).

FIGURE 7.1
I used a dome
of Styrofoam to
bulk up the pasta
and also to use
as a stand-in
to set lighting
and exposure.

Canon 5D Mark II
ISO 100
1/160 sec.
f/5.6
70–200mm lens

FIGURE 7.2
First, I added
the cooked pasta
to the bowl and
some white wine
to the glass in the
background.

Canon 5D Mark II
ISO 100
1/160 sec.
f/6.3
70–200mm lens

Canon 5D Mark II
ISO 100
1/160 sec.
f/5.6
70–200mm lens

FIGURE 7.3
Next, I added the mussels and sauce on top of the pasta.

Canon 5D Mark II
ISO 100
1/160 sec.
f/5.6
70–200mm lens

FIGURE 7.4
The last step was to add parsley as a garnish to add more color to the dish.

FIGURE 7.5
I added the fork to the bowl to make it look like the pasta was about to be eaten.

Canon 5D Mark II
ISO 100
1/160 sec.
f/5.6
70–200mm lens

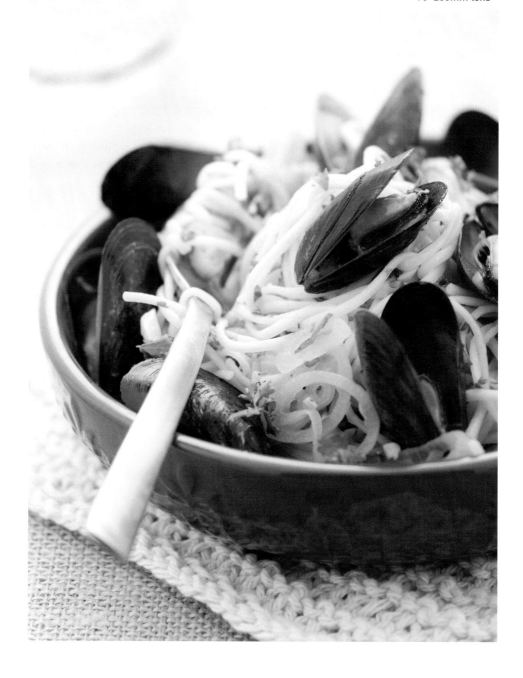

LIGHTING SETUP

I had actually planned on using natural light with this dish, but my timing for purchasing the mussels and the rest of the day's work made the hours fly by and prevented me from using window light. And, since I didn't want to wait too long to cook the mussels for fear of them going bad, I decided to go ahead and create the photo with a studio light.

I used an AlienBees™ ABR800 light with a 56-inch Moon Unit, which is basically a large softbox that fits on the light. I placed it at the back of the table to backlight the food, and I set a piece of black foam board at the bottom to block some of the harsh light from spilling onto the background of the photo. I also set the Lastolite TriGrip diffuser in front of the light to diffuse the rest of the light coming from the softbox. To fill in the front and top of the dish, I placed a piece of folded foam board on both sides of the food, and I set a piece of foam board on top to bounce light in from above (**Figure 7.6**).

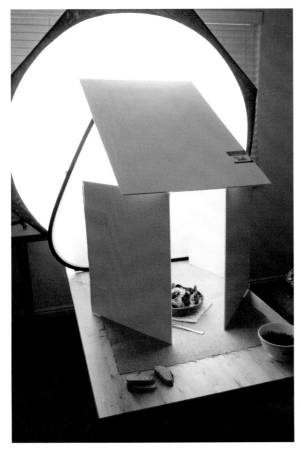

FIGURE 7.6
Behind the Scenes:
Mussels with Linguine
A AlienBees ABR800
 with Moon Unit
B Lastolite
 TriGrip diffuser
C White foam board
D Folded white
 foam boards
E Canon 5D Mark II with
 70–200mm lens

POSTPROCESSING

Now let's go through the steps to edit this photograph.

STEP 1: OPEN THE IMAGE IN CAMERA RAW

First I opened the RAW file in Adobe Camera Raw.

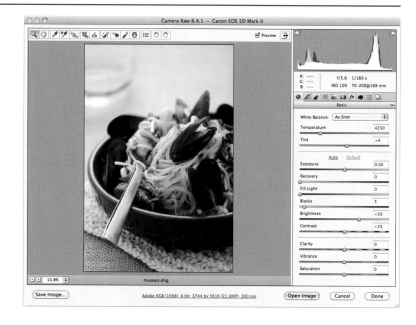

STEP 2: EDIT CAMERA RAW SETTINGS

The white balance in this photo needed a bit of adjustment, so I set the White Balance drop-down menu to Auto and slightly adjusted the Temperature setting by moving the slider to the left. I added to the Exposure, Recovery, and Vibrance settings by moving the sliders to the right to brighten up the image and enhance the colors. When I was finished, I clicked the Open Image button to open the photo in Photoshop.

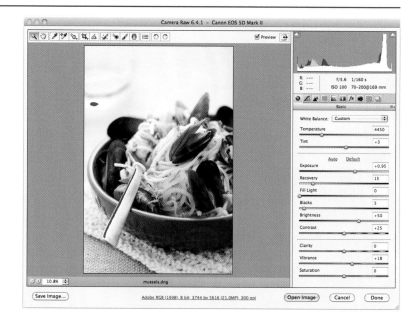

STEP 3: EDIT IN PHOTOSHOP

The colors and tones in the image already looked good, so I did very little to this image in Photoshop. I added some color pop on a separate layer, and I added a High Pass sharpening layer on the top and masked it so that it was affecting only the sharpest area of the image—in this case, the mussel on top and some of the pasta. Then I saved the photo as a PSD file and closed it.

PROCESSING IMAGES WITH ADOBE PHOTOSHOP

For more detailed explanations on how to create the Photoshop editing effects seen in this chapter, please turn to Chapter 6, "Processing Images with Adobe® Photoshop®."

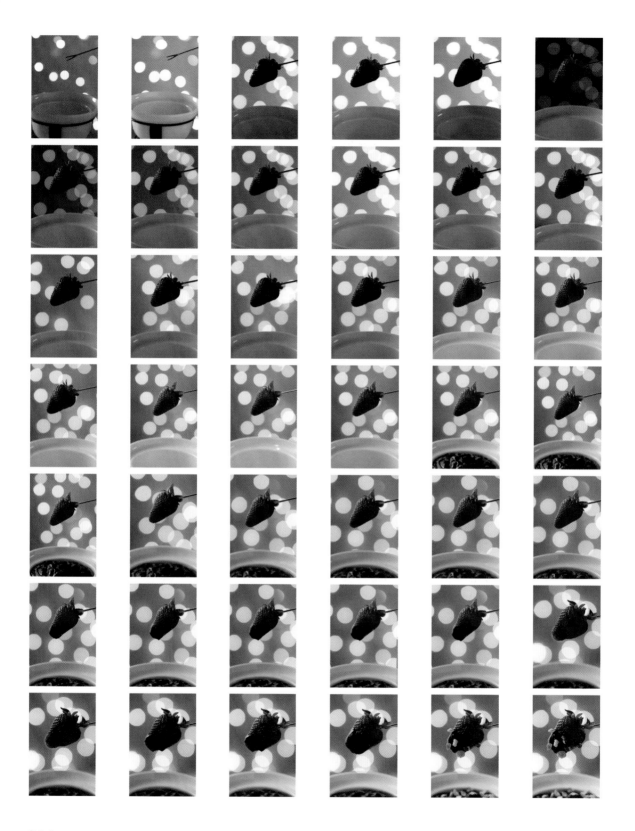

CHOCOLATE FONDUE

I love playing with lights and creating images that are a bit of a challenge. This photo was no exception—adding the string lights to the background was a good way to add a mood to the scene, and the image was fun to create.

STYLING AND PROPS

In this image, I really wanted to show a strawberry as if it had just been dipped into the chocolate fondue. In order to achieve this, I needed to position the fondue fork in the air so it was hovering over the pot. To set this up, I clamped a Manfrotto™ Magic Arm (**Figure 7.7**) to the side of the table and angled it over the fondue pot. I used gaffer tape to secure the fork to the Magic Arm.

Once the strawberry was stuck on the fork, I lifted the chocolate-filled fondue pot just until the chocolate covered the strawberry and then placed the pot back into position (**Figure 7.8**). I used this method instead of moving the strawberry down into the pot because it allowed me to keep the strawberry in place and not have to reposition the camera (which was on a tripod). For a finishing touch, I added chopped hazelnuts to the fondue pot and stuck them on the strawberry one by one (**Figure 7.9**).

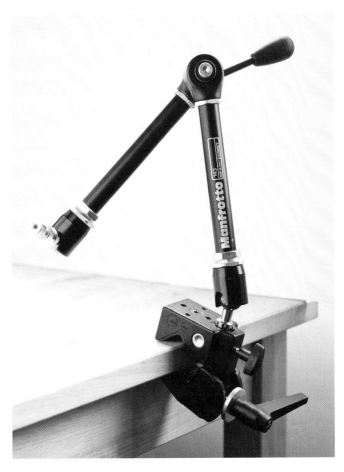

FIGURE 7.7
Manfrotto Magic Arm.

FIGURE 7.8
I lifted the pot up to the strawberry instead of bringing the strawberry down to the pot.

Canon 7D
ISO 100
1/5 sec.
f/5.6
70–200mm lens

Canon 7D
ISO 100
1/5 sec.
f/5.6
70–200mm lens

FIGURE 7.9
For a finishing touch, I placed chopped hazelnuts both in the fondue pot and on the chocolate-covered strawberry.

FIGURE 7.10
Behind the Scenes: Chocolate Fondue

A White string lights hanging from background stands

B AlienBees ABR800 with Moon Unit

C Manfrotto Magic Arm

D Folded white foam boards

E Canon 7D with 70–200mm lens

LIGHTING SETUP

To light the strawberry, I used an AlienBees™ ABR800 ringflash with a 56-inch Moon Unit placed behind and off to the left of the subject. I bounced light back onto the strawberry with two folded white foam boards (**Figure 7.10**).

For the lights in the background, I used white string lights and hung them from a background stand in front of a light-colored board. To make the lights large and blurry, I used a long focal length (200mm) and a somewhat wide aperture (*f*/5.6). I also positioned the lights about 5 feet behind the strawberry, which added to the compression effect, making the lights appear large. I used a slower shutter speed to brighten up the background—since the strawberry was lit only by the strobe light, this didn't affect the main subject.

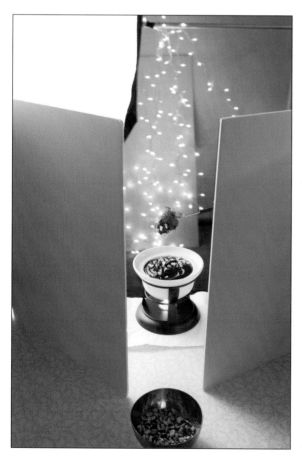

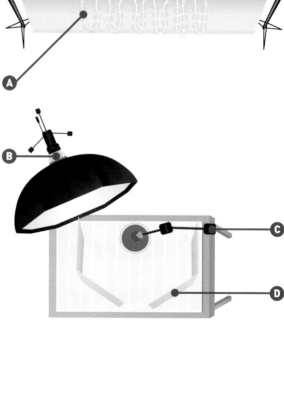

POSTPROCESSING

Now let's go through the steps to edit this photograph.

STEP 1: OPEN THE IMAGE IN CAMERA RAW

First I opened the RAW file in Camera Raw.

STEP 2: EDIT CAMERA RAW SETTINGS

I adjusted the white balance by sliding the Temperature slider slightly to the left. I increased the Exposure and Recovery settings by moving their sliders to the right. I wasn't concerned with the overexposed areas in the background because the string lights were supposed to be very bright.

STEP 3: USING THE ADJUSTMENT BRUSH IN CAMERA RAW

The front of the strawberry was somewhat dark, so I used the Adjustment Brush to add one f/stop of exposure to the image. I clicked the Adjustment Brush tool at the top, moved the Exposure slider to the right, and then painted over the strawberry. When I was finished, I clicked the Open Image button to open the photo in Photoshop.

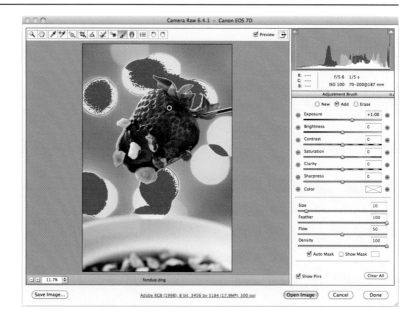

STEP 4: ADDING A LEVELS ADJUSTMENT LAYER IN PHOTOSHOP

The first thing I did in Photoshop was to add a Levels Adjustment layer to brighten the image. I clicked Levels in the Adjustments panel, then moved the white slider to the left. I renamed the layer and changed its blending mode to Luminosity.

STEP 5: CHANGING THE BLEND IF SETTING

Because the previous Levels adjustment made some of the image too bright, I clicked the *fx* icon in the Layers panel to bring up the Layer Style window. In the Blend If section, while holding down the Option (Windows: Alt) key, I clicked the bottom white slider and dragged it to the left to split the slider. This brought back some of the detail in the white areas that were overexposed because of the Levels adjustment.

STEP 6: FINISHING UP IN PHOTOSHOP

Lastly, I added some color pop to the image on a new layer. I also added a High Pass sharpening layer and masked the layer so that only the strawberry was sharpened. Then, I saved the photo as a PSD file and closed it.

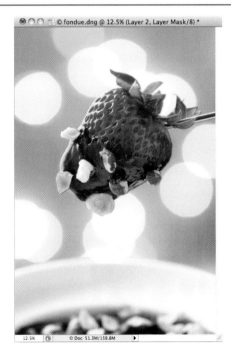

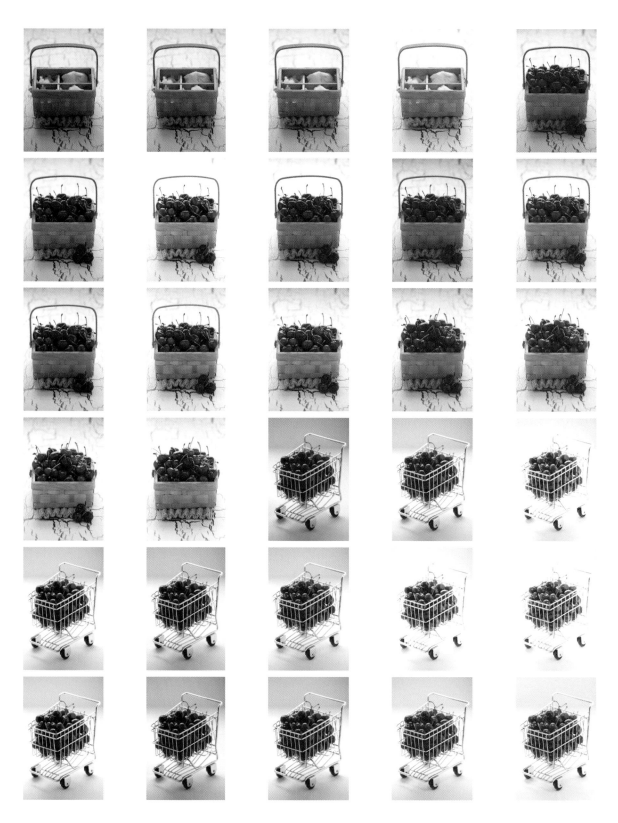

BASKET OF CHERRIES

This photograph was one of those images that happened because I saw some gorgeous cherries at the grocery store and bought them to eat. Then, I decided to find a way to photograph them (they also made it into the banana bread photograph in this chapter). I ended up with two different images—one with a regular basket, and another with a miniature shopping cart on a white background.

STYLING AND PROPS

To prep the cherries for this image, I washed them in a colander and put them in a bowl so they would have a fresh look with water drops. I did my best to find nice-looking cherries to go near the top, which would be more visible in the photograph. I stuffed some paper towels in the compartments in the basket so I could use all of the cherries I had, yet still give them a lot of height and bulk (**Figure 7.11**). I also found a group of three connected cherries, which I placed in front of the basket to add some balance to the image (**Figure 7.12**).

For the props, I chose a black-and-white crackled tabletop and used a small piece of blue knitted fabric under the basket for a splash of contrasting color. I also quickly created a second setup by using a miniature shopping cart on a plain white background (**Figure 7.13**). To create this look, I moved the cherries to a new container (the shopping cart) and placed one piece of white foam board underneath the cherries and one in the background.

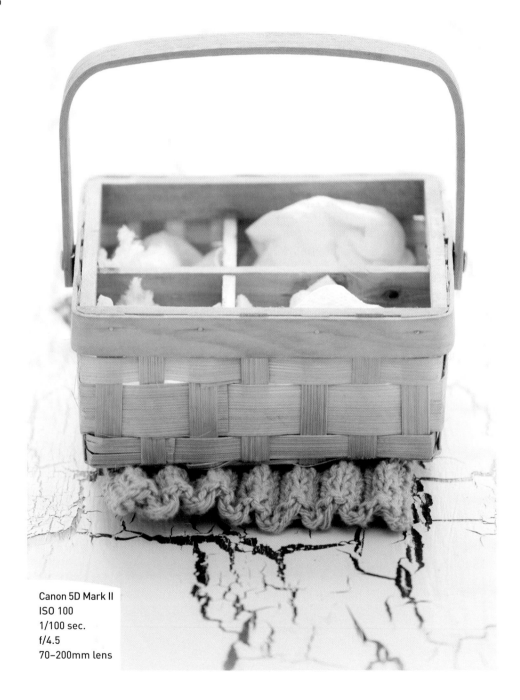

FIGURE 7.11
I stuffed paper towels into the basket to bulk up the cherries.

Canon 5D Mark II
ISO 100
1/100 sec.
f/4.5
70–200mm lens

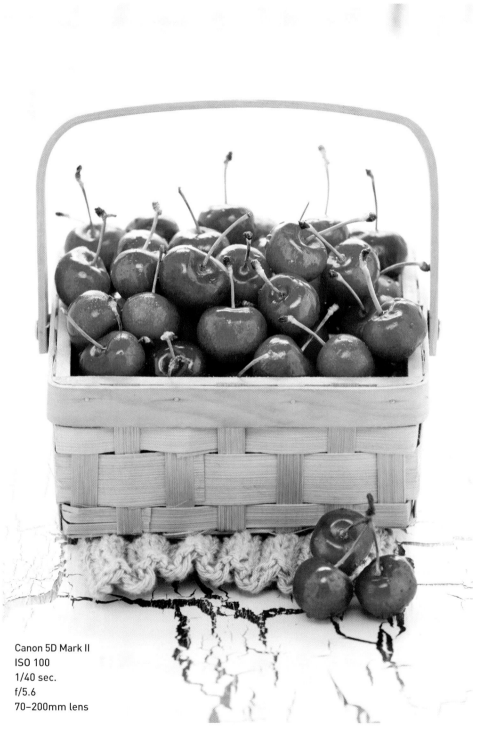

Canon 5D Mark II
ISO 100
1/40 sec.
f/5.6
70–200mm lens

FIGURE 7.13
To photograph the cherries in a different setting, I put them in a miniature shopping cart and placed white foam board underneath and behind them.

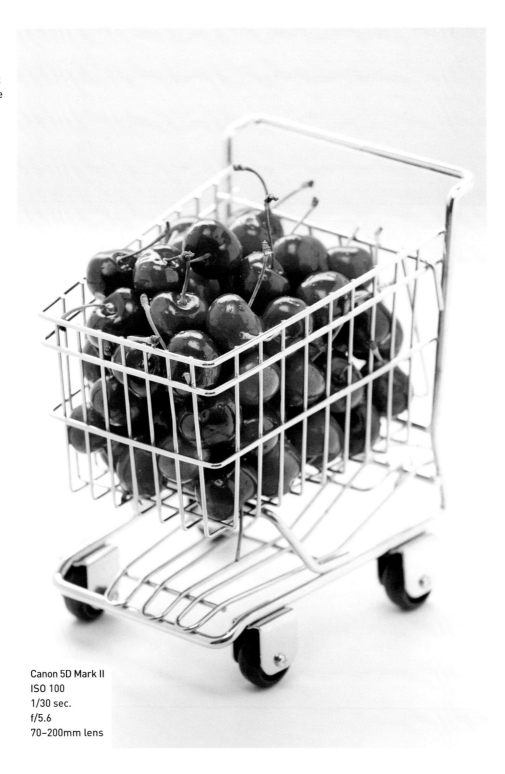

Canon 5D Mark II
ISO 100
1/30 sec.
f/5.6
70–200mm lens

LIGHTING SETUP

I used a very basic North-facing window-light setup for the first image (**Figure 7.14**). I placed folded foam board on either side of the cherries and diffused some of the window light with a Lastolite™ TriGrip diffuser. I then used a small handheld reflector to bounce light directly on the front of the cherries.

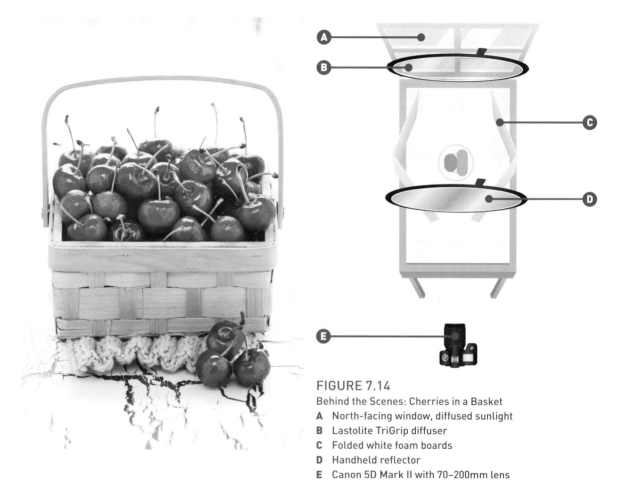

FIGURE 7.14
Behind the Scenes: Cherries in a Basket
A North-facing window, diffused sunlight
B Lastolite TriGrip diffuser
C Folded white foam boards
D Handheld reflector
E Canon 5D Mark II with 70–200mm lens

For the second image, I placed a piece of white foam board underneath the shopping cart and put another piece of foam board in front of the diffuser to give the illusion of a seamless white background (**Figure 7.15**). By using a wide aperture (*f*/5.6) and a long focal length (185mm), I was able to blur the background enough to hide the crease where the two pieces of foam board connected.

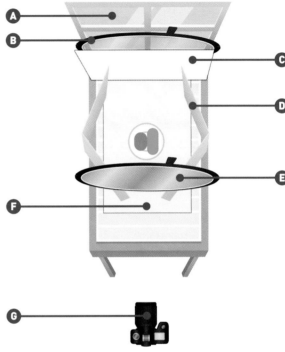

FIGURE 7.15

Behind the Scenes: Cherries in a Miniature Shopping Cart

A North-facing window, diffused sunlight
B Lastolite TriGrip diffuser
C White foam board for background
D Folded white foam boards
E Handheld reflector
F White foam board under cherries
G Canon 5D Mark II with 70–200mm lens

POSTPROCESSING

Now let's go through the steps to edit the photo of the cherries in the basket.

STEP 1: OPEN THE IMAGE IN CAMERA RAW

First I opened the RAW file in Camera Raw.

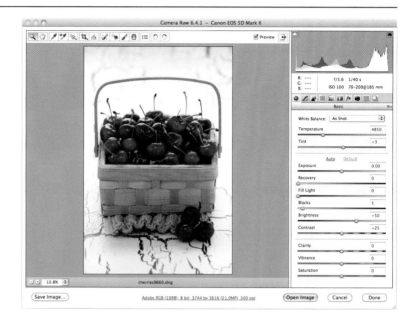

STEP 2: EDIT CAMERA RAW SETTINGS

I adjusted the white balance and made it slightly warmer by sliding the Temperature slider to the right. I increased the Exposure, Recovery, and Vibrance settings by moving their sliders to the right. When I was finished, I clicked the Open Image button to open the photo in Photoshop.

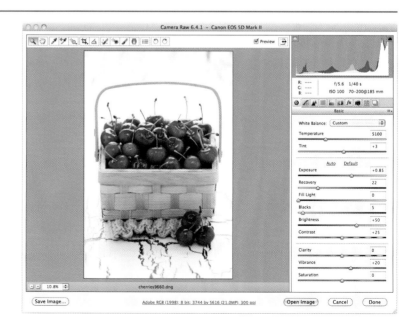

STEP 3: EDITING IN PHOTOSHOP

The first thing that needed to be done was to remove the blemishes that are noticeable on some of the cherries.

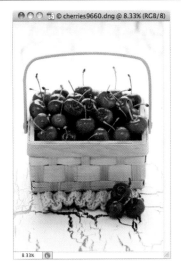

STEP 4: USING THE CLONE STAMP TOOL

To clean up the blemishes on the cherries, I added a new, blank layer and used the Clone Stamp tool to remove the bruises and spots.

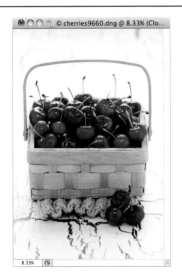

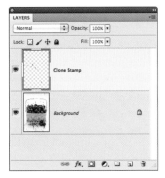

STEP 5: ADDING A DODGE & BURN LAYER

To add some fill light to the cherries, I added a blank layer, chose Edit > Fill, filled the layer with 50% gray, and clicked OK. Then I changed the blending mode of the layer to Overlay. I used a soft brush and painted with white at a low brush opacity (10%) over the cherries to brighten them up.

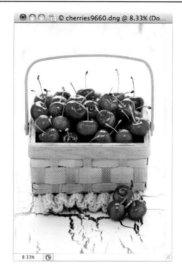

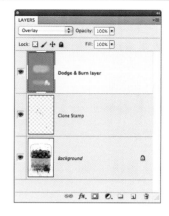

STEP 6: FINISHING UP IN PHOTOSHOP

Lastly, I added some more brightness to the image with a Levels Adjustment layer, and I added a High Pass sharpening layer and masked it so that only the cherries were sharpened. I saved the photo as a PSD file and closed it.

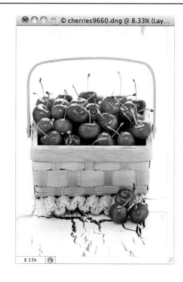

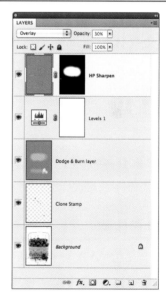

BANANA BREAD

I had a few bananas that were just sitting around getting old, so I decided that the best use of them would be in some good old-fashioned banana bread. I added fresh cherries to add some color and flavor to the bread, and I topped it off with a pat of margarine.

STYLING AND PROPS

There really wasn't too much styling involved with this food. I had two loaves of the banana bread, so I cut several slices from the better-looking loaf and picked out three pieces to use for the photo. I stacked them so you could see the cherries and crumbs in the front slice.

I put a slice of margarine on the bread (**Figure 7.16**) to add some color to the image. I cut a few pats of the margarine to get one that was a good size for the bread and then used my fingers to smooth out the harsh edges. After placing it on the bread, I used a hand steamer to slightly melt it, giving the impression that the bread was fresh out of the oven and still warm (**Figure 7.17**).

USING MARGARINE IN FOOD PHOTOGRAPHS

When you want to add butter to a dish, it's usually best to use margarine. Margarine has a nice deep-yellow color to it, whereas real butter can often end up looking washed out or faded.

I went with a white plate, a very subdued and soft-colored tabletop, and a hand-knitted, cream-colored placemat. For a splash of color, I placed a teacup with a pink-and-white pattern off to the left in the background. I also added another plate of banana bread to fill in the upper-right corner of the frame and balance the scene.

FIGURE 7.16
Placing a small pat of butter on the bread added color and life to the photo.

Canon 5D Mark II
ISO 100
1/20 sec.
f/5.6
70–200mm lens

Canon 5D Mark II
ISO 100
1/30 sec.
f/5.6
70–200mm lens

FIGURE 7.17
Using a hand steamer, I was able to control the melting of the butter on the bread.

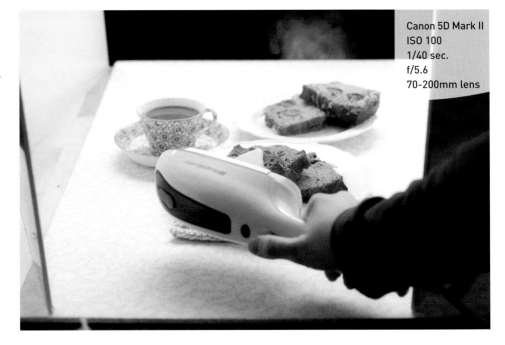

Canon 5D Mark II
ISO 100
1/40 sec.
f/5.6
70-200mm lens

LIGHTING SETUP

This was another simple natural-light setup (**Figure 7.18**). I used a North-facing window and placed folded white foam board on either side of the dish. I used a piece of black foam board at the base of the window to block reflections from showing up in the coffee.

FIGURE 7.18

Behind the Scenes: Banana Bread

A North-facing window, diffused sunlight
B Black foam board
C Folded white foam boards
D Canon 5D Mark II with 70–200mm lens

POSTPROCESSING

Now let's go through the steps to edit the photo.

STEP 1: OPEN THE IMAGE IN CAMERA RAW

First I opened the RAW file in Camera Raw.

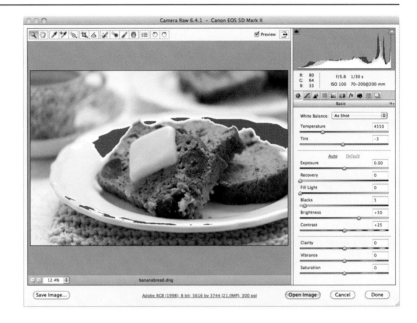

STEP 2: EDIT CAMERA RAW SETTINGS

To adjust the white balance, I selected Auto from the White Balance drop-down menu. The Auto setting warmed up the image, and I didn't need to make any further changes. I also increased the Exposure, Recovery, Blacks, and Vibrance sliders by moving them to the right. When I was finished, I clicked the Open Image button to open the photo in Photoshop.

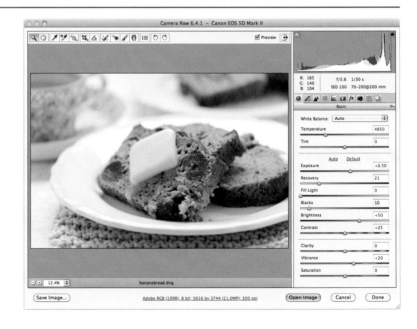

STEP 3: ADDING A DODGE/BURN LAYER

The front of the bread needed some selective brightness, so I added a dodge/burn layer and painted white over the areas using a soft brush at a low brush opacity (10%).

STEP 4: ADDING COLOR POP

Next I added some color saturation by adding a color pop layer. To do this, I duplicated the background and blurred the layer using Filter > Gaussian Blur. Then I changed the blending mode of the layer to Soft Light and reduced the layer's opacity to 30%.

STEP 5: SHARPEN AND SAVE

The last step was to add a High Pass sharpening layer and mask it so that only the front part of the bread was sharpened. Then, I saved the image as a PSD file and closed it.

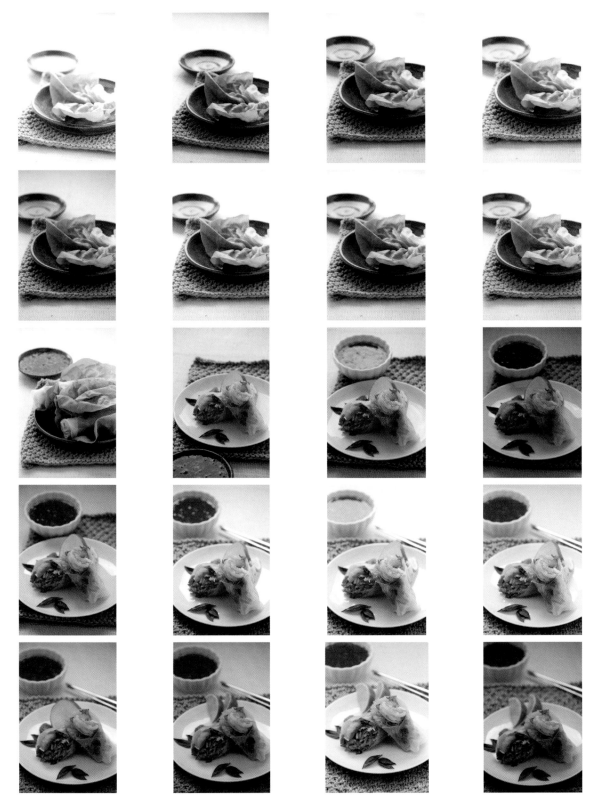

SHRIMP SPRING ROLLS

I saw a recipe for these spring rolls on a TV show and was intrigued. I had ordered (and eaten) them several times at restaurants but never made my own. I decided to give it a shot—not only did they look nice, but they tasted pretty good, too.

STYLING AND PROPS

I cooked, prepared, and rolled the spring rolls, being careful to layer the vegetables in between the shrimp and rice noodles before rolling so that the color contrast was more apparent. The actual plating of the spring rolls was, at first, a challenge. I had originally planned to create some images of a plate full of uncut spring rolls, but I just wasn't happy with the results I was getting (**Figure 7.19**).

So instead of showcasing more than one spring roll, I cut just one and set it on a small plate. I garnished the plate with sprigs of Thai basil and a few wedges of lime, both of which were seasoning ingredients in the rolls. I also added an uncut piece of shrimp in the half of the spring roll to the right.

On the tabletop, I used a subtle cream cloth, and I used a green placemat under the plate to complement the green in the food. I started out with a darker plate, but after doing a few test photos I switched to a small white plate because I felt that it better balanced with the food and tabletop. I also added some chopsticks in the scene and placed a small white dish of sweet chili sauce in the upper-left portion of the frame (**Figure 7.20**).

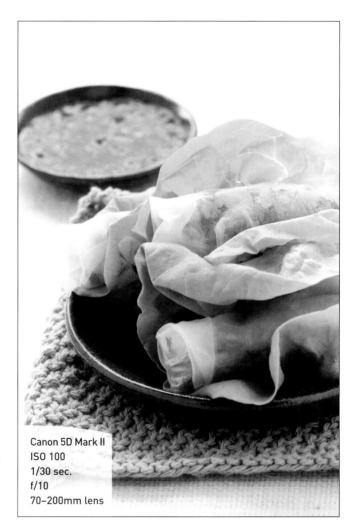

Canon 5D Mark II
ISO 100
1/30 sec.
f/10
70–200mm lens

FIGURE 7.19
This is one of the first photos from this set—I didn't like the way the uncut spring rolls looked here, so I decided to change up the plating to get something I would be happy with.

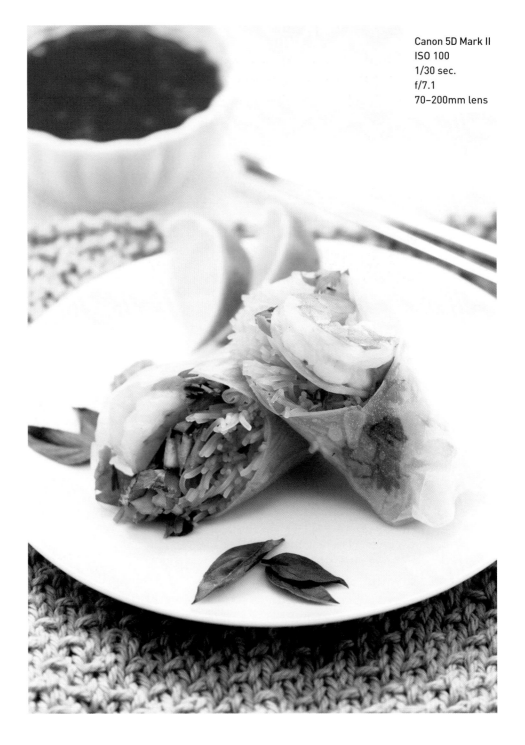

FIGURE 7.20
This is the
finished photo
from this series.

Canon 5D Mark II
ISO 100
1/30 sec.
f/7.1
70–200mm lens

LIGHTING SETUP

To light this dish, I used a North-facing window and placed folded white foam board on either side of the dish (**Figure 7.21**). Because there was a lot of reflection coming in from the window onto the sweet chili sauce, I placed a piece of black foam board at the base of the window (**Figure 7.22**). I also used a handheld reflector to bring in light to the very front of the spring rolls.

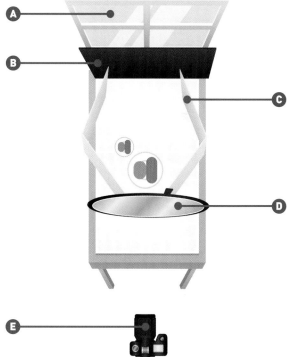

FIGURE 7.21

Behind the Scenes: Shrimp Spring Rolls
A North-facing window, diffused sunlight
B Black foam board
C Folded white foam boards
D Handheld reflector
E Canon 5D Mark II with 70–200mm lens

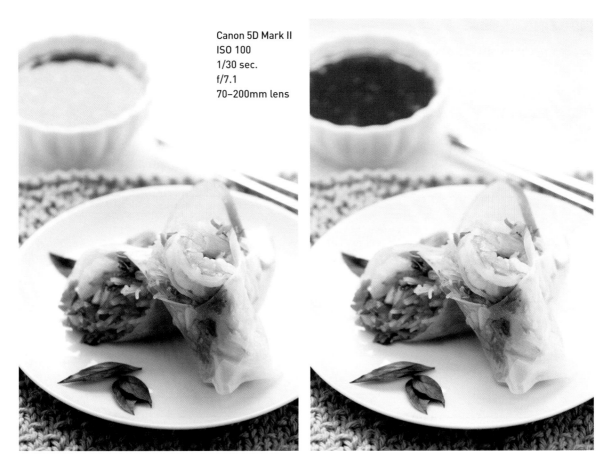

Canon 5D Mark II
ISO 100
1/30 sec.
f/7.1
70–200mm lens

FIGURE 7.22
The image on the left has a significant amount of light reflecting on the dipping sauce in the background. In order to block the light coming through the window, I placed a piece of black foam board at the base of the window (right image).

POSTPROCESSING

Now let's go through the steps to edit this photograph.

STEP 1: OPEN THE IMAGE IN CAMERA RAW

First I opened the RAW file in Camera Raw.

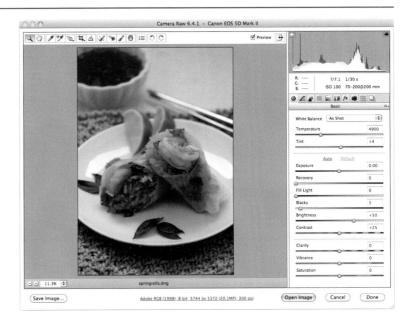

STEP 2: EDIT CAMERA RAW SETTINGS

I used the Temperature and Tint sliders to adjust the white balance in the image until it looked right. The image was a little bit dark, so I increased the Exposure, Recovery, and Vibrance settings by moving the sliders to the right. When I was finished, I clicked the Open Image button to open the photo in Photoshop.

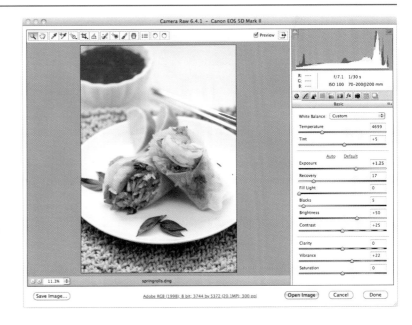

STEP 3: ADDING A LEVELS ADJUSTMENT LAYER

First I added a Levels Adjustment layer to the image. Then I increased its brightness by dragging the white slider to the left.

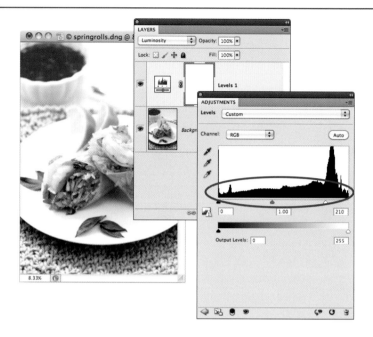

STEP 4: FIXING CLIPPED WHITES

Because the Levels adjustment was a bit too bright for the overall image, I clicked the *fx* icon in the Layers panel to open the Blending Options settings in the Layer Style window. Then, in the Blend If section, I held down the Option (Windows: Alt) key and dragged the white slider to the left, splitting it into two. This removed some of the overly bright areas of the adjustment.

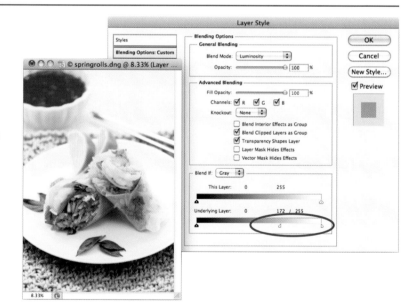

STEP 5: FINISHING UP IN PHOTOSHOP

I finished up by adding a color pop layer. I selectively sharpened it using the High Pass filter, masking only the portion of the image that was already in focus. Then, I saved the image as a PSD file and closed it.

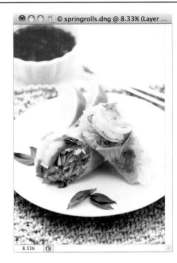

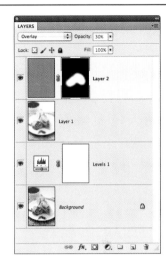

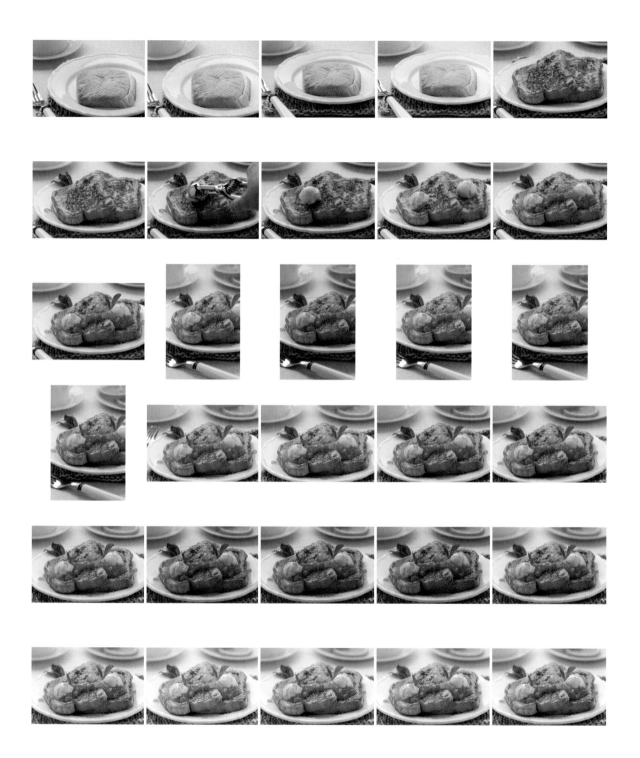

FRENCH TOAST

I'm usually a bacon and eggs girl when it comes to breakfast, but when I get a sweet tooth I often will default to making French toast. This dish is flavored with orange zest, which also added color and texture to the photograph.

STYLING AND PROPS

I cooked three pieces of French toast and layered them on the plate, putting the best-looking one in front (**Figure 7.23**). Then, because the French toast is flavored with oranges, I garnished the plate with orange zest curls. I added some sprigs of mint to the back of the plate and used a melon baller to scoop out two balls of soft margarine and place them on the toast (**Figure 7.24**). I finished off the plating with some orange marmalade (added carefully with a small plastic spoon) and a few more sprigs of mint for color (**Figure 7.25**). Finally, I added some maple syrup and got a photo of the syrup drizzling over the top of the French toast (**Figure 7.26**).

Since there were a lot of yellow and orange colors in the scene (the toast, butter, and oranges), I wanted to balance them with an opposite color, so I added mint leaves and a green placemat. I also added some oranges to the background to balance the scene compositionally.

FIGURE 7.23
I started with three
pieces of French
toast layered
on the plate.

Canon 5D Mark II
ISO 100
1/40 sec.
f/9
70–200mm lens

FIGURE 7.24
Next, I added some
mint and some
curls of orange zest
to the plate and
then used a melon
baller to scoop out
soft margarine to
add to the toast.

Canon 5D Mark II
ISO 100
1/40 sec.
f/9
70–200mm lens

Canon 5D Mark II
ISO 100
1/60 sec.
f/5.6
70–200mm lens

FIGURE 7.25
I then added some additional curls of orange zest, a few more sprigs of mint for color, and some orange marmalade.

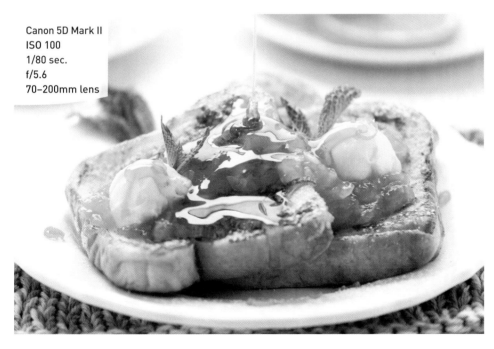

Canon 5D Mark II
ISO 100
1/80 sec.
f/5.6
70–200mm lens

FIGURE 7.26
To finish it off, I slowly poured maple syrup over the top of the French toast.

LIGHTING SETUP

I used a very simple natural-light setup for this image (**Figure 7.27**). I placed folded foam board on either side of the French toast and diffused some of the window light with a Lastolite™ TriGrip diffuser. I then used a small handheld reflector to bounce light directly on the front of the food.

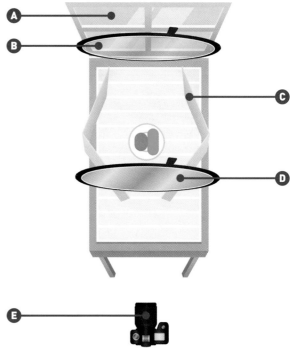

FIGURE 7.27

Behind the Scenes: French Toast

A North-facing window, diffused sunlight
B Lastolite TriGrip diffuser
C Folded white foam boards
D Handheld reflector
E Canon 5D Mark II with 70–200mm lens

POSTPROCESSING

Now let's go through the steps to edit this photograph.

STEP 1: OPEN THE IMAGE IN CAMERA RAW

First I opened the RAW file in Camera Raw.

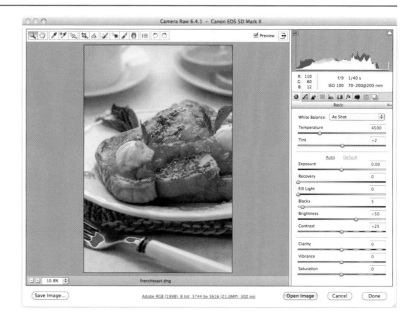

STEP 2: EDIT CAMERA RAW SETTINGS

The white balance on this image was perfect out of the camera, so I left it as it was. The image was a little bit dark, so I increased the Exposure, Recovery, and Vibrance settings by moving the sliders to the right. When I was finished, I clicked the Open Image button to open the photo in Photoshop.

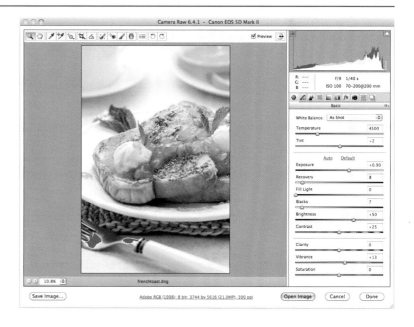

STEP 3: ADDING A LEVELS ADJUSTMENT LAYER

First I added a Levels Adjustment layer to the image. I increased its brightness by dragging the white slider to the left.

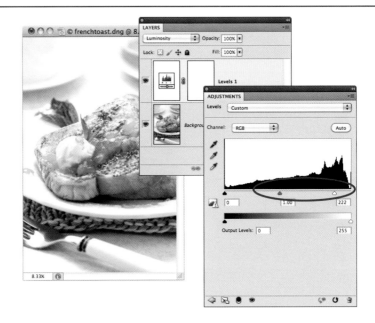

STEP 4: FIXING CLIPPED WHITES

Because the Levels adjustment was a bit too bright for the overall image, I clicked the *fx* icon in the Layers panel to open the Blending Options settings in the Layer Style window. Then, in the Blend If section, I held down the Option (Windows: Alt) key and dragged the white slider to the left, splitting it in two. This removed some of the overly bright areas of the adjustment.

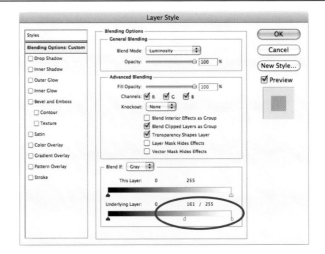

STEP 5: FINISHING UP IN PHOTOSHOP

I finished up by adding a color pop layer. I selectively sharpened it using the High Pass filter, masking only the portion of the image that was already in focus. Then, I saved the photo as a PSD file and closed it.

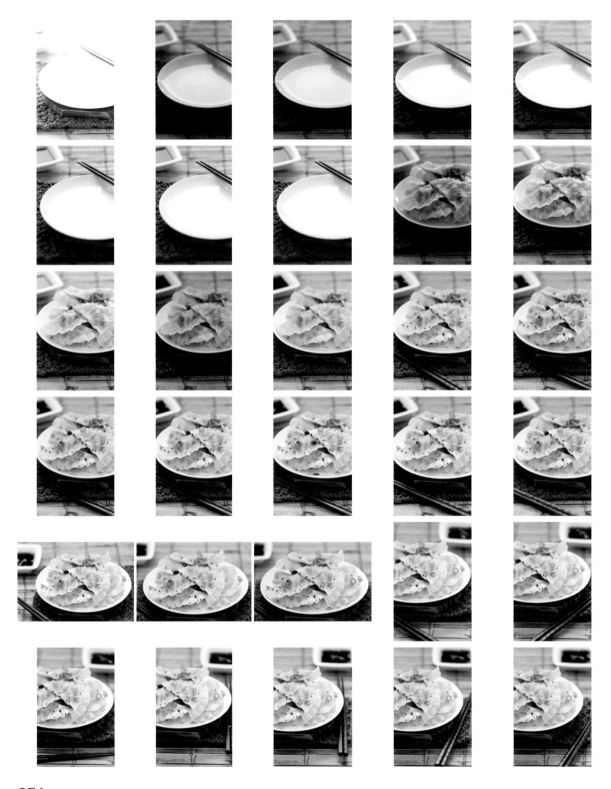

PORK DUMPLINGS

Oftentimes I find myself cooking with the full intention of only *eating* the food, but instead I end up setting it all up and photographing it, too. This was one of those moments. I used a simple natural-light setup for the food, so it didn't take too long and left me enough time to enjoy my meal afterward.

STYLING AND PROPS

To make the wontons, I first prepared the filling and then used a plastic dumpling mold to fold and seal the wonton wrappers (**Figure 7.28**). This also gave them a very pretty crimped look along the edges. Then, I seared and steamed them in a pan, and when they were ready, I piled them on a small plate. To garnish, I sprinkled black sesame seeds on top and placed sliced green onions throughout the dish for color (**Figure 7.29**).

I wanted to use darker colors for the props, so I chose a bamboo placemat underneath with a darker knit placemat on top. I set the plate on a small wooden stand to give the image some depth. I finished it off with dark wooden chopsticks in the foreground and a small dish of dipping sauce in the background.

FIGURE 7.28
Dumpling mold.

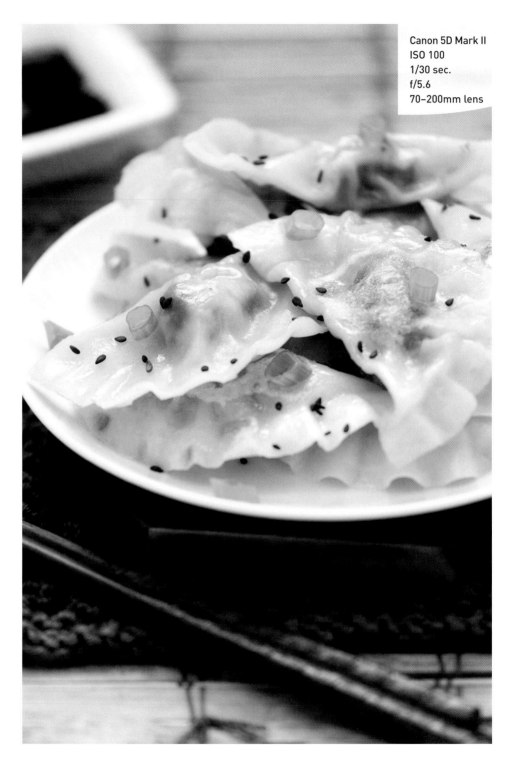

FIGURE 7.29
I added sesame seeds and green onions to garnish the dumplings and give them texture and color.

Canon 5D Mark II
ISO 100
1/30 sec.
f/5.6
70–200mm lens

LIGHTING SETUP

I used a North-facing window for the main light and placed folded white foam board on either side of the dish (**Figure 7.30**). The window was adding a lot of reflection to the dipping sauce in the background, so I added a piece of black foam board to block the light (**Figure 7.31**). To bring light in to the front of the dish, I used a small hand-held reflector.

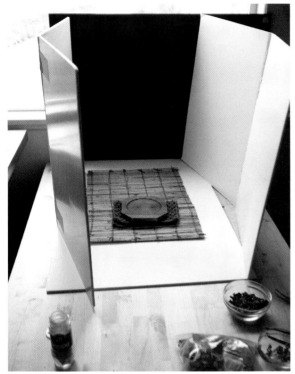

FIGURE 7.30

Behind the Scenes: Pork Dumplings

A North-facing window, diffused sunlight
B Black foam board
C Folded white foam boards
D Handheld reflector
E Canon 5D Mark II with 70–200mm lens

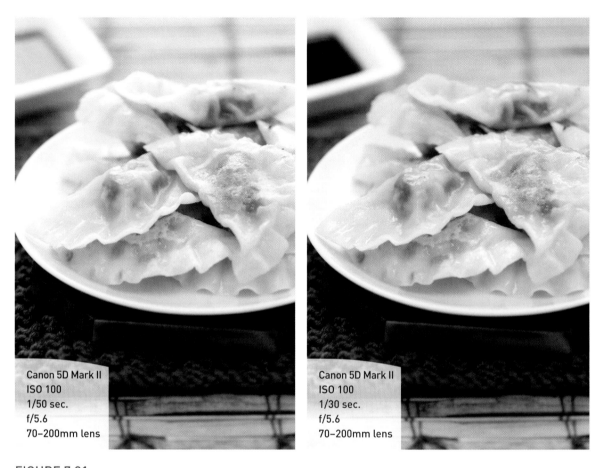

Canon 5D Mark II
ISO 100
1/50 sec.
f/5.6
70–200mm lens

Canon 5D Mark II
ISO 100
1/30 sec.
f/5.6
70–200mm lens

FIGURE 7.31
The image on the left has a significant amount of light reflecting on the dipping sauce in the background. In order to block the light coming through the window, I placed a piece of black foam board at the base of the window (right).

POSTPROCESSING

Now let's go through the steps to edit this photograph.

STEP 1: OPEN THE IMAGE IN CAMERA RAW

First I opened the RAW file in Camera Raw.

STEP 2: EDIT CAMERA RAW SETTINGS

I set the White Balance to Auto and left it there since it did a good job warming up the image. The image was a little bit dark, so I increased the Exposure and Recovery settings and moved the Blacks slider slightly to the right to bring out some contrast. Then I decreased the Brightness a bit and added some Vibrance to boost the colors. When I was finished, I clicked the Open Image button to open the photo in Photoshop.

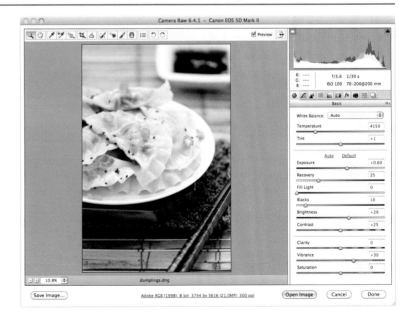

STEP 3: ADDING A COLOR POP LAYER

To add some color to this image, I duplicated the *background* layer, chose Filter > Blur > Gaussian Blur, set the Radius field to 50 pixels, and clicked OK.

STEP 4: ADJUSTING BLENDING MODES AND OPACITY

Next, I changed the blending mode to Overlay and set the Opacity to 30%. I also renamed the layer.

STEP 5: FINISHING UP IN PHOTOSHOP

I finished up by adding selective sharpening using the High Pass filter and masking only the portion of the image that was already in focus. Then, I saved the image as a PSD file and closed it.

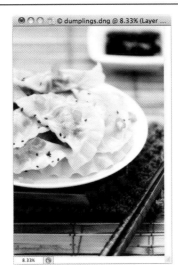

PASTA ON A FORK

Most of the images I create are of food that I cook and eat, usually for lunch or dinner, with an extra plate set aside to photograph. This image, however, is more of the "playing with light" variety—a fun way to work with leftover pasta and a hand steamer to see what kinds of fun visuals I can create.

STYLING AND PROPS

To start off, I cooked pasta and mixed it with marinara sauce. I let the food cool down while setting up the scene, and then I took a fork and twirled it in a big pile of the pasta. I used my fingers to position some of it on the fork and then brought it over to the set. I carefully attached the fork to the end of a Manfrotto Magic Arm with gaffer tape and then moved the arm around to try a few different angles (**Figure 7.32**). To finish off the styling, I spooned some additional marinara sauce onto the top of the pasta (**Figure 7.33**) and then placed a small sprig of oregano on the top for some contrasting color (**Figure 7.34**). The pasta was constantly slipping toward the end of the fork, so I had to carefully watch it so it didn't slip off completely. I used scissors to snip off some of the dangling strings of pasta so the entire image would fit within the frame.

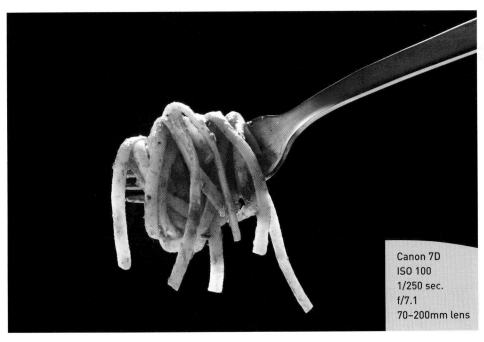

Canon 7D
ISO 100
1/250 sec.
f/7.1
70–200mm lens

FIGURE 7.32
I started by adding pasta to a fork, then I attached the fork to the Magic Arm and moved it into position.

FIGURE 7.33
Next I added some fresh marinara sauce to the pasta.

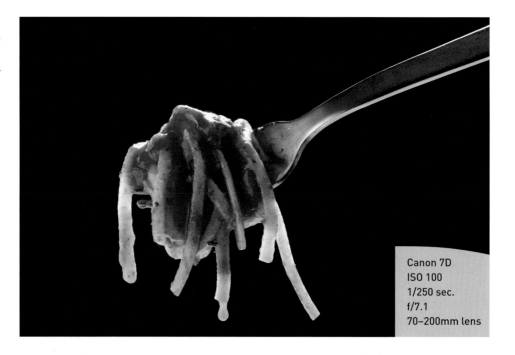

Canon 7D
ISO 100
1/250 sec.
f/7.1
70–200mm lens

FIGURE 7.34
As a finishing touch, I added a small sprig of oregano for some color.

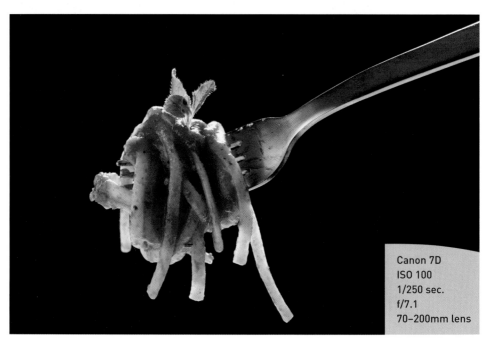

Canon 7D
ISO 100
1/250 sec.
f/7.1
70–200mm lens

The props used in this photo were quite simple. I chose this specific fork because it had a matte finish and was less reflective than a shiny fork. I used a piece of black foam board in the background, and I used a hand steamer to add steam to the scene (**Figure 7.35**).

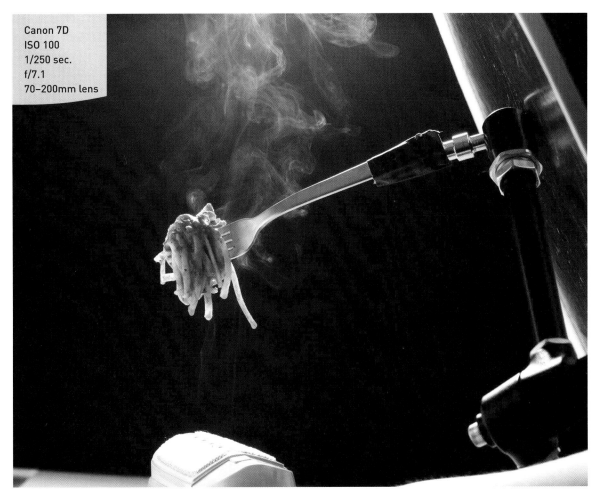

Canon 7D
ISO 100
1/250 sec.
f/7.1
70–200mm lens

FIGURE 7.35
I used a hand steamer to add steam to the image, making it look like the pasta was still hot and fresh.

LIGHTING SETUP

Backlighting was necessary in order to showcase the steam rising from the pasta. I also needed a light bright enough so I could use a fast shutter speed to capture the steam rising without it blurring. To do this, I decided to use a small flash. I placed the flash at the end of the table and used a Lastolite TriGrip diffuser to soften and spread out the light. I used a piece of black foam board as the background. I placed a folded white foam board to the left, a small reflector to the right, and a piece of foam board underneath to bounce light back onto the subject.

The final photo is actually two images combined into one (**Figure 7.36**). Before I took each set of steam photos, I did a few "non-steam" images, and while photograph-ing those I added some more reflection and light to the pasta and fork with another piece of white foam board (**Figure 7.37**). The image without the steam has better light, yet I still wanted to add steam, so I merged the photos. I demonstrate how I combined these photos in the next section, "Postprocessing."

FIGURE 7.36
This is the final photograph, which is actually two images com-bined into one.

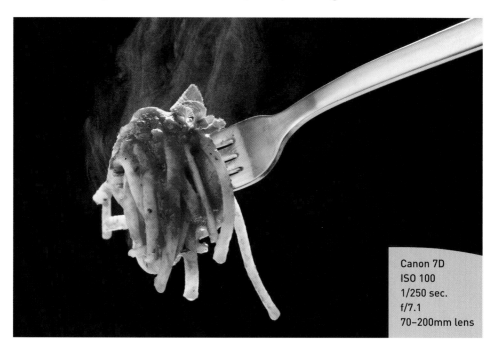

Canon 7D
ISO 100
1/250 sec.
f/7.1
70–200mm lens

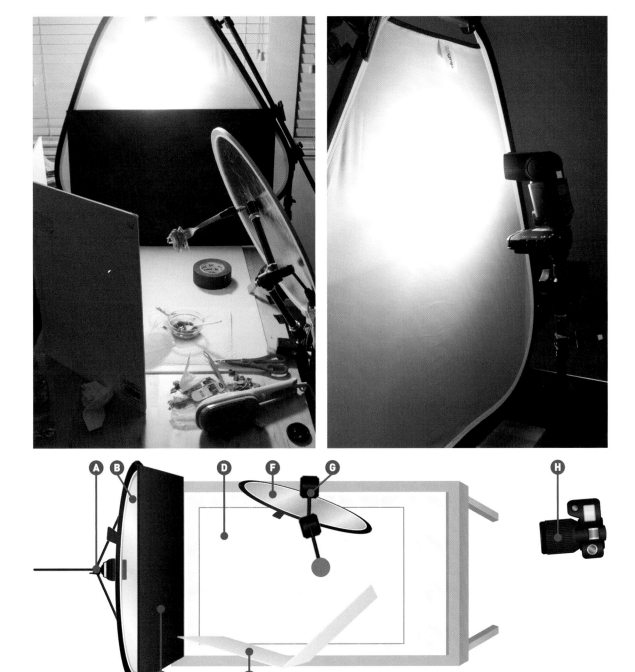

FIGURE 7.37
Behind the Scenes: Pasta on a Fork

A Canon 430EX Speedlight	**D** White foam board	**G** Manfrotto Magic Arm
B Lastolite TriGrip diffuser	**E** Folded White foam board	**H** Canon 7D with 70–200mm lens
C Black foam board	**F** Small reflector	

POSTPROCESSING

Now let's go through the steps to edit this photograph and merge the two images in Photoshop.

STEP 1: OPEN THE IMAGES IN CAMERA RAW

First I selected the two RAW files I wanted to work with and opened them both in Camera Raw.

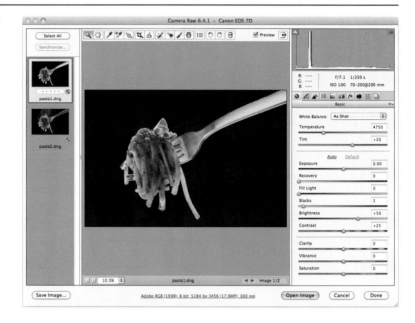

STEP 2: EDIT CAMERA RAW SETTINGS

I made some minor adjustments to the first image (Exposure, Recovery, and Blacks) and still needed to edit the second image. Since they were from the same series, I decided to synchronize them. I clicked the Select All button and then the Synchronize button.

STEP 3: SYNCING CAMERA RAW SETTINGS

A new window popped up asking me what I wanted to synchronize. I made sure that at least the three settings that I changed (Exposure, Recovery, and Blacks) were selected and clicked OK. When finished, I clicked the Open Images button to open both photos in Photoshop.

STEP 4: PUTTING BOTH IMAGES IN THE SAME DOCUMENT

With both images open in Photoshop, I needed to get them into the same document. Using the Move tool, I clicked Pasta1, held the Shift key down, and dragged the image over to the Pasta2 document.

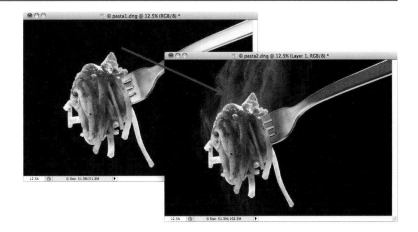

STEP 5: ADDING A LAYER MASK

Both images were on the same document, but only the top layer (the image with no steam) was visible. Since I wanted to show the steam from the bottom layer, I used masking. To get started, I clicked the Add Layer Mask icon at the bottom of the Layers panel to add a layer mask to the top layer.

STEP 6: LAYER MASKING

Next I set a small brush to zero hardness and painted with black over the areas where the steam would show through. This essentially "punches a hole" through the top layer so that you can see the layer beneath it.

STEP 7: THE FINAL IMAGE

After I finished painting, I ended up with a well-lit photo of pasta on a fork with steam rising from the top. Then, I saved the image as a PSD file and closed it.

Conclusion

When we are cooking, eating, serving, or just near food, there are a lot of senses at play. Not only can we see the food, we can also smell, taste, touch, feel, and even hear it. A heaping plate of something may not look appealing but can smell and taste so delicious that its looks don't matter. But when *only* looking at food, we have only our sense of sight to rely on. As photographers, it's our job to stimulate all of the senses with one photograph and make the food look as good (or better) than it tastes.

Although this is a technical, "how to" book on food photography, there is a lot more to photography than gear and technique. If you're reading this book, especially if you've gotten this far, then you no doubt love food and are passionate about sharing that love with others through your photographs. Stay true to that love, let your passion drive you, and rely on your eyes to see light, colors, and textures. In other words, don't let your camera do all of the thinking for you.

It's also important to understand that you will never, ever finish the learning process as a photographer. It's so crucial to continually challenge yourself, test your limits, and try new things. Find a style of learning that works for you—whether it's reading books (like this one), watching videos, hands-on doing, or doing a bunch of research online. The key is to keep on growing and always move forward. Look at lots (and lots and lots) of beautiful food photographs and study *why* you like them. Photographers aren't photographers only when holding a camera, we are constantly (and oftentimes subconsciously) searching for our next photograph. So, try to *see* light even when you don't have your camera—watch how it falls across objects, creates shadows, and changes colors during the different parts of the day.

The bottom line is that making beautiful photographs of food is what we ultimately set out to do as food photographers, and I truly hope that this book is helpful to you in your journey. And don't forget that one of the biggest compliments you could ever receive about a food photograph is that it made people hungry. When people want to eat something because they saw it in your image, then you're on the right track.

So stay hungry, find and create beautiful light, keep cooking, and always keep a camera close by—you never know when you'll find something beautiful.

INDEX